Modern Pioneers in Typography and Design: Anna Simons, Edward Johnston, Rudolf von Larisch, F. H. Ehmcke.

INGE DRUCKREY

Copyright © 2024 Graphics Press LLC

PUBLISHED BY GRAPHICS PRESS LLC

POST OFFICE BOX 430, CHESHIRE, CONNECTICUT 06410

WWW.EDWARDTUFTE.COM

All rights to text and illustrations are reserved by Inge Druckrey and Graphics Press LLC. This work may not be copied, reproduced, or translated in whole or in part without written permission of the publisher, except for brief excerpts in reviews or scholarly analysis. Use with *any* form of information storage and retrieval, electronic adaptation or whatever, computer software, or by similar or dissimilar methods now known or developed in the future is strictly forbidden without written permission of the publisher and copyright holder. A number of illustrations/images are reproduced by permission; those copyright holders are credited on pages 186–187.

Printed in the United States of America First Printing, April 2024

Acknowledgments

I am grateful to the following libraries and museums for access to their collections and for the advice and assistance of the staffs.

IN GERMANY: 2004 Typotage, Leipzig. Bayerische Staatsbibliothek, Munich. Deutsches Buch- und Schriftmuseum der Deutschen Nationalbibliothek, Leipzig. Gutenberg Library, Mainz, with special thanks to Gertraude Benöhr. Klingspor Museum, Offenbach a. M., with special thanks to Martina Weiss and Stefan Soltek. Staatliche Museen zu Berlin-Preussischer Kulturbesitz, Kunstbibliothek. Staatsbibliothek zu Berlin, Potsdamer Platz. Stadtbibliothek, Köln. Typographische Gesellschaft, Munich.

IN AUSTRIA: Bibliothek des Museums für Angewandte Kunst, Vienna.

IN ENGLAND: British Library, London. Ditchling Museum for Arts and Crafts, Ditchling, East Sussex, and its director Donna Steele; a special thank you also to Professor Ewan Clayton, who showed me highlights of the museum's collection. Johnston Foundation in Ditchling, East Sussex, especially its director, Gerald Fleuss.

IN IRELAND: Trinity College Library, Dublin.

IN SWITZERLAND: Zürcher Hochschule der Künste ZHdK, Bibliothek as well as the Zürcher Hochschule der Künste ZHdK, Archiv, especially Guido Krummenacher. Museum für Gestaltung Zürich, Grafiksammlung and Plakatsammlung, a special thanks to Barbara Junod and Alessia Contin.

IN THE UNITED STATES: Beinecke Rare Book and Manuscript Library, Yale University, New Haven, Connecticut. Cary Graphic Arts Library, Rochester Institute of Technology, Rochester, New York, especially Steven Galbraith. Center for British Art Library, Yale University, New Haven, Connecticut. Getty Research Library, J. Paul Getty Museum, Los Angeles, California. Henry E. Huntington Library, San Marino, California. Newberry Library, Manuscript Collection, Chicago. Robert B. Haas Family Arts Library, Yale University, New Haven, Connecticut. San Francisco Public Library, Book Arts and Special Collections, with special thanks to Susie Taylor. University of the Arts Library, Philadelphia, Pennsylvania. William Andrews Clark Memorial Library, University of California, Los Angeles.

The beautiful images in this book would not exist without the exemplary work of many photographers and designers, among them:

Heinz Hefele, for photographs of Thea Budnick's exercise book. Florian Bolk, for photographs of the inscription on the pediment of the Reichstag in Berlin. Wolfgang Günzel, for the many photographs from the Collection of the Klingspor Museum, Offenbach, a. M., Germany. Dietmar Katz, for photographs of original artwork by Ehmcke in the

Staatliche Museen zu Berlin, Preussischer Kulturbesitz, Kunstbibliothek. Thomas Matyk, for a scan of a poster by Alfred Roller in the Bibliothek des Museums für Angewandte Kunst, Vienna, Austria. Mark Zurolo, for his photographs of pen shapes, two explanatory drawings, his expert technical advice on many occasions, and most of all, his teaching an eighty-two year old lady the intricacies of InDesign. The staff of GHP Media, West Haven, Connecticut, especially Francisco Nogueira and Craig Wermann, for their outstanding photographs and image correction, as well as Donia Jennings, for coordinating the work. Bonnie Scranton, for her impressive work cleaning and partially redrawing the trademarks by F. H. Ehmcke.

My research, which goes back a good thirty years, would not have been possible without the assistance of the following individuals:

Howard Gralla, for introducing me to Lili Wronker, and through her to the Anna Simons student, Ursula Suess, and most of all for setting up the grid for my book, which helped me tremendously. Ursula Suess, for generously allowing me to acquire the exercise books she created in Anna Simons's class. Marilyn Braiterman, the antiquarian bookseller, who found the beautiful portfolio *Titel und Initialen für die Bremer Presse* for me. Matthew Carter, for introducing me to John Dreyfuss. Many thanks to John Dreyfuss, for directing me to the correspondence between Anna Simons and Edward Johnston, held at the Newberry Library in Chicago. Hermann Zapf, for connecting me with the Anna Simons student, Thea Budnick, as well as sending me copies of published material on Anna Simons. Thea Budnick, for allowing me to photograph several pages of her exercise book from Anna Simons's class. Barbara Kanner, my longtime assistant and friend, for realizing that her family's 19th century ledger, handwritten in pointed pen current, would add immeasurably to this book. Yvonne Schwemmer-Scheddin, for giving me the manuscript of her lecture on Anna Simons. Adrian Frutiger, for entrusting me with a draft of an intended book meant to honor his teachers Alfred Willimann and Walter Käch, as well as providing me with pertinent information on Anna Simons's contributions to the Zürich school. Hans Eduard Meier, for telling me about his experience as a student of Willimann and Käch. Ewan Clayton, for the high quality photographs of Edward Johnston's blackboard writing at the Royal College of Art in London. Frank Purrmann, my research assistant in Munich, for locating members of the family who took Anna Simons in after her house was destroyed, as well as for information on the location of her grave. Marianne Siegenheim, a niece of Anna Simons, for sending me photographs of the elderly Anna Simons when she lived with Marianne's family, as well as a copy of a family tree. Ruari McLean and Antonia Maxwell Carlisle-McLean, for

information about Anna Simons at a time when I knew nothing about her. Erich Alb, for leads to property right holders of the work of a number of important Swiss designers. Jörn Scharlemann, a favored family member, who convinced me to visit the town of Ditchling with its many sites connected to Edward Johnston. Dorothea Hofmann, for her support and friendship over many years and for sharing some of her research material with me. My brother Eike Druckrey for supplying me with recent German books or newspaper articles related to my book.

It took much support and many editors, copy editors, and proofreaders to bring to completion a book written by an author whose first language was not English. My heartfelt thanks to all of the following:

Virgina James Tufte and Dawn Finley, for three summers of intense writing workshops and important editorial advice. Susan Viguers, for many years of helping me to structure the book, as well as teaching me about the mysteries of endnotes. Molly Cort, Managing Editor, RIT Press, for initial editorial assistance. Kris Holmes for her thoughtful critique of the Anna Simons chapter. Juliane E. Brand for fierce constructive criticism in the later stages of the book. Lindsey Westbrook and Cathy Shufro, for copy editing assistance. Carolyn Williams, for her excellent proofreading. Barbara Kanner, for keeping my files straight, as well as putting her German language background to good use. The staff of Graphics Press, for generous assistance on many occasions: above all Jared Ocoma, for technical help in so many instances; Pam Mozier, for organizational help and for packaging and sending books; and Kristie Addy, Cynthia Bill, and Bonnie Darling. And a huge thank you to Peter Taylor and Michael Rogers, for keeping Ace happy and well, and taking care of the house and grounds.

To Virginia James Tufte,
my mother-in-law, who introduced me
to the craft of writing
and to
Edward Rolf Tufte,
my husband, for his support
over many years
and his generosity in publishing
this book.

Contents

INTRODUCTION 13

ANNA SIMONS 20

RUDOLF VON LARISCH 72

F. H. EHMCKE 102

WAVES OF INFLUENCE: ZÜRICH CONNECTIONS 154

Above:
One of the four sides of the Forum Stone, the remains of a four-sided pillar that is inscribed with Latin writing from ca. 600 BCE. It was found in 1899 on the Roman Forum. From Harald Haarmann, *Universalgeschichte der Schrift* (Frankfurt am Main: Campus Verlag GmbH, 1990), 295.

Top right:
Roman inscription, ca. 200 BCE.

Immediate right:
Roman inscription, ca. 100 CE

Detail of tenth-century psalter in English Carolingian hand, probably written in Winchester, England. Harley MS 290 (folio 203v). Photo courtesy of the British Library Board.

Introduction

A brief history.
Latin letters, *our* letters, have been in use for about 2,400 years. The earliest example of Latin writing goes back to ca. 600 BCE. The letters, simply scratched into the soft surface of volcanic limestone, are barely decipherable to contemporary eyes (opposite page, top left).[1] A later example of a Roman inscription in a similar, linear style from ca. 200 BCE, here not scratched but carved into stone, already looks very familiar to us (opposite page, immediate right). The refinement of the letters in this carving suggests that they might have been written on the stone with a stylus-like tool before they were carved.

By about 50 BCE the writing tool used to sketch letters onto the stone prior to carving them had gradually changed from a stylus to a tool resembling a broad-edged brush that was held at an angle of about 25 degrees (opposite page, third image). This simple change of the tool, and of the angle at which the tool was held, resulted in rhythmic variations in the widths of the strokes making up each letter.

Walter Käch wrote the two white letters—here projected onto the image of a Roman carving—with chalk on a classroom blackboard. Photo courtesy of Museum für Gestaltung Zürich, Grafiksammlung.

Use of this tool led to beautiful forms especially in letters with curved strokes. In the O above, for example, the brush held at the 25-degree angle would have started at the top of the left curve of the O. With the angle of the brush kept constant, the stroke begins to gain weight until it reaches its full width at the turning point of the curve—the optical middle of the O. On the way down the left side of the letter the stroke gradually loses width again, regaining the original thin width as it reaches the bottom of the O. The same process is followed in shaping the right curve. This beautiful swelling stroke, caused by the shape and angle of the brush and the gesture of the hand describing the curve, is repeated in the curves of R, B, P, C, D, and G. The 25-degree angle also results in the slight leftward tilt of the axes of all curves, an effect most visible in the O above. Another change in the shape of letters comes from the elegant formulations of the beginnings and endings of horizontal and vertical strokes, or serifs, carved following the stroke of the brush.

The most refined phase of Roman stone inscriptions lasted from ca. 50 BCE to 150 CE.[2] From then on, broad-edged writing tools, such as reed pens and quills, shaped all manuscript hands, as well as, after the invention of printing, all of our typefaces up to the middle of the eighteenth century.

peccatorum eorum

eruiscera misericordiae di nri

Example of Carol Twombly's typeface Adobe Caslon Pro Semibold, 1990.

Example of Robert Slimbach's Adobe Garamond Pro Semibold, 1988.

| 13

Modern broad-edged pen

Detail from a page in Giambattista Palatino's writing manual *Libro nuovo d'imparare a scrivere* (1545), showing an example of the handwriting style cancellaresca corsiva; woodcut. From Jan Tschichold, *Meisterbuch der Schrift* (Ravensburg, Germany: Otto Maier Verlag, 1952), 228.

Modern pointed pen. Photos of pens courtesy of Mark Zurolo.

Detail from a page in Lucas Materot's writing manual *Les Oeuvres* (1608), showing an example of his handwriting style which is similar to later English roundhand; copperplate engraving. Translation of top line reads: "Letters, easy to copy for women." Ibid, 135.

With the invention of printing in the West around 1440, scribes, who had worked for hundreds of years in monasteries copying books and important manuscripts, had to find new employment. By the beginning of the sixteenth century they began to serve as scribes for the nobility, keep records in church chanceries and the judiciary, worked as itinerant teachers of fine writing, and published books on the craft of writing.[3] It may be that these new occupations gave them a feeling of greater freedom, as it is around this time that we see them showing off their amazing hand skills. Previously beautiful but restrained book writing exploded into elegant, decorative flourishes.

However, the broad-edged pen demanded complicated manipulation, such as tilting the pen to achieve the stroke weight that the scribes envisioned.[4] It might have been their experience with copperplate engraving, and the delicate lines this printing technology made possible, that prompted scribes gradually to change first to finer-edged, and then to pointed pens.

This seemingly tiny difference in the shape of the pen nib led to the evolution, over time, of an entirely new writing style: the pointed pen current. This style is characterized by thin lines, a prominent slope, fluid changes in the weight of strokes—made possible by varying the pressure on the nib—and, above all, that letters were now consistently linked. It was particularly this linkage that increased writing speed and led to this style's being adopted as the common business hand all over Europe. It was brought to the United States by the early colonists and, becoming fashionable, stayed around until the end of the nineteenth century (opposite page, top).[5]

Detail of a page from a nineteenth-century American ledger written in pointed pen current. Photo courtesy of Barbara Kanner.

It might well have been the pointed pen current's popularity that spilled over into typeface design. By the middle of the eighteenth century a new generation of typeface designers and printers—foremost among them the Frenchman Firmin Didot and the Italian Giambattista Bodoni—developed the so-called neoclassical typefaces. This new style, characterized by extreme contrast between fine lines and heavy strokes, almost entirely displaced older typefaces in both Europe and the United States. Letters of older typefaces were based on *manuscript hands*—shaped by the broad-edged pen through variations in pen angles and hand gestures—and had by these means miraculously created such variations of Roman letters as half uncial, Carolingian hand, textura, and many others. Neoclassical letters, on the other hand, were not written but *drawn*. They actually closely resembled ninth-century versals, a lettering style created to indicate the start of a new verse or paragraph. Scribes drew these letters by tracing the outlines of traditional Roman letters with a pointed pen and then used a brush to fill in the resulting empty spaces (image right).

Thus removed from the writing process, neoclassical faces lost essential information inherent in Roman letters, information that can only be accessed by writing letters with a broad-edged pen. This craft had provided, in the words of Thomas J. Cobden-Sanderson, "ever-living and fluent prototypes for the development of new letterforms." When, therefore, typefaces lost their connection to broad-edged-pen writing, typeface design hit a dead end.

To make matters even worse, the Industrial Revolution brought major changes to the printing industry. Until then punch cutting, typesetting, and letterpress printing had been done by highly experienced craftsmen with sensitivity and feeling for their craft; once they were replaced by machine operators, and aesthetics were no longer a consideration, book design and production suffered commensurately. This resulted in shoddy layout, paper, typefaces, and printing. The Swiss art and design historian Willy Rotzler

Antiqua by Firmin Didot, ca. 1790

L M N O P

From Jan Tschichold, *Meisterbuch der Schrift*, 171.

Versals, ca. 800 CE

NOMNE

Cod. Pal. lat. 864 1v. Photo courtesy of the Universitätsbibliothek Heidelberg.

Versals

H G D b b

Detail from an exercise book of Anna Simons's student Thea Budnick. Photo courtesy of Gundula Grützner.

commented on this in his contribution "Book Printing in Switzerland" to *Book Typography 1815–1965 in Both Europe and the United States of America*:

> Aesthetic taste did not keep pace with technical advances in the printing industry and the mass production of printed matter. Thus the nineteenth century's enormous intellectual achievements were presented to contemporaries and posterity in a physical form that manifests an almost inexplicably low standard of taste. Just how great the discrepancy between subject matter and form in these books was, becomes clear when we compare them to those of the age of Humanism and the Enlightenment.[7]

The preference for neoclassical typefaces, and the sole use of pointed pens for cursive writing, lasted about 150 years. No wonder, then, that by the late 1800s no memory remained of what had shaped the letters of earlier typefaces. As Noel Rooke noted in his introduction to Edward Johnston's *Writing and Illuminating and Lettering:* "Penmanship had decayed, even the methods of shaping, and still more of using any but a narrow pen, had been lost."[8]

This was roughly the situation on the day in 1888 when William Morris (1834–1896) attended a slide lecture by Emery Walker and saw several enlarged images of fifteenth-century typefaces. They were a revelation to him. The story goes that Morris decided right then and there, on the way home from the lecture, to design his own typeface.[9] Being William Morris, he followed through on the idea. With Walker's help he worked from enlarged photographs of a fifteenth-century Venetian typeface, tracing the letters many times before designing his new typeface, the Golden Type, to match the heavy woodcut illustrations of Edward Burne-Jones for a new edition of Chaucer's works. Produced by the excellent punch cutter Edward Prince, this was the first face to suggest a way to return to the essential forms of Roman letters.

Just three years later, in 1891, Morris started the first fine press, Kelmscott Press, with the help of a few retired typesetters and printers. His goal was to produce books whose every element—typeface, layout, paper, ink, printing, and binding—would be of the highest quality. And this he did. Printing beautiful books again was revolutionary and led to an explosion of private presses in England. The most important of these was Doves Press. Founded by Thomas J. Cobden-Sanderson and Emery Walker in 1900, Doves Press played a significant role in spurring the establishment of private presses on the Continent, especially in Germany.

Rather than going back to fifteenth-century manuscript hands, most of the founders of the first fine presses followed Morris's process and photographically enlarged and traced letters from fifteenth-century books to create their own typefaces.

Page from "Romaunt of the Rose," *The Works of Geoffrey Chaucer* (Hammersmith: Kelmscott Press, 1896), 285. Photo courtesy of the Yale Center for British Art, Paul Mellon Collection.

Example of Morris's first typeface, the Golden Type.

Morris, in showing that it was possible to break out of the dead-end of neoclassical typefaces, opened the door a bit for the development of modern typeface design; a development that did not really begin until the mid-twentieth century, when it was finally understood that the letters of Roman inscriptions and of early typefaces had been shaped less by the chisel of the stone carver or the graver of the punch cutter than by broad-edged writing tools.

William Morris's beautifully produced books foreshadowed a renewal of typeface design. But it was Edward Johnston (1872–1944), through his research into medieval and Renaissance manuscripts, who identified those manuscript hands that had served as models for the best typefaces of the earliest printed books and could serve the same function now. Additionally, Johnston had realized early on, that the shape of our letters was not based on geometric constructions, but rather had evolved through the process of writing. He brought back the tools of the early scribes, the broad-edged reed pen and quill, which he saw as the essential letter-making tools.[10] Through his creation of the very first course on the craft of writing—or formal writing, as he called it—and his handbook, *Writing and Illuminating and Lettering*, Johnston's discoveries became widely known and, over time, made modern typeface design possible. His influence lasts even into our time.

Next to Johnston, it was Rudolf von Larisch (1856–1934) who laid the groundwork for modern typography and the application of letters in graphic design. Initially Larisch and Johnston did not know of each other and covered different, if complementary, aspects of these new fields. But the two men came to the same conclusion about how to raise the quality of typefaces and, with that, of books: that it was essential to go back to the beginning and practice handwriting with the tools that had first shaped our alphabet. Larisch was additionally intent on improving the spacing of letters, an important component of his vision of an enhanced appearance of letters in all text, including inscriptions and signage.

Through their teaching and publications Johnston and Larisch became known throughout Europe as well as in the United States; Larisch's books had a smaller audience, as they were never translated into English. But both men energized succeeding generations of students. Notable among the first generation were Anna Simons (1871–1951), a direct student of Johnston, and F. H. Ehmcke (1878–1965), who was deeply influenced by the ideas of Larisch but also—through Simons—those of Johnston.

This book represents my research into the lives, work, and teaching of Johnston, Simons, Larisch, and Ehmcke. The last chapter, "Waves of Influence: Zürich Connections," traces their contributions during the academic year of 1920–1921 at the School of Arts and Crafts in Zürich, Switzerland, where they had a lasting, but surprisingly little-known influence on generations of students up to and including—whether they realize it or not—today's designers.

Notes

1. Forum Stein (lapis niger) in Rom. Photo courtesy Harald Haarmann, *Universalgeschichte der Schrift* (Frankfurt a. M., New York: Campus Verlag, 1990), 295.
2. Ibid., 471.
3. Klara G. Roman, *Encyclopedia of the Written Word* (New York: Frederick Ungar Publishing Co. 1980), 425.
4. Ewan Clayton, *The Golden Thread: the Story of Writing* (London: Atlantic Books, 2013), 167–169.
5. Klara G. Roman, *Encyclopedia of the Written Word*, 313.
6. Clayton, *The Golden Thread: the Story of Writing*, 268.
7. Willy Rotzler, "Book Printing in Switzerland," in Kenneth Day ed., *Book Typography 1815–1965, in Europe and the United States of America* (Chicago: The University of Chicago Press, 1966), 307.
8. Noel Rooke, "A biographical Note," in Edward Johnston, *Writing and Illuminating and Lettering* (London: A and C Black Ltd., 1994), v.
9. Clayton, *The Golden Thread: the Story of Writing*, 269.
10. Edward Johnston, "Author's Preface," in *Writing and Illuminating and Lettering* (New York: Dover Publications, Inc., 1995) xi.

*From time to time I have seen photographs or examples of her
Manuscripts and Lettering, or Decorative Capitals reproduced with printing,
and such examples have shown how all her work has been marked
by these qualities of thoroughness and perfect workmanship, until,
by these things, and by her own talent and her great sincerity of purpose,
her Work has achieved a high distinction of its own.*

—Edward Johnston, 1938

Anna Simons (1871–1951)

Anna Simons was born in 1871 in München-Gladbach to an old, established family of the Rheinland. Women were barred from attending art school in nineteenth-century Germany, and since Simons's mother, Karoline Marie Weber, was aware of her daughter's talent and the fact that she was not cut out for the traditional role of a woman, she insisted, shortly before her death, that Simons go to England. And so in 1896, at just twenty-five years old, Simons left Germany to begin her studies at the Royal College of Art in London. This decision was unusual and courageous for a young woman in her circumstances. She wrote about it later in a slightly mocking way:

> At the time of Mr. Johnston's appointment to the Royal College of Art, I had the good fortune to be a student there, for at that time women students were not admitted to Prussian arts and crafts schools. Since the early nineties the fame of William Morris and the appreciation of his work had been spreading all over the continent. The Prussian Ministry of Commerce dispatched an architect, Hermann Muthesius, to the German embassy in London to study English architecture and English arts and crafts. To enter an English school of art seemed therefore advisable.[1]

Anna Simons at her graduation as an associate of the Royal College of Art, London, 1904. From *Anna Simons* (München-Berlin: R. Oldenbourg Verlag, 1938), 19; hereafter called the "Festschrift for Anna Simons." Author's collection.

After passing the entrance exam she began taking a broad range of courses in arts and crafts, intending to become an art teacher. In 1902, six years after she arrived, the college was reorganized and a number of elective courses added to the curriculum. The one she chose was on writing and lettering, taught by Edward Johnston. "The idea of writing and lettering as forming an integral part of art education," she wrote, "was quite unknown then."[2]

A bit of background: William Lethaby, then principal at the Central School of Arts and Crafts in London, had intended to include such a course in his curriculum for quite a while; in 1898 a chance meeting with Johnston, who had recently quit the study of medicine to become an artist, gave Lethaby the idea of asking Johnston to study the craft of formal writing, so that he might later develop a course on the subject. Johnston was interested in handwriting but totally untrained. So, "starting from zero and alone," as Noel Rooke noted in his introduction to Johnston's 1906 handbook *Writing and Illuminating and Lettering*, he began to study different manuscript hands at the British Museum, not only analyzing them but, most important, writing them himself.[3] By doing so Johnston (re)discovered the tool used by early scribes—the broad-edged reed pen—and realized that it was the use of this pen and, more specifically, the subtle changes in its angle that had created the beautiful letters of manuscripts throughout the history of writing. Johnston thereupon taught himself to cut and use pens of this kind, which led him to better understand letter shapes, the stroke sequences used by scribes in the Middle Ages, the treatment of stroke endings, and writing speed.

Edward Johnston at Lincoln's Inn, London, 1902. From Priscilla Johnston, *Edward Johnston* (London: Faber and Faber, 1959), 64. Photo courtesy Andrew Johnston.

Manuscript hands shown below are excerpts from the original manuscripts Johnston studied at the British Museum. All images on this page are courtesy the British Library Board.

Seventh-century uncial writing, probably Continental, of the Gospel of St. John. Loan MS 74 (folio 53v).

Seventh-century English half-uncial writing of Latin Gospels, from the Durham Book, written at Lindisfarne, NE England, under Irish influence. Glosses (interlinear translations) in the Northumbrian dialect were added in the tenth century. Cotton MSS Nero D IV (folio 8).

Carolingian writing, English, tenth century psalter, probably written at Winchester, England. Harley MS 2904 (folio 203v).

Recognizing Johnston's talent, Lethaby asked Sir Sydney Cockerell, who had been private secretary to William Morris and was himself a collector of early manuscripts, to suggest specific manuscripts for Johnston to use as models. After several years of testing various manuscript hands for clarity and readability, Johnston chose six for further study. These included seventh-century uncial and half-uncial writing and tenth-century English writing from the Winchester Psalter, an example of early Carolingian script.

Johnston was still experimenting and testing when Lethaby asked him to teach a course at the Central School that he called Illuminating. Four years later Johnston taught the course at the Royal College of Art. As Johnston's daughter Priscilla recalls in her 1959 book *Edward Johnston*, "This class, in September of 1899, represented probably the first of its kind ever to be held, the parent of all these classes in lettering which appear in the curriculum of so many art schools today."[4] Although each class lasted only two and a half hours, it often took Johnston ten times as long to prepare.[5] His first students included, among others, the young Noel Rooke, "then hardly more than a boy,"[6] the architectural student Eric Gill, and the solicitor Graily Hewitt. The second class was joined by "sixty-year-old established bookbinder Thomas J. Cobden-Sanderson of the Doves Bindery, who had bound the Kelmscott Press books for Morris" and would later cofound Doves Press together with Emery Walker.[7] What an unusual group of students.

By the time Simons took Johnston's class in 1902 both the subject matter and the pedagogy were well established. "Mr. Johnston's lectures," she commented, "gradually gave us insight into the realm of good lettering and, as he had only recently surmounted the initial difficulties himself, he was able to help us with ours." Students found it hard to cut and use the reed pens until, as Simons noted, Rudolf Blanckertz, a German pen manufacturer, provided pens "made from oriental reed and fitted with a brass spring."[8]

Johnston's gift was the combination of a good eye and an analytical and highly creative mind. In the process of developing his new course he discovered a way to simulate the broad-nibbed pen with chalk on the blackboard in order to show students the amazing form-giving power of this tool. "Indeed he might have claimed to have invented a new art," his daughter Priscilla wrote, "being probably the first man to have used chalk on a blackboard as a medium for expressing his art itself and not merely for explaining something about it."[9] Teaching with the help of a blackboard became essential, given the increasing numbers of students in Johnston's classes at the Royal College. He refined this skill to such an extent that wherever he lectured, as at the Art Teachers Conference in Dresden in 1912, it created a sensation. Simons noted: "Mr. Johnston's demonstrations on the blackboard were unforgettable events. His letters and initials, freely written with chalk, always bore the mark of original and spontaneous creations."[10]

From then on this simple but highly informative teaching technique would be copied by everyone teaching writing and lettering. Simons used it in her classes, and those of her students who became teachers used it in theirs, generation after generation.

Edward Johnston's writing on a blackboard at the Royal College of Art, ca. 1926. Photographer unknown. Photo courtesy Professor Ewan Clayton.

Detail of an exercise book by Simons's student Thea Budnick, showing a modernized half uncial based on Johnston. Photo courtesy Gundula Grützner.

Tenth-century English psalter in Carolingian script, probably written at Winchester. Harley MS 290 (folio 203v).

Edward Johnston's writing on a blackboard, Royal College of Art, ca. 1926. Photographer unknown. Photo courtesy Professor Ewan Clayton.

Johnston preferred to start each course with writing out his modernized half-uncial letters, a manuscript hand he had developed based on the Irish half uncial of the *Book of Kells*. This script, consisting largely of semicircular strokes, was easy to learn. Simons noted, "These circular strokes have to be written with a certain swing, and so demonstrate clearly the fundamental difference between a written stroke and a carefully-drawn line."[11]

Johnston chose this modernized version of the Irish half uncial as his first Foundational Hand, a manuscript hand that was readable and formally linked to contemporary lowercase writing styles and printing faces: "This modern half uncial has been used by me as a 'copy book' hand for students of penmanship since 1899, being gradually modified to its present form. It is in effect the 'straight-pen' form (written with the nib of the pen parallel to the base line of the writing) of the 'Roman' small letter that is practically the Roman half uncial. With the simplest necessary finishing strokes added (it comes very close) to the Irish half uncial of the *Book of Kells*. It therefore represents the ancestral type of [the] small letter."[12] "All his life," his daughter recalled, "he considered the *Book of Kells* and the Durham Book as the greatest glories of calligraphy, even long after he had abandoned the use of his early round hand that derived from them."[13]

After half-uncial letters, Johnston's course of study continued with "slanted penforms, adapted from the tenth-century Winchester Psalter with its minuscules and majuscules," which showed characteristics of the Carolingian hand. Johnston later chose this style of writing as his new Foundational Hand: "I doubt if there is any other extant," his daughter quoted him, "that would make a good strain from which to breed varieties of our excellent and readable printers' 'Roman lower-case' as this Winchester MS which contains, as it seems to me, the perfected seed of our common print besides marks of the noble race from which it sprang."[14] This wonderful statement clearly refutes all accusations that the aim of Johnston's teaching was simply to copy the best of historic manuscript hands.

Seventh-century Irish half uncial, Latin Gospels, Gospel of St. Matthew, in the *Book of Kells*, *Trinity College* Dublin. Photo courtesy the Board of Trinity College, TCD MS 58 (folio 61v).

Simons recalled, "The half uncial and Carolingian hands were joined in time by built-up versals and Roman capitals, in color or India ink, and later still by Roman small letters and simple written capitals and italics based on Renaissance forms."[15] This list of manuscript hands was part of Simons's studies with Johnston and would later become the core of her own teaching.

After passing her art teacher exam Simons stayed on to take additional courses in architecture, painting, and sculpture as well as applied art with Lethaby. After eight years of study she graduated in 1904 as an Associate of the Royal College of Art, the fourth woman to receive the degree. Her specific degree was in ornament and design. She must have been an impressive student. Peter Holliday mentions her in his book on Johnston: "The young German, Anna Simons, was, with Gill, Johnston's most brilliant pupil."[16]

In 1905, in response to a special order by the Prussian Ministry of Commerce establishing summer courses in writing and lettering, a summer course was organized "for suitable teachers of arts and crafts and trade schools" at the School of Arts and Crafts in Düsseldorf under the direction of Peter Behrens.[17] The creation of such a course was largely due to Hermann Muthesius, who, after his return from the German embassy in London, "had been appointed inspector of the professional schools' section at the Prussian Ministry of Commerce."[18] His position in the Department of Commerce rather than the Department of Education points to a possible awareness of the link between writing, lettering, and type design, a topic of great interest to German type foundries.

Behrens wanted to include both Johnston's and Rudolf von Larisch's ideas in these new courses on the renewal of writing and lettering. For Larisch's ideas he hired F. H. Ehmcke, who had developed his own teaching philosophy from Larisch's. For the Johnston method Behrens tried to convince Johnston himself to teach the course. In March 1905 Muthesius wrote to Lethaby, then principal of the Royal College of Art: "Do you think that he [Johnston] would come over himself to give lessons? Or is there any pupil of his who could do so? Or, finally do you think the Düsseldorf lady whom you lately recommended to me would know enough of Mr. Johnston's art to give the lessons?"[19]

On March 19, 1905, Harry Count Kessler, then director at the Museum for Arts and Crafts in Weimar, wrote to Johnston: "I am glad to say that I have found it possible to awaken great interest in your endeavors in Germany. At the great Exhibition of Art and Handicrafts in Dresden . . . there will be a special section devoted to fine writing on paper, stone, etc. And what is perhaps still more important, I have prevailed on Muthesius to have one of your pupils engaged for the Industrial School in Düsseldorf to teach your methods there."[20]

Opposite page:
Page of an exercise book by Simons's student Thea Budnick, showing the practice of drawing versals. Photo courtesy Gundula Grützner, ca. 1943. Johnston wrote that versals are "generally regarded as paragraph-marking letters." Johnston, *Writing and Illuminating and Lettering*, rev. paperback ed. (London: A and C Black, 1994), 79.

Opposite page:
Hermann Muthesius, letter to William Lethaby, 1905 (top), and Count Harry Kessler, letter to Edward Johnston (bottom). Photos courtesy Manuscript Collection of the Newberry Library, Chicago.

On May 3, from a hotel in South Kensington, London, Simons, the "Düsseldorf lady," wrote:

Dear Mr. Johnston,
A course of lettering for art school teachers is taking place in Düsseldorf under the auspices of the Prussian Minister of Commerce. They have appointed me to conduct the class for pen writing according to your method. My work is to begin on May 11 and lasts to the 20th, but I start for Germany on Monday night May 8th. I should very much like to have a talk with you about it. Could you see me any time before then? I wonder whether I have to thank you for a recommendation to Professor Behrens of Düsseldorf who directs the course?
Yours sincerely,
Anna Simons[21]

In a few pages, handwritten in English years later, Simons recalled the first course in Düsseldorf in 1905. Eleven teachers, each from a different arts and crafts school in Prussia, were sent to take the course, which lasted three weeks. The different subjects of the course were:

Writing with a Quellstift, Writing with a Brush, and Writing with a Quill. Lettering for Stencil Cutting, Plaster Cutting, Linoleum Cutting and Printing. Professor Behrens opened the course with a lecture on the History of Letters and later on gave another on the History of Printing. . . . Ehmcke superintended the various exercises before named, and I was asked to explain his [Johnston's] method. Mr. Johnston very kindly told me exactly how to plan out the course, lent me photographs and told me of books that would be helpful. . . . For the amount of work to be carried out, only ten days were left to go through all the different alphabets. The hours were comparatively long, 8:00 to 12:00 and 2:00 to 6:00, so that a fair amount of practice was attained. But the chief object was to arouse interest and that was fully accomplished.[22]

Since each of these summer courses included teachers from eight to eleven different towns, there were by the end of the second year about twenty schools in Prussia with at least one faculty member capable of teaching formal writing and lettering. In the years that followed, Simons taught not only in Düsseldorf but also in Weimar, Halle, Munich, and Hamburg, and after World War I in Frankfurt a. M., Nuremberg, and Zürich. Her early students included such luminaries as Peter Behrens, F. H. Ehmcke, Emil Rudolf Weiss, Ernst Schneidler, and later Jakob Erbar and Rudo Spemann, all of whom in turn became influential teachers and type designers. Her teaching was so successful that Stanley Morison stated in 1926, "The school of calligraphers practicing the teaching of Johnston and Gill, which has arisen since 1905, has in its hands the whole of German type design."[23]

Mr. Johnson I thought I might ask you, kindly to advise me how to get hold of him. Do you think he would come over himself to give lessons? Or is there any pupil of his who could do so? Or, finally, do you think the Düsseldorf lady whom you lately recommended to me, would know enough of Mr. Johnson's art to give the lessons?

Perhaps you will be kind enough to discuss the matter with Mr. Johnson whenever you may see him in your College and I should then be greatly obliged if you kindly could write me a word and give directions to me what course

best to take.

Thanking you very much beforehand

Yours very truly
H. Muthesius.

P.S. The course comprises 6 hours lessons a day of which Prof. Behrens gives the greater part.

still more important. I have prevailed on <u>Muthesius</u> to have one of your pupils engaged for the Industrial School at Düsseldorf, to teach your methods there. I expect he will write to you about this soon, if he has not already done so. He

In 1908, with Simons's help, a major exhibition of English book design was arranged at the Weimar Museum; it included work of the Society of Calligraphers, which was under the direction of Johnston. The exhibition aroused much interest. The direct result was a three-week writing course taught by Simons at the School of Arts and Crafts in Weimar—later the Bauhaus—then under the directorship of Henry van de Velde. Simons's teaching in Weimar was a huge success, and her description of the event in a letter to Johnston shows how truly revolutionary these first writing courses were:

February 27, 1909

Dear Mr. Johnston,
The Weimar course ended last Saturday and as it was a new departure I should like to tell you about it. Professor van de Velde sent two of his own pupils, ladies, to it and from the school twelve pupils attended, seven men and five women students and another lady joined from outside. The time allowed was three weeks of six days of rather more than 6 hours each. The results were in some cases excellent. The two v. d.V. pupils . . . were very keen and ought to do well. One of the men, a Belgian from Antwerp, and a girl student from the same place mastered the technique perfectly and as both have taste and a nice feeling, their work was very gratifying. Nearly all the others took great interest and so did Professor van de Velde himself. He constantly brought his visitors to see the class—among them were Graf Kessler, who came twice, the poets Hugo von Hofmannsthal and Gerhart Hauptmann with their wives, the head of the School Council, a judge from Hamburg—HRH Princess Reuß to whom I explained in English—the Court Chamberlain and on the last day HRH the Grand Duke. The latter was specially struck and pleased by the legibility of the writing. I was glad to have your *Men and Women* by the Doves Press to show to all the visitors.[24] Professor van de Velde was delighted with it. Your address to Graf Kessler was greatly admired by everybody. I was told that the Ordinance and Survey Office was very sorry not to have known about the course in time, as they would have liked to send some of their men. It was almost a pity you did not give the course yourself, as everybody was so interested in the method. Professor van de Velde is certainly a personality and most interesting to talk to. He is a friend of Mr. Cobden-Sanderson. . . .
Please remember me to Mrs. Johnston and believe me,
Yours sincerely,
Anna Simons.[25]

About the Düsseldorf summer courses Simons wrote: "All the teachers who have gone through the course teach the method learned to their students, and it is gratifying to find that pupils of old pupils, other teachers from the same school, or other schools in the same town, keenly apply for permission to take part in these courses, often offering to pay their own expenses."[26]

After a short hiatus the course resumed in the summer of 1909, again lasting three weeks, but now under the directorship of F. H. Ehmcke. One week

was allotted to Simons's course. Another of her classes, focusing entirely on Johnston's teaching, took place in Berlin–Neubabelsberg under the direction of Peter Behrens. In a report about this course in the *Kunstgewerbeblatt* of 1910, Simons included a beautiful introduction:

> The monuments of every important cultural period carry, unmistakably, the stamp of their time—but still more directly—because it is less self-conscious, writing gives testimony about the substance of a generation that created it. And most astonishing in all of that is, that writing is not here and there newly invented, but rather has organically developed over the course of thousands of years.[27]

The Düsseldorf School of Arts and Crafts, realizing the importance of these courses for its students, established a four-week course in writing and lettering, taught by Simons and following Johnston's method: "One group of students attending from 8–12, the other from 2–6, every day for one month."[28]

Muthesius's brilliant idea of providing special summer courses in writing and lettering for art teachers from all over Prussia had resulted in an ever-growing number of well-trained craftspeople and teachers in this new field. Between 1905 and 1912 alone, several hundred teachers and students took Simons's intensive courses. Her amazing success was partly due to the fact that Germany was just starting to change from blackletter to Latin writing and "the realization, that from the knowledge of formal writing it was possible to design type, an idea which had immense influence first in Germany, then America and finally in France and England."[29] In fact, many of Simons's students, well trained in formal writing, later became type designers. The other reason for her success was that she was a very good teacher, highly competent and deeply caring about her subject matter. According to Ehmcke, "[i]t was through her introduction of Johnston's method and, more important, how she introduced it that she had a greatly stimulating influence on my work."[30] Van de Velde, writing admiringly of Simons, recalled "the years during which I was able to share the enthusiasm with which she taught her courses around 1908 or 1912 at the Weimar School of Arts and Crafts, which I had entrusted to her."[31]

But what was her teaching really like? As she had in the first summer courses in Düsseldorf, Simons taught intensive lessons that lasted from six to eight hours a day for several days, most often weeks, and sometimes even months. To create and hold an atmosphere of intense concentration for such a long time demanded tremendous discipline from the students as well as skill, stamina, and charisma from the teacher.

Above and opposite page:
Two spreads of an exercise book by Simons's student Thea Budnick, showing modernized half uncial based on Johnston. Writing of individual letters and writing of text. Photo courtesy Gundula Grützner.

Opposite page:
Anna Simons in her writing class, Düsseldorf, 1933. Photographer unknown. From the "Festschrift for Anna Simons," 21.

Both Ursula Suess and Thea Budnick, former students of Simons, whom I met and interviewed, agreed that the atmosphere in her class was one of seriousness and absolute silence; they remembered Simons as a demanding, even awe-inspiring teacher. Formal writing is a craft, a training of fine hand control, which can only develop through intense practice over a sufficiently long time. No wonder many of Simons's students became excellent and influential teachers themselves, capable of creating a similar environment of intense focus. This recurring influence of Simons's approach kept the high quality of writing and lettering alive up to World War II. Initially, Simons would have followed Johnston's course quite closely; in later years, however, she also incorporated Rudolf von Larisch's ideas and added blackletter manuscript hands to her exercise repertoire.

Johnston's conviction that "only an attempt to do practical work will raise practical problems, and therefore useful practice is the making of real or definite things, such as books" might have influenced Simons's assignment that students should write their own manuscript books.[32] Leo Nix, a student in Simons's three-month master class in 1933, recalls:

All the materials necessary for the course were provided. This included large sheets of parchment paper, which were folded to a more manageable size, reed pens, which we had to cut following Simons's instruction, ink, and a brush. We carefully ruled out the sheets in assigned increments. This established the height of the letters. . . . In our course, we started to write the uncial and half-uncial script. Anna Simons walked from one student to the next, sat down in each student's chair, and wrote a few letters, making us aware of their difference.[33]

A close examination of Suess's exercise books reveals still more about Simons's teaching. She established the size of the books (19⅞ × 14¾ inches) and set the proportion for the margins, following Johnston's suggestions in *Writing and Illuminating and Lettering*: "The two pages of an *opening* may be viewed as one sheet having two columns of text; and the two inner margins, which combine to form an interspace, are therefore made narrow (about 1½ inches each) so that together they are about equal to one side margin. These proportions 1½ : 2 : 3 : 4 [are] approximate to the proportions common in early MSS."[34]

The ruling of the pages—double page spreads of 29½ × 19⅞ inches—is such that it establishes the top and bottom of the x-height of lowercase letters as well as the space between lines. The ascenders and descenders can then move freely between the lines.

Margin proportions in manuscript books according to Johnston.

Anna Simons's student Ursula Suess's exercise book showing tenth-century minuscule used to write individual letters. Author's collection.

Nesting of pages

As in any good book design, the position of the field of text never changes from one page to the next so that the margins stay intact throughout the book. Finished sheets were put aside and bound after the course was completed.

Suess's books consist of between seven and fourteen sheets of parchment paper folded in half. These double-page spreads were nested into one another and sewn onto a narrow folded piece of thin cardboard in the center of each book. The secured pages were then sewn onto the soft spine of the cover. The fact that the students wrote their own books must have inspired them to write as perfectly as they could. Suess and Budnick both identified so strongly with their books that Suess made sure hers went with her when she emigrated to the United States, and Budnick kept hers in mint condition while fleeing the Russians through war-torn, burning German cities.

We can learn much about the way she taught from a description of her teaching approach that Simons contributed to a 1913 exhibition in England. According to this she began her lessons by writing letters on a blackboard, briefly explaining as she went.

> The pupils then endeavor to write three lines of each letter with the reed pen dipped into ink in the ordinary way. The teacher goes from pupil to pupil, showing each how to cut and hold the pen, correcting letters already written and writing one of each at the beginning of each line. This is very important, as it enables the pupil to realize how the pen is held, how the different letters are made, and more important still, what a properly cut pen feels like.[35]

Once each letter was sufficiently understood and written skillfully enough, students applied their knowledge to writing a text of their own choosing. It was essential that they choose a meaningful text; to work on anything frivolous would have been unthinkable.

Suess's exercise books give insight into how Simons structured her course. Students studied a number of manuscript hands in their exercise books. The study of each hand began with the alphabet—each letter written repeatedly over several pages, and capital and lowercase letters practiced separately. These exercises were followed by writing a longer text, first in all capital letters, then in lowercase letters, followed by capital and lowercase combined.

a a a a a a a a
a a a a a a a a
a a a a a a a a
b b b b b b b b
b

page 5 [leaving 2 sheets for endpapers] is then ruled with pencil as shown & script 1. a formal, upright, straight-pen hand, based on halfuncial characters written on the blackboard and explained. The pupils then endeavour to write 3 lines of each letter with the reed pen dipped into ink in the ordinary way. The teacher then goes from pupil,* showing each how to cut and hold the pen, correcting letters already written and writing one of each at the beginning of each line. This is very important, as it enables the pupil to realise how the pen is held, how the different letters are made and more important still what a properly cut pen feels like. It should be possible to make the round of 20 pupils in about an hour & one half or four times a day if the hours are from 9-12 in the morning & 3-6 in the afternoon as is usual in Germany. — *to pupil

Anna Simons's description of her teaching approach for a 1913 exhibition in England. From the "Festschrift for Anna Simons," 25.

Passages from Ursula Suess's exercise books showing lowercase letters (this page) and text (opposite page, top) written in the style of mid fifteenth-century textura, as well as (opposite page, bottom) writing in mid fourteenth-century precursive.

Wenn man will gehn ins Hessenland von Frankfurt her, liegt linker Hand ein groß Gebirg, reicht bis zum

Die minne ist nicht mann
noch weib hat weder seel noch
hat sie leib sie hat auf erden
nicht ein bild, ihr nam ist kund sie
selbst verhüllt nur eines wisse das
noch nie zu falschem herzen mīne
trat und wiss das andere das ohn
sie sich gottes huld dir nimals na
naht. w. v. d. vogelweide.
um zwei uhr einer schönen juni‑
mondnacht ging ein kater längs
des dachfirstes und schaute in den

Influenced by Larisch, Simons later included experiments with the darkness and texture of a page by writing with a wider or finer pen, using more open or more compact line spacing, or by increasing the length of ascenders, which also results in a more open line spacing. The different manuscript hands covered in exercise books by Suess and Budnick include Johnston's modernized half uncial, uncial, tenth-century minuscule, condensed antiqua minuscule with a pen angle of 45 degrees (this hand includes serifs), the same alphabet further condensed, Gothic writing of the thirteenth century, textura of the Gutenberg Bible, mid-fourteenth-century precursive, sixteenth-century cursive, and Fraktur. Since Johnston did not include blackletter hands in his teaching, Simons had to develop these manuscript hands on her own, based on the study of original sources.[36]

Any student of Simons's intensive writing courses would have come away with a solid basis for the teaching of writing and lettering, as well as for the design of typefaces and many other professional applications. But most important, they would have gained a deeper understanding of the link between the writing tool and the shape of Roman letters. Paul Renner, the designer of Futura, expressed this beautifully: "Not as romantics did we go back to writing with a pen, but to understand letters from the inside."[37]

The number of students taught by Simons must be very large, and the number of *their* students even larger, but specific numbers, let alone names, are hard to establish. Often students or publications listed the head of a department as the person they studied with. One such example is Rudo Spemann, probably the most talented German calligrapher between the wars. In most publications he is considered a star student of Ernst Schneidler. Others have said that he focused prominently on writing and lettering in Ehmcke's department at the School of Arts and Crafts in Munich, but no information is given as to his teacher.[38] Only one of the sources I discovered establishes the fact that it was indeed Simons with whom Spemann studied in Munich. Writing for a small pamphlet published by the Klingspor Museum in honor of Spemann's ninetieth birthday, Hans Schmidt includes in his biography the fact that Spemann studied under her in 1925.[39] This would refer to Anna Simons's intensive course in formal writing which she offered once a year in Ehmcke's department; a course that met for up to six hours a day, every day, for several weeks.

Minna Blanckertz, friend and biographer of Simons, has said that most calligraphers and type designers in Germany were directly or indirectly students of Simons.[40] It was Simons who first introduced Johnston's course on formal writing in Germany. Johnston had not only created the content of the course after careful studies but also invented a new way to teach this material. The course was entirely new, with no precedents. Knowingly or unknowingly, anyone teaching formal writing and lettering in Germany would have relied on either Simons's course or her translation of Johnston's book.

Page from Rudo Spemann's handwritten book *Die erst Epistel Pauli zu den Chorinthern*, 13:1 (r). Photo courtesy Sammlung Klingspor Museum, Offenbach a. M.

The lineage can be traced through the choice and sequence of manuscript hands studied: writing those hands with chalk on a blackboard, the use of vellum exercise books, and, most important, the reintroduction of the broad-nibbed pen. Johnston's major contribution was his insight that the form-giving properties of this pen influenced manuscript hands throughout the history of writing.

Page from one of Thea Budnick's exercise books with Carolingian script. The top half shows the script written with a narrow pen; the long ascenders and descenders result in wide line spacing. The bottom half shows Carolingian script written with a wider pen and short ascenders and descenders, which allow for tight line spacing. Photo courtesy Gundula Grützner.

Simons's unique contribution was her brilliant teaching of this idea, though, sadly, awareness of her role was lost after a couple of generations.

Emil Rudolf Weiss, the talented German typographer and type designer, was one of Simons's first students. His own most talented student, Johannes Boehland, was in turn the calligraphy teacher of Gudrun von Hesse, who, according to a brief biography for an exhibition at New York's Grolier Club, "began her career teaching calligraphy and heading a small bookbinding studio.... When she met her future husband, Hermann Zapf, she was already well established as a calligrapher and fine binder."[41] Although Zapf mentioned to me in a telephone interview that he studied calligraphy from Johnston's book in Simons's translation, I can imagine that his marriage to von Hesse might have been helpful to him too. She, in another telephone interview, indicated that she took a one-semester writing course with Boehland in Berlin, and recalled how impressed she was by his teaching. Regarding Simons, von Hesse commented that she knew nothing about her with the exception of Simons's 1926 portfolio collection *Titel und Initialen für die Bremer Presse* (Titles and initials for the Bremer Presse). Hermann Zapf, however, said that "for her (Simons's) translation of Johnston's book we all have to be immensely grateful."[42]

Anna Simons's translation of Johnston's book *Schreibschrift, Zierschrift, und Angewandte Schrift* was published in Germany in 1910. Priscilla Johnston called the translation "a not very enviable assignment.... Johnston's first instruction to her [Simons] was that where he had used a term with five or six different meanings, he had meant them all and she must translate them accordingly."[43] Even with such impossible demands, the translation is exceptionally well done. The German reads even more fluidly than the English original, and the typography helps to make the very dense content more accessible.

Another factor proved useful in the translation. While in England, Simons lived for some years with a great-granddaughter of Elizabeth Fry, a prominent activist of the Quaker movement. Priscilla Johnston writes: "This remote cousin was unknown to Johnston but something of the Quaker strain apparently persisted in both of them and Simons asserted that, because of this, when she came to work on the translation, certain attitudes of mind and modes of expression were familiar to her."[44] Johnston himself wrote about the translation:

> In 1910 she [Simons] translated my book—*Writing and Illuminating and Lettering*—a translation that must have been in some ways more difficult to make than the original! Much of it was of a highly technical nature and much of it dealt with fine and subtle distinctions. Though I am not able to read this translation, my knowledge of the translator makes me feel certain that it has been faithfully and accurately translated, and I am confident that no one else (either then or later), could have done it so well.[45]

Front cover of the German translation of Johnston's book. 2nd ed. (Leipzig: Klinghardt and Biermann, 1921). The design of the book is the same as the original English edition from 1906.

The many type designers who studied writing and lettering initially from Johnston's book in Anna Simons's translation include Walter Tiemann, Rudolf Koch, Paul Renner, Hermann Zapf, and Jan van Krimpen.[46] Tiemann writes that Koch openly admitted how much he benefited from Johnston's teaching, but that "Koch was much too high-spirited, much too emotional, and too stubbornly German to give in to the strict historic foundation of the English master's noble restraint."[47] William Rothenstein, principal of the Royal College of Art in London, wrote in his contribution to the Festschrift for Simons, "I am happy to know that a richly deserved tribute is now to be paid one who has been largely instrumental in bringing a new vigor to German script, which, like handwriting elsewhere, had lost much of its early dignity."[48]

My interview with Ursula Suess, who eventually became a calligraphy teacher in New York, gave me an idea how Simons lived and worked. Unaware of the importance of Simons, Suess took her course as a private student in 1941 or 1942 simply to join a boyfriend. The course was offered in Simons's house; the two students came once a week for about two hours and then were expected to follow up with intensive homework. Simons at that time was in her early seventies. She was poor, having lost most of her money due to inflation, and it was the middle of World War II. Her home, close to the center of Munich and the English Garden, was a narrow row house with two windows in front and two in back. In 1932 Ehmcke had written: "Her beautiful and very personally and comfortably furnished home is in a small house in the Kaulbachstrasse in Munich. It reminds me in many ways of the small, elegant private houses in Hammersmith, where the gentlemen artisans of the English presses and bookbinding studios preferred to live."[49] In 1942 the impression was very different. The ground floor had been rented to a paper manufacturer, and big rolls of paper were stacked in the entrance hall. To get to Simons's studio one had to climb a dark staircase, where on the landing halfway up stood a cast-iron stove with a small figure of the Venus de Milo on top. In the winter, Suess recalls, she would warm her hands on the figurine, since the house was very cold. The studio itself consisted of a large wooden table, where one side was reserved for the two students, and the other for Simons's assistant.

Simons had originally moved to Munich in 1914, on the eve of World War I, when the political climate between England and Germany had worsened. Before that her main residence had been in London, and she had commuted back and forth. But once she started teaching her annual intensive courses in Ehmcke's department at the School of Arts and Crafts in Munich, a move to Munich made sense. This decision was fortunate, since the Bremer Presse, one of the many private presses that sprang up in Germany following the model of Doves Press in England, moved in about 1920 to larger quarters in Munich. Simons did her most interesting work at this private press.[50]

Anna Simons, age 61, at the Bremer Presse, Munich, 1932. From the "Festschrift for Anna Simons," 7.

The Doves Bible, 1903, vol. 1, p. 27. Opening chapter, first book of Moses, called Genesis. Initial and first line of text by Edward Johnston. Photo courtesy William Andrews Clark Memorial Library, University of California, Los Angeles.

The Bremer Presse was founded in Bremen, Germany, in 1911 by Ludwig Wolde and Willy Wiegand, both sons of very wealthy families. When Wolde departed the business in 1922, Wiegand, a lawyer, became the sole owner. The aim of the press was to print only classical world literature, either in the original language or in the best German translation. The distinction of the editorial board and the quality of their choices of literature were matched by great concern for quality at every level of printing and production. Wiegand was able to hire as his bookbinder Frieda Tiersch, who had previously worked with Charles McLeish, finisher at Doves Bindery. In 1913 Joseph Lehnacker was hired as printer and wood engraver, and later as manager of presswork. He had trained at the Düsseldorf School for Crafts and Industry and had been a student of Ehmcke and Simons. The same year, Wiegand engaged Simons to write titles and initials for all Bremer Presse books.

Following the model of Doves Press, Wiegand rejected all illustration and limited the appearance of his books to pure typography, with calligraphic title pages and initials as the only form of ornamentation. Wiegand was adamant that his press, like Doves Press, should have its own typeface. Early on, he and Wolde had collected a library of incunabula and traveled in Italy to look at beautiful examples in libraries there. Based on these studies, Wiegand chose two fifteenth-century typefaces, one by Johann von Speyer and one by Adolf Rusch, as the models for his first typeface. He was able to engage Louis Hoell, the best and most experienced punch cutter in Germany. Hoell had cut typefaces for Otto Eckmann and Peter Behrens and was part of the earliest breakthroughs in the renewal of type design in Germany. Later he cut many faces for F. H. Ehmcke, Lucian Bernhard, and Emil Rudolf Weiss. In 1912 Wiegand asked Hoell to cut the first typeface for the Bremer Presse, the 16-point Antiqua. According to Heinrich F. S. Bachmair, "Together with Hoell, Wiegand developed, in very close daily collaboration, the typefaces of the Bremer Presse, which were cast by the Bauer Type Foundry."[51] After intense work for several months and fourteen different test cuts, the first typeface appeared in 1913. Its quiet, even texture, due in part to the exclusion of diagonal lines in V and W, replaced by u and w, simplified letter spacing and helped to achieve, in spite of the boldness of the face, an evenly gray field of text.

Simons's role at the Bremer Presse was similar to Johnston's at Doves Press. Her assignment to write titles and initials for all of the books they published was ideal, since she could apply not only her writing skill but also her extensive knowledge of the history and cultural background of a wide variety of manuscript hands. It afforded her the freedom to come up with new variations on old forms, which gave her a broad palette to capture something of the style, content, and period of individual books. Such skills were essential, since books from the Bremer Presse covered a wide range of literature, including the Greek and Roman classics, the writings of the German mysticism, the sonnets of, among others, Milton and Shakespeare, texts of the Italian Renaissance, and a

new edition of the Luther Bible. The press was limited to only one typeface, so it was up to the title page and initials to give each book its distinctive character.[52]

Simons described her design process as follows: she would receive a sample page of the text with space left for the initial. She would then write the initial directly onto the page with a broad-nibbed pen, carefully considering its size, style, color, and texture to create the most pleasing relationship with the text as well as the entire page. She might have had to do this many times until she found a successful solution. This step was followed by tracing the letter and making a refined outline drawing with a pointed quill, which Lehnacker then used as a model for the wood engraving.[53] The final wood block could thus be locked, together with the type, onto the press, enabling initials and text to be printed together.

Simons's initials are proof of her skill and inventiveness as well as of the astonishing flexibility of the letters of the Roman alphabet. Probably her most impressive initials are the ones for the folio edition of Dante's *Divine Comedy* (see following spread). Here, instead of using only one letter, an initial, Simons used an intricate three-part arrangement of the first two words of the text to evoke the three-part structure of the epic poem as well as Dante's terza rima, with its chain of interlocking triple rhymes. In the initial for the first canto, "La Gloria," the large G carves out and activates a shape of negative area, whereas the two adjacent columns of vertically stacked letters provide a visual bridge to the texture of the main text. The old problem of vertically stacking a narrow I between other wide letters is solved by the tail of the R and the long, slightly drunken serif on top of the A, which create a shape of negative area that holds the width of the column.

The more usual single letter initials of the Bremer Presse books mirror the lettering style of the title page but vary slightly in their design to simulate the subtle variations of handwritten initials. These initials, repeatedly based on the same letter, become endlessly playful, sometimes even humorous variations of the original design. The title pages are spectacular examples of lettering.

The limited amount of text—just the title and the author's name, or sometimes only the latter, with the title on the following page—gave Simons a chance to turn these pages into visually prominent entrances and at the same time capture qualities of the subject matter of the particular book at hand. Through her sensitive choice of different calligraphic forms she was able—as she states in the introduction to her *Titel und Initialen für die Bremer Presse*—"to evoke equally the lively but monumental poetry of the Dante, the light and cheerful one of the *Chansons*, or the fervent, informal one of the songs of the German mysticism)."[54]

druckerei, sonder je dem Buchdru

First typeface of the Bremer Presse. From Heinrich von Kleist, *Robert Guiskard Herzog der Normänner* (Tölz, Germany: Bremer Presse, 1919), 12. Author's collection.

DANTE
LA DIVINA
COMŒDIA

Anna Simons, typographic arrangement of the title page for Dante's *Divine Comedy* (Munich: Bremer Presse, 1921). Author's collection.

Canto primo.

LA GLORIA

DI COLUI che tutto move
 per l'universo penetra, e risplende
 in una parte più, e meno altrove.
Nel ciel che più della sua luce prende,
 fu'io; e vidi cose che ridire
 nè sa nè può chi di lassù discende;
Perchè, appressando sè al suo disire,
 nostro intelletto si profonda tanto,
 che retro la memoria non può ire.
Veramente quant'io del regno santo
 nella mia mente potei far tesoro,
 sarà ora materia del mio canto.
O buono Apollo, all'ultimo lavoro
 fammi del tuo valor sì fatto vaso,
 come domandi a dar l'amato alloro.
Infino a qui l'un giogo di Parnaso
 assai mi fu; ma or con amendue
 m'è uopo entrar nell'aringo rimaso.
Entra nel petto mio, e spira tue,
 sì come quando Marsia traesti
 della vagina delle membra sue.

O divina virtù, se mi ti presti
 tanto, che l'ombra del beato regno
 segnata nel mio capo manifesti,
Venir vedra'mi al tuo diletto legno
 e coronarmi allor di quelle foglie,
 che la materia e tu mi farai degno.
Sì rade volte, padre, se ne coglie,
 per trionfare o Cesare o poeta,
 colpa e vergogna dell'umane voglie,
Che partorir letizia in su la lieta
 delfica deità douria la fronda
 peneia, quando alcun di sè asseta.
Poca favilla gran fiamma seconda:
 forse dietro da me con miglior voci
 si pregherà perchè Cirra risponda.
Surge a'mortali per diverse foci
 la lucerna del mondo; ma da quella
 che quattro cerchi giunge con tre croci,
Con miglior corso e con migliore stella
 esce congiunta, e la mondana cera
 più a suo modo tempera e suggella.
Fatto avea di là mane e di qua sera
 tal foce quasi, e tutto era là bianco
 quello emisperio, e l'altra parte nera,
Quando Beatrice in sul sinistro fianco
 vidi rivolta, e riguardar nel sole:
 aquila sì non gli s'affisse unquanco.
E sì come secondo raggio suole
 uscir del primo, e risalire in suso,
 pur come peregrin che tornar vuole;
Così dell'atto suo, per gli occhi infuso
 nell'imagine mia, il mio sì fece;
 e fissi gli occhi al sole oltre nostr'uso.

311

Dante, *Divine Comedy* (Munich: Bremer Presse, 1921) 310–311. Initial for the first canto of "Paradiso" by Anna Simons. Author's collection.

Anna Simons, "Titel und Initialen für Saint Augustine, *De Civitate Dei Libri XXII*." In *Titel und Initialen für die Bremer Presse* (Munich: Verlag der Bremer Presse, 1926), 11, Author's collection.

Examples of the Schwabacher typeface, on this and the following page, are from Hans Eduard Meier, *The Development of Writing,* 10th ed. (Cham, Switzerland: Syndor Press, 1994), p. 29. Author's collection.

ao
Schwabacher typeface

umn
Schwabacher typeface

umn
Bremer Presse Bible typeface

Of all of Simons's title pages, the large title for Saint Augustine's *De Civitate Dei Libri XXII* (City of God) is especially beautiful. The original text of this book was published during Roman times, in 426 CE, and thus the choice of classical Roman letters is appropriate. The entire block of letters is compact and visually holds together in spite of several words with formally difficult arrays of letters. By using very long serifs, which barely touch but visually link individual letters, and by drastically shortening the horizontals in all T's, as well as other fine adjustments, Simons managed to turn each word into a coherent word picture and also hold the block-like arrangement. All initials (left column) are printed in a deep black, contrasting beautifully with the soft gray texture of the text (please see page 57). On this point the Bremer Presse books are spectacular. Such even gray of a page of text is only possible with optically perfect, even letter spacing. Larisch's idea of a proper rhythm of a line of type demanded that the spaces between letters not only be optically equal, but also match the white spaces within adjacent letters. Wiegand, a follower of Larisch's ideas, was well aware of this rule.

The title page for the five-volume Luther Bible (following spread), celebrating the four hundredth anniversary of its original 1534 publication, is another impressive example of Simons's calligraphic skill and Lehnacker's amazing wood engravings, as well as of the overall printing quality of the press, which made the beautiful, even, deep black possible. The letterforms in the title, with the exception of the capital A and a few ornamental additions, are the same as the text, but in the large size they show off their unusual and elegant design. The boldness of this title—*Biblia: Das ist: Die Gantze Heilige Schrifft-Deudsch. D. Martin Luther.* (Bible: This is, the complete Holy Scripture in German, Martin Luther)—evokes for me the boldness of Luther himself standing up to the Pope. Because the Luther Bible was one of the first translations of Latin scriptures into German and represented the beginning of a German literary language, it was important for the Bremer Presse to choose a uniquely German typeface. The one selected was based on a newly invented hybrid rather than an existing blackletter manuscript hand; it combines elements of blackletter with Latin forms to ensure ease of reading.

More specifically, the face draws from Schwabacher, a blackletter typeface used in the original edition. Typical elements of Schwabacher are the open lowercase A, the overall round but pointed O, and a relatively wide U, compared to narrower M and N, all with simple angled stroke endings. But here the type of the Bremer Presse does something entirely different: all vertical strokes, as in the lowercase U, M, and N, have on the top and bottom bold horizontal serifs, which emphasize the top and baseline of the x-height and help to enforce the unity of individual words.

S·AVRELII
AVGVSTINI
DE CIVITATE DEI
LIBRI XXII

Anna Simons's title page design for Saint Augustine, *De Civitate Dei Libri XXII* (Munich: Bremer Presse, 1925), Author's collection.

The initials for the Luther Bible of the Bremer Presse (opposite page, right column) are a more spontaneous variation on the text face. In most cases quite large, they include additional ornamental elements but share the 45-degree pen angle with the text face. The heavy strokes, interrupted by fine white lines or parallel line textures, evoke German woodcut illustrations of the fifteenth century and also share some of their funkiness. These slightly textured initials go well with the texture of the body type.

The type for the Luther Bible is clearly calligraphic in origin. The writing, with a pen angle of close to 45 degrees, results in similar stroke widths in both horizontal and vertical directions, which gives the face its heavy quality (left column). This 45-degree angle is an ever-present form element. It appears in the cut of the heavy serifs, the beginning stroke of the long lowercase S and T, and most prominently in the beginning and closing strokes of all curves. In the letter O for example, the first downstroke in the direction of the 45-degree angle is a long, thin line, down to about one half the height of the letter. It then abruptly turns, widening the stroke to the full width of the pen. This results, especially in the lowercase O, E, D, C, and A, in a certain spikiness, visually evoking a feeling of blackletter. The Bremer Presse Bible type is beautiful and astonishingly easy to read. In fact, the first time I saw it, I found the pages of the Luther Bible so inviting that I did not even pay attention to the typeface.

The capital letters of traditional German blackletter are almost indecipherable, especially when an entire word is capitalized. This illegibility is obvious in Luther's first edition, and so it was a special requirement for the Bremer Presse type designer to come up with readable capitals. The capital letters of the Luther Bible type draw mainly from Schwabacher, but are greatly simplified. Some, such as B, D, E, and N, have the same stroke arrangement as Schwabacher, but the more fluid forms of Schwabacher are straightened out or simplified. Another helpful change is that some capitals like A, M, and V are simply enlargements of the lowercase forms. All capitals in the Luther Bible type are similar in color, and not much taller than the lowercase letters, so they blend well into the text. An additional advantage was that Luther did not capitalize as many nouns as Germans do today. Words in all capitals, as in the first line of opening chapters in the Bremer Presse edition, are not ideal, but are better than the capitals in Luther's original version and quite legible.

Wiegand's last two typefaces—the hybrid face of the Luther Bible and the Greek typeface for *Songs of Sappho* and Homer's *Iliad* and *Odyssey*—are calligraphic in origin. This undeniable fact is clearly visible, but also verified by various respected sources. B. H. Newdigate wrote in the *London Mercury* in 1924: "I have sometimes urged in these notes and elsewhere that an entirely sound revival in type design can only come from the practice of calligraphy.

Martin Luther, *Biblia, Das ist: Die Gantze Heilige Schrifft, Deudsch* (Munich: Bremer Presse, 1926), 5:1, title page design by Anna Simons. Author's collection.

Bremer Presse Bible typeface, initial from the opening chapter of the First Book of Moses, 1:1.

ΣΑΠΦΟΥΣ ΜΕΛΗ

Title design for *Songs of Sappho* by Anna Simons, Bremer Presse, 1922. Author's collection.

ἄρμ' ὑπασδεύξαισα ὠκέες στρουθοὶ περὶ

Greek type of the Bremer Presse, the first Greek type based on broad-nibbed pen writing.

A highly interesting confirmation of my contention comes to me in the specimen pages of a new edition of Homer, which is being printed in a new Greek type by the Bremer Presse. This new Greek type is eminently readable and super eminently beautiful, and might well suggest the lines on which our modern printing of Greek texts should be reformed."[55]

And Campbell Dodgson of the British Museum wrote in *The London Times Literary Supplement* of August 11, 1927, about the Luther Bible: "The type, especially designed and cut for this edition is a 'Fraktur,' or blackletter, beautiful in appearance, extremely legible, and free from eccentricity. . . . The initials, used only at the beginning of each book, are of a fine and simple Gothic design with white lines cut to relieve the massive black of the main lines which build the letter." He concluded, "These and the title have been designed by Anna Simons."[56] But Simons's contribution to the Bremer Presse books may have been even more significant than her creation of titles and initials.

Thomas J. Cobden-Sanderson, together with Emery Walker, chose the printed version of a face by Nicklaus Jenson as a model for the face of the Doves Press. But to base a new type design on a printed version of an older face has its drawbacks. Before he could do outline drawings, Walker had to enlarge a printed version of Jenson's face to clean up any ink gain and dirt specks, which, since it involved some interpretation, would have changed or at least softened the original design. Gutenberg, on the other hand, used the most beautiful blackletter manuscript hand of the time as the model for his face, which gave him a much sharper and precise model for the textura of his bible. In Simons, Wiegand had the most skilled and the most scholarly calligrapher in Germany right on his staff—someone who could not only write in any manuscript hand and thus serve as a more direct source for a typeface but also customize a face to serve specific needs. I would suggest that he was very aware of her distinct and rare talents. He might have made a number of requests, including the choice of a manuscript hand. In the case of the Luther Bible he might have suggested retaining blackletter elements, especially of the Schwabacher, but at the same time making the manuscript hand more readable, especially in the case of capital letters. This request might have led Simons to widen the lowercase letters and include bold horizontal serifs on all vertical strokes to retain solid word pictures. These more open lowercase letters in turn allowed a simplification of capital letters.

Such modernization of an old manuscript hand was very much in keeping with Johnston's own attempt at, and successful solution for, a more readable half uncial. As for the new Greek face, Wiegand might have simply suggested that Simons write some Greek text with a broad-nibbed pen, which had never been done before. She herself gives no reference to any involvement in the creation of a Greek manuscript hand, but simply states that

"the monumental Greek type also set new tasks for me. The titles of the *Iliad* and *Odyssey* follow old inscriptions without slavishly copying them."[57]

In 1926 the Bremer Presse published a large portfolio (17⅝ by 13½ inches) of all the title pages and initials Simons had done up to this date, the aforementioned *Titel und Initialen für die Bremer Presse*, printed in an edition of 220 on their hand press. In most cases, the design of the title of a book and its initials are shown on the same page. In the case of Dante's *Divine Comedy*, however, three pages had to be given to fit all the initials. Not only do the initials represent nearly an entire alphabet, but they sometimes include six to eight variations of the same letter. All initials and the entire text blocks for title pages were written with broad-nibbed pens of various widths in the original size, directly on the paper, before outline drawings were made for the wood engravings. Simons's beautiful work was honored by Wiegand in the Festschrift for her in 1934: "Even less could I have predicted that her intelligent and formally assured work would become such an essential element of the books of the Bremer Presse that today I simply cannot imagine how the design of our books would have been possible without her."[58]

In the introduction to this portfolio Simons mentions that in 1921 the press created a smaller version of the first typeface "based on entirely new drawings by Dr. Wiegand and cut by Hoell." It is clear, then, that Wiegand did the drawings for the Bremer Presse typefaces as well as supervising the punch cutting. His role—analogous to that of Walker and Sanderson at the Doves Press—thus did give him the right to claim that he designed the Bremer Presse typefaces, but he omitted all mention of the source for his drawings, namely the beautiful, calligraphic models made by Simons. She closes her introduction by stating that "type design, printing, and the creation of titles and initials all work together in the combined effort to create works that are recognized by readers as living expressions of their own time."[59]

Wiegand himself wrote, "I always considered the work in the context of our press as a kind of cooperative venture and therefore my own name has never been mentioned; even in connection with the type designs, which were all ultimately designed and perfected by me, I was never inclined to mention my name."[60] Given the times, it should perhaps not surprise us that although the work was collaborative, and he was not explicitly named, he still took credit.

Anna Simons, *Titel und Initialen für die Bremer Presse*, 1926. Title page design by Anna Simons. Author's collection.

Anna Simons, title and initials for *Lieder der deutschen Mystik* in *Titel und Initialen für die Bremer Presse*, 1922. Author's collection.

ANNA SIMONS | 53

Anna Simons, title and initials for *Chansons d'Amour* in *Titel und Initialen für die Bremer Presse*. Author's collection.

Anna Simons, title page design for *Songs of Sappho* (Munich: Bremer Presse, 1922).

ΣΑΠΦΟΥΣ
ΜΕΛΗ

ΠΟΙΚΙΛΟΘΡΟΝ' ἀθανάτ' Ἀφρόδιτα
παῖ Διὸς δολοπλόκε λίσσομαί σε,
μή μ' ἄσαισι μηδ' ὀνίαισι δάμνα
 πότνια θυμόν,

ἀλλὰ τυίδ' ἔλθ', αἴ ποτα κἀτέρωτα
τᾶς ἐμᾶς αὔδως ἀίοισα πήλυι
ἔκλυες, πατρὸς δὲ δόμον λιποῖσα
 χρύσιον ἦλθες

ἄρμ' ὑπασδεύξαισα· καλοὶ δέ σ' ἆγον
ὤκεες στρουθοὶ περὶ γᾶς μελαίνας
πυκνὰ δίννηντες πτέρ' ἀπ' ὠρανῶ αἰθέ-
 ρος διὰ μέσσω.

αἶψα δ' ἐξίκοντο, σὺ δ' ὦ μάκαιρα
μειδιάσαισ' ἀθανάτωι προσώπωι
ἤρε', ὄττι δηὖτε πέπονθα κὤττι
 δηὖτε κάλημμι,

κὤττι μοι μάλιστα θέλω γενέσθαι
μαινόλαι θυμῶι. τίνα δηὖτε Πειθὼ
μαῖσ' ἄγην εἰς σὰν φιλότατα, τίς σ' ὦ
 Ψάπφ' ἀδικήει;

Anna Simons, chapter opening of *Songs of Sappho* (Munich: Bremer Presse, 1922); first-time use of the Bremer Presse's new 16-point Greek type.

This page and opposite page: Anna Simons, title page and chapter opening initial for Saint Augustine, *De Civitate Dei Libri XXII* (Munich: Bremer Presse, 1925). Author's collection. Note the beautiful integration of title page, initial, and text.

S·AVRELII
AVGVSTINI
DE CIVITATE DEI
LIBRI XXII

Liber primus.

GLORIOSISSIMAM CIVITATEM DEI SIVE IN HOC temporum cursu, cum inter impios peregrinatur ex fide uiuens, siue in illa stabilitate sedis aeternae, quam nunc expectat per patientiam, 'quoadusque iustitia conuertatur in iudicium', deinceps adeptura per excellentiam uictoria ultima et pace perfecta, hoc opere instituto et mea ad te promissione debito defendere aduersus eos, qui conditori eius deos suos praeferunt, fili carissime Marcelline, suscepi, magnum opus et arduum, sed Deus adiutor noster est. nam scio quibus uiribus opus sit, ut persuadeatur superbis quanta sit uirtus humilitatis, qua fit ut omnia terrena cacumina temporali mobilitate nutantia non humano usurpata fastu, sed diuina gratia donata celsitudo transcendat. rex enim et conditor ciuitatis huius, de qua loqui instituimus, in scriptura populi sui sententiam diuinae legis aperuit, qua dictum est: 'Deus superbis resistit, humilibus autem dat gratiam'. hoc uero, quod Dei est, superbae quoque animae spiritus inflatus adfectat amatque sibi in laudibus dici: "parcere subiectis et debellare superbos". unde etiam de terrena ciuitate, quae cum dominari adpetit, etsi populi seruiant, ipsa ei dominandi libido dominatur, non est praetereundum silentio quidquid dicere suscepti huius operis ratio postulat et facultas datur. Caput 1. Ex hac namque existunt inimici, aduersus quos defendenda est Dei ciuitas, quorum tamen multi correcto impietatis errore ciues in ea fiunt satis idonei; multi uero in eam tantis exardescunt ignibus odiorum tamque manifestis beneficiis redemptoris eius ingrati sunt, ut hodie contra eam linguas non mouerent, nisi ferrum hostile fugientes in sacratis eius locis uitam, de qua superbiunt, inuenirent. an non etiam illi Romani Christi nomini infesti sunt, quibus propter Christum barbari pepercerunt? testantur hoc martyrum loca et basilicae apostolorum, quae in illa uastatione Vrbis ad se confugientes suos alienosque receperunt. hoc usque cruentus saeuiebat inimicus, ibi accipiebat limitem trucidatoris furor, illo ducebantur a miserantibus hostibus, quibus etiam extra ipsa loca pepercerant, ne in eos incurrerent, qui similem misericordiam non habebant. qui tamen etiam ipsi alibi truces atque hostili more saeuientes posteaquam ad loca illa ueniebant, ubi fuerat interdictum quod alibi belli iure licuisset, tota feriendi refrenabatur inmanitas et captiuandi cupiditas frangebatur. sic euaserunt multi, qui nunc Christianis temporibus detrahunt et mala, quae illa ciuitas pertulit, Christo inputant; bona uero, quae in eos ut uiuerent propter Christi honorem facta sunt, non inputant Christo nostro, sed fato s suo, cum potius deberent, si quid recti saperent, illa, quae ab hostibus aspera et dura perpessi sunt, illi prouidentiae diuinae tribuere, quae solet corruptos hominum mores bellis emendare atque conterere itemque uitam mortalium iustam atque laudabilem talibus adflictionibus exercere probatamque uel in meliora transferre uel in his adhuc terris propter usus alios detinere; illud uero, quod eis uel ubicumque propter Christi nomen uel in

3

Note the even gray of the text.

The three ex libris below are included in Eberhard Hölscher, *Anna Simons,* Monographien Künstlerischer Schrift (Berlin-Leipzig: Verlag für Schriftkunde Heintze und Blanckertz, ca. 1934), 2:39. Author's collection.

In addition to teaching and working for the press Simons also ran a studio, usually with the help of one assistant, to handle a wide variety of commissions from private clients. This work included many of the new professional opportunities that Johnston had listed in his *Writing and Illuminating and Lettering,* including manuscript books, title pages, single poems, family trees, monograms, emblems, ex libris bookplates, maps, certificates, and government decrees.[61] Simons could rely on this work to supplement the income from her teaching after the Bremer Presse closed in 1939.

Simons's work in one area of the list, the ex libris and monograms, is especially inventive. They show her fine visual sensitivity to gray value, texture, and composition as well as her use of the shifting play between words meant to be read immediately and those initially hidden behind an ornamental appearance. She uses reduction in the size of words, denser spacing, and changes of reading direction so as to purposefully obscure readability. She is keenly aware of the effects of various formal qualities on the eye of the reader—for instance that large letters and heavier strokes jump to the foreground and attract the eye, obscuring smaller and lighter letters. She is also aware that individual letter strokes, when larger sized, are distinct and separate from the background, while smaller-sized strokes tend to blur into gray areas and become readable only after closer inspection. Clearly she is also interested in visual texture—for instance variations in the proportion of lettering stroke to background area—and consciously plays with similar and contrasting textures.

One of her ex libris includes the depiction of a crossed torch and sword. The drawing of these objects is completely integrated with the gray value and texture of the accompanying letters BUECHEREI WALTER BLOEM (Library Walter Bloem). Initially one notices a small ornamental texture on both the blade of the sword and shaft of the torch. Only upon closer examination do the two crossing lines of text emerge: IMMERDAR (always) and NUR IN NOT (only in need). Another ex libris combines the two initials of the owner's name, H and G, again exemplifying letters meant to be both ornament and immediately legible. The larger size and darker strokes of the H and G draw the eye first, and the wavy line above the H initially appears no more than an ornamental ribbon. But a second look reveals the two lines of text: Aus meiner Bücherei (From my library). The two darker vertical strokes of the H hold and frame the design, nicely contrasting with the playful line segments in the ornamented G and the cross-stroke of the H and the drawn G.

For years, when I looked at the initial C that Simons drew to stand for Cobden Sanderson, I saw in the interior of the letter only intricate ornamentation consisting of long double strokes and shorter, curved line elements of similar weight and texture. This results in a complex, decorative pattern of even strokes and small white background areas inside the C. Nothing stands

out, and it is hard to separate figure from ground. And then one day I saw the other three letters: B, P, and M, standing for Bremer Presse Munich. These designs are engaging, witty, and even cunning in the ways they play with the eyes of the reader.

Besides her Bremer Presse work, Simons received a number of other large commissions. For the Weltausstellung für Buchgewerbe und Graphik (International exhibition for book arts and graphic arts) in Leipzig in 1914 she wrote a visual history of Western scripts on four five-foot-high parchment panels (see the photographs on the following two spreads). Based on her deep knowledge of the history of writing and her remarkable skill, she was able to recreate each writing style in her own hand. Even more interesting, her chosen texts not only provide examples of the writing style for each period, they also represent a sample of the literature from each of those times and regions. The first two panels show Western alphabetic scripts beginning with Greek writing of the third century BCE and ending with blackletter writing from the sixteenth century, a total span of 1,900 years. Seeing these two panels together allows for surprising comparisons. When did a broad-nibbed writing tool become common? Why did the angle of the pen change at different periods, and what is the effect of this change? When did the custom of using capitals with lowercase letters start? How does fifteenth-century humanist writing compare to the Carolingian script of the ninth century, and how can one recognize the difference between Schwabacher and Fraktur? Simons's use of actual text rather than random words makes the viewer aware of the advent of word spacing. On the last two panels Simons provided an overview of cursive writing, from an example of early fourteenth-century cursive to examples of different twentieth-century cursive hands in England, France, Switzerland, and Germany. When the Leipzig exhibit closed, Blanckertz donated the four large panels to the Deutsches Museum in Munich. Sadly, these original parchment panels were destroyed by air raids on Munich in World War II. However, in 1926 Simons had, very fortunately, handwritten a similar set of panels on commission for the School of Arts and Crafts in Zürich. I was eventually able to locate these panels in the school's archive, then newly reopened. It is typical of Simons's old-fashioned tactfulness that she added to these new panels two Swiss cursive hands from the beginning and end of the nineteenth century.

At the same Leipzig exhibition Simons also displayed, in a special area of the exhibit space, her priceless collection of twenty-two books from the English fine press movement. Her collection, which she titled " Das Haus der Frau" (The house of women) included two books by Doves Press—one of them autographed—and one by Kelmscott Press.

Anna Simons, monogram design in Josef Lehnacker, ed., *Die Bremer Presse* (München: Typographische Gesellschaft, 1964), 72. Photo courtesy Typographische Gesellschaft München.

The captions on this and the following spread are translations of names and time periods for each of the manuscript hands shown in Simons's *Geschichte der Schrift*. The different texts are samples of literature from the different time periods.

Anna Simons, *Geschichte der Schrift* (History of Writing), written for the Zürich School of Arts and Crafts, 1926. Photo courtesy Museum für Gestaltung Zürich, Grafiksammlung.

Greek capital writing
iii century before Christ

Byzantine writing, Papyrus
ii century after Christ

Roman capital writing
iv century after Christ

Uncial writing
vi century after Christ

Irish half-uncial writing
vii century after Christ

Geschichte der Schrift

Karolingerschrift · ix · Jahrhundert
Cui nomen erat Johannes. hic uenit in testimonium perhiberet de lumine · ut omnes crederunt per illum · Non erat ille lux sed ut testimonium perhiberet de lumine · Erat lux uera

Gotische Schrift · xiii · Jahrhundert
Ouch erkande ich nie so wisen man, Swer mit disen schanzen allen kan Ern möhte gern künde han An dem hat witze wol getan. Welher sture disiu mære gernt Der sich niht versitzet noch verget Vnd waz si guoter lere wernt. Vnd sich anders wol verstet.

Antiqua Minuskel · xv · Jahrhundert
None ancor guista assai cagion dichiolo che inhabito il tundi chio ne piansi si colte ghieran lali elgireauoli on con altro furor dipecto dansi due leon fen o due fulgon

Schwabacher Schrift · xvi · Jahrhundert
Weil jhr aber so grosse Bitt Gantz quitledig all seiner band Anlegt wöll wir jhn richten nicht Jedoch soll er raumen das land Sonder zu ehren euch gemein Vnd nimmermehr kommen darein Sol jhm das Leben gschencket sein Zu straff dieser verhandlung sein.

Fraktur Schrift · Mitte des xvi · Jahrhundert
Zum ersten mach ein rechte sirung/van gleychen seyten vnd wincklen vnd teyll die mit vier bar linie/aufrecht vnnd vberzwerch/in neun kleyn sirung vnd setz in ytliche ein mittel puncten/vnd nimm ein cirkel setz jn mit dem ein fuß in die selben puncten nach ein ander/

Carolingian writing
ix century

Gothic writing
xiii century

Antiqua minuscule
xv century

Schwabacher script
xvi century

Fraktur script
middle of the xvi century

Precursive
Middle of the xiv century.

Humanist script
Middle of the xv century.

Cursive
Beginning of the xvi century.

French cursive
Middle of the xvi century.

Tudor script
Beginning of the xvii century.

End of the eighteenth century.
Time of Goethe French Revolution

Beginning of the nineteenth century.
Engl. World script Helvetia

End of the nineteenth century.
Swiss Confederation French Republic

Twentieth century.
Engl. Imperial German script

Monumental letters being mounted on the pediment of the Reichstag. Photo courtesy Michael S. Cullen, *Der Reichstag: Die Geschichte eines Monumentes* (Berlin: Verlag Frölich und Kaufmann, 1983), 323.

Peter Behrens, titling face for the catalog of Das Deutsche Haus, the German pavillion at the 1904 World's Fair in Saint Louis. Photo courtesy Michael S. Cullen, *Der Reichstag: Die Geschichte eines Monumentes,* 321.

In 1909 Behrens received a commission to design an inscription for the pediment of the German Reichstag in Berlin: DEM DEUTSCHEN VOLKE (To the German people). He chose an uncial-like face, which he had previously done for the title of the catalog of Das Deutsche Haus, the German pavillion at the 1904 World's Fair in St. Louis. In 1938, in his contribution to the Festschrift for Simons, he wrote, "Anna Simons took on the job of doing the 1:1 detail drawings of the 1.50m high letters for bronze-casting."[62] (The letters were in fact sixty centimeters high.) In a side note in *Der Reichstag: Geschichte eines Monuments* (The Reichstag: History of a monument), Michael S. Cullen quotes Behrens as saying "that he modified his [earlier] writing to develop the letters for the inscription DEM DEUTSCHEN VOLKE." Cullen concludes, however, that "when and how Behrens completed his commission is not known."[63]

I see the competent hand of Simons in the enlargement and detailing of the letters. Her letters are clearly *written* with a pen angle of about 40 degrees, which places thick and thin strokes in the right places based on her very confident hand gesture. What a difference from the model Behrens gave her. His letters appear traced rather than written, and consequently lack consistancy. This is very apparent in the C, T, E, and S. Cullen and also Behrens properly credit Simons, but the inscription remains linked to Behrens's name. This kind of omission is of course no rarity. As Alice Gregory pointed out in her *New York Times* article on women composers, "Women Once Heard, Now Silent": "Such behind the scenes labor has in fact been a large part of the work women have contributed over the centuries."[64]

In 1934 the bimonthly literary journal *Schriften der Corona* (temporarily connected to the Bremer Presse, and under the editorial guidance of Herbert Steiner) reserved an entire issue to honor Simons, *Anna Simons: Eine deutsche Schriftkünstlerin* (Anna Simons: A German lettering artist), a Festschrift that I have by now quoted numerous times. It was dedicated to her by her family and many friends, and includes contributions by an impressive array of famous contemporaries, from Alfred Altherr to, among others, Peter Behrens, F. H. Ehmcke, Edward Johnston, Rudolf von Larisch, Stanley Morison, Wilhelm Niemeyer, Sir William Rothenstein, Edwin Redslob, Herbert Steiner, Henry van de Velde, and Willy Wiegand.

Peter Behrens and Anna Simons, "DEM DEUTSCHEN VOLKE" inscription on the pediment of the German Reichstag, Berlin. Photo courtesy Florian Bolk.

The Festschrift for Simons contains work dedicated to her as well as many examples of her own work. Among these are two of the hundreds of certificates she was commissioned to write: one conferring an honorary Munich citizenship on Paul von Beneckendorff und von Hindenburg, the president of Germany, and the other conferring an honorary citizenship of the State of Bavaria on the chancellor of Germany, Adolf Hitler. The inclusion of this second certificate must have been considered by the editor a great honor at the time, but it eventually hurt her reputation to the extent that she was shunned in Switzerland, and by the end of the war even in Germany. On the other hand, Yvonne Schwemmer-Scheddin quotes Simons, when the National Socialists approached her in 1933 to write certificates for the party, as having proudly said, "Für die Partei schreibe ich nicht" (I refuse to write for the party).[65] This resistance was a courageous act, and perhaps also a dangerous one.

In the Festschrift, dedicated to Simons and intended to honor her character and work, Herbert Steiner wrote, "One important contribution should not be left out, one that carries the initials A.M.S."[66] He was referring to Simons's volunteer work during World War I, when she offered to apply her unique skills to the creation of diagrams for the Feldpost Bureau A.M.S. This resulted in entirely handwritten, elegant documents. The initials stand for Anna Marie Schubart, who had early on recognized the need for an office to serve as a clearinghouse for information on families separated during the war. Simons's work documented and tracked individual cases over the course of a year and helped families to reunite. Her diagrams, entirely handwritten, were not only elegant but also immensely useful. They documented all the requests for missing people that came in each month, how many cases were resolved, and when the families were informed. The diagrams also show the slow and then sudden increase in requests during the worst months of the battle of Verdun in the summer of 1916. "For close to ten years," Steiner writes, "Simons functioned as Schubart's helper, advisor and friend."[67] Their friendship is the only close one I have found in Simons's life.

Because of her extensive knowledge and experience in the history of lettering, typography, and type design, as well as her fluency in both English and German, Simons was highly sought after as a translator. She translated both of Johnston's books—*Writing and Illuminating and Lettering* (1910) and *Manuscript and Inscription Letters for Schools and Classes and for the Use of Craftsmen* (1912)—into German, as well as Morison's book *Four Centuries of Fine Printing* (ca. 1925); she also wrote a review of the latter, which expertly guides the reader through some of the issues the book covers.[68] In addition she published many articles, among them a lengthy history of the English fine press movement and a beautifully written German obituary for the legendary Thomas J. Cobden Sanderson, whom she knew personally.[69] The obituary includes a catalog raisonné of Doves Press.

Anna Simons, ca. 1946. Photographer unknown. Photo courtesy Sammlung Klingspor Museum, Offenbach a. M.

With the closing of the Bremer Presse in 1939 Simons lost a workplace that had given her unusual opportunities to prove and develop her abilities, but also an important source of income. In a letter to Johnston in which she thanks him for his contribution to her Festschrift, she writes, "It is however only fair to let you know that of all my possessions, the one thing that has retained its full value and still enables me to make a living, while everything else has melted away, is your teaching and all I learned from you. You will therefore be able to gauge how much I really owe you."[70]

Simons continued to teach at the Akademie für Freie und Angewandte Kunst München (Academy for Fine and Applied Arts Munich) and offered additional private lessons throughout the war. But the number of students interested in formal writing dwindled over time due to the rise of the Bauhaus and Tschichold's publication of *The New Typography* (1928), which demanded a typography appropriate for the Machine Age—that is, no serifs or visual remnants of handwriting—as well as exploding the classical arrangement of a page of text. Life for Simons became increasingly hard as illness and progressive gout made it difficult for her to work. Her house was destroyed in one of the many air raids on Munich, and with it all the work she kept there. In fact, over the course of the war most of her other work—that held at the Bremer Presse, at the Schrift Museum Rudolf Blanckertz in Berlin, and in private hands—was destroyed as well. After Simons survived the Munich air raid in a bomb shelter she was taken in and cared for by a cousin, Käthe Keetmann-Simons, in Prien am Chiemsee, not far from Munich. She died there in 1951, at close to eighty years old, and is buried in the Prien cemetery. Her tombstone, designed by Ehmcke, once read HIER RUHT PROFESSOR ANNA SIMONS MEISTERIN DER SCHÖNEN SCHRIFT. When I visited the cemetery in ca. 1998 the tombstone could not be found; it had been sanded down and the stone reused for a new inscription representing a member of the family that took her in.

Anna Simons was, as the inscription on her tombstone beautifully stated, a true master in all aspects of her craft, the only such master who focused her entire career not only on the skill and application of writing and lettering, but was also deeply knowledgeable about the history of her craft. Her oft-repeated epithet "student of Edward Johnston" undervalues her own, well-deserved place in the history of the writing movement. But this diminishment is partly her fault. During all of her teaching years in Germany she consistently stated that her courses simply represented Johnston's teaching, to the extent that the name "Johnston" became so widely known and revered in Germany that even Johnston himself felt that she gave him too much credit. "I can claim only," Priscilla Johnston quotes him, "to have given at that early date a working basis for my students and to have suggested some ways in which they might experiment for themselves."[71] Simons was far from simply an extension of Johnston.

F. H. Ehmcke, inscription for the tombstone of Anna Simons in the cemetery of Prien, Germany. Translated, the inscription reads: "Here rests Professor Anna Simons, Master of Beautiful Writing, June 8, 1871 to April 2, 1951." From *Monumentale Schriften von F. H. Ehmcke* (Munich: Georg D. W. Callwey Verlag, 1953), 21. Photo courtesy Bayerische Staatsbibliothek.

Lehnacker, in his book *The Bremer Presse* (1964), answers his own question as to why Simons never designed typefaces though she was clearly more qualified than anyone around her. "It was," he observes, "out of modesty."[72] Steiner perfectly characterizes Simons's personality in the Festschrift: "Everything for which we thank her today includes also her rare and genuine cultivation, in the worldly and in the deeper sense, her sincere earnestness, and the reserved dignity which attest to and confirm tradition."[73]

Kurt Georg Schauer, in his *Deutsche Buchkunst 1890 bis 1960,* recognizes her proper place in the history of the writing movement. "She belonged," he states, "with Rudolf Koch, Rudolf von Larisch, and Fritz Helmuth Ehmcke, to the writing masters who attained high distinction for the new culture of writing."[74] Annemarie Meiner, in an article shortly before Simons's death, appropriately called her "one of the great, formative personalities in the realm of writing and lettering."[75]

Notes

Chapter epigraph from "Anna Simons," special issue of *Schriften der Corona* 8 (München-Berlin: R. Oldenbourg Verlag, 1938), 59; hereafter "Festschrift for Anna Simons". Unless otherwise noted, all translations in this chapter are by the author.

1. Anna Simons, "Edward Johnston und die englische Schriftkunst," in *Edward Johnston*, Monographien künstlerischer Schrift (Berlin and Leipzig: Verlag für Schriftkunde Heintze and Blanckertz, ca. 1938), 1:6.
2. Simons, "Edward Johnston und die englische Schriftkunst," 9.
3. Noel Rooke, "Edward Johnston: A Biographical Note," in Edward Johnston, *Writing and Illuminating and Lettering*, rev. paperback ed. (London: A and C Black, 1994), v.
4. Priscilla Johnston, *Edward Johnston* (London: Faber and Faber, 1959), 96.
5. Rooke, "Edward Johnston," vi.
6. Johnston, *Edward Johnston*, 98.
7. Johnston, *Edward Johnston*, 101.
8. Simons, "Edward Johnston, und die englische Schriftkunst," 10–12.
9. Johnston, *Edward Johnston*, 186.
10. Simons, "Edward Johnston und die englische Schriftkunst," 12.
11. Simons, "Edward Johnston und die englische Schriftkunst," 5.
12. Edward Johnston, *Manuscript and Inscription Letters for Schools and Classes and for the Use of Craftsmen*, facsimile ed. (New York: Pentalic, n.d.), plate 4.
13. Johnston, *Edward Johnston*, 95.
14. Johnston, *Edward Johnston*, 150, 151.
15. Simons, "Edward Johnston und die englische Schriftkunst," 16.
16. Peter Holliday, *Edward Johnston: Master Calligrapher* (London: British Library; New Castle, DE: Oak Knoll Press, 2007), 90–91.
17. Order by the Prussian Ministry of Commerce, March 1905, to the principals of arts and crafts and trade schools instituting the first writing course, trans. Anna Simons. Newberry Library, Chicago, Wing MS fzw 947, S 6112 (hereafter Newberry Library). I was told by Jill Gage, the custodian of the John M. Wing Foundation on the history of printing, that the Newberry Library acquired the correspondence of Simons and Johnston in 1964 from the English book dealer Elkin Matthews, Ltd.
18. Simons, Manuscript Collection of the First Courses in Düsseldorf, Newberry Library.
19. Hermann Muthesius, letter to William Lethaby, Newberry Library.
20. Harry Count Kessler, letter to Edward Johnston, March 19, 1905, Newberry Library.
21. Simons, letter to Johnston, May 3, 1905, Newberry Library.
22. Simons, handwritten documentation of the first writing course in Düsseldorf, pages 1–4, Newberry Library.
23. Stanley Morison, *Type Designs of the Past and Present* (London: Fleuron, 1926), 60.
24. Robert Browning, *Men and Women* (Hammersmith, UK: Doves Press, 1908), printed by T. J. Cobden-Sanderson and Emery Walker, with calligraphic flourishes by Edward Johnston.
25. Simons, letter to Johnston about her course in Weimar, February 27, 1909, Newberry Library.
26. Simons, handwritten documentation of her writing courses from 1905 to about 1913, Newberry Library.
27. Simons, "Der Schriftkursus in Neubabelsberg," *Kunstgewerbeblatt, Neue Folge* 21 (1910): 102–105.
28. Simons, handwritten documentation of her writing courses from 1905 to about 1913.
29. Rooke, "Edward Johnston," viii.
30. F. H. Ehmcke, "Anna Simons," Festschrift for Anna Simons, 9–34.
31. Henry van de Velde, "L'occasion de rendre hommage . . .," Festschrift for Anna Simons, 72.
32. Edward Johnston, Author's Preface to *Writing and Illuminating and Lettering*, xxv.

33. Leo Nix, "Tante Anna mit dem schwarzen Sack," *Ars Scribendi* 3 (December 1999), 8–9.
34. Edward Johnston, *Writing and Illuminating and Lettering*, 72.
35. Ehmcke, "Anna Simons," Festschrift for Anna Simons, 25.
36. Nix, "Tante Anna," 8–9.
37. "Paul Renner," in *Jahresgabe der Typographischen Gesellschaft München*, ed. Philipp Luidl and Günter Gerhard Lange (Munich: Typographische Gesellschaft München, 1978), 100.
38. Brita Resch, "Biographisches," in *Der Klang in der Schrift* (Offenbach a. M.: Klingspor Museum Offenbach a. M., 2005), 3.
39. Hans Schmidt, *Gottes Will hat kein warum: Rudo Spemann zum neunzigsten Geburtstag* (Offenbach a. M. : Vereinigung Freunde des Klingspor Museums e.V., 1995), 19.
40. Eberhard Hölscher, *Anna Simons* (Berlin and Leipzig: Verlag für Schriftkunde Heintze und Blanckertz, ca. 1940). n.p.
41. *German Fine Printing 1948–1988*, exhibition checklist, Grolier Club, New York, December 1991–March 1992 (New York: Grolier Club and The Typophiles, 1992), n.p.
42. Gudrun von Hesse, telephone interview with the author, July 2004; Hermann Zapf, telephone interview with the author, August 5, 1999.
43. Johnston, *Edward Johnston*, 169.
44. Johnston, *Edward Johnston*, 170.
45. Johnston, "Anna Simons was a student in my Writing and Lettering and Illuminating Class . . .," Festschrift for Anna Simons, 59.
46. Ruari McLean, *Typographers on Type* (New York: W. W. Norton, 1995), 114.
47. Walter Tiemann, *Beseelte Kalligraphie: In Memoriam Rudo Spemann* (Offenbach: Gebr. Klingspor, 1951?), 10.
48. William Rothenstein, "When, a few years ago, I visited some of the Continental Schools of Art, I was surprised and delighted . . .," in Festschrift for Anna Simons, 67.
49. Ehmcke, "Anna Simons," in Festschrift for Anna Simons, 34.
50. This account is based in part on Joseph Lehnacker, *Die Bremer Presse: Königin der deutschen Privatpressen* (Munich: Typographische Gesellschaft, 1964).
51. Heinrich F. S. Bachmair, "Die Bremer Presse," in *Gutenberg-Jahrbuch* (Mainz, Germany: Verlag der Gutenberg Gesellschaft, 1950), 337.
52. Simons, author's foreword to *Titel und Initialen für die Bremer Presse* (Munich: Verlag der Bremer Presse, 1926) n. p.
53. Simons, "Lettering in Book Production," in *Lettering of Today* (New York: Studio Publications, 1937), 61.
54. Simons, author's foreword.
55. B. H. Newdigate, "The Greek Type of Willy Wiegand," *London Mercury*, 1924, 73, quoted in Bernhard Zeller and Werner Volke, eds., "Der Foliodruck," in *Buchkunst und Dichtung: Zur Geschichte der Bremer Presse und der Corona* (Passau, Germany: Passavia AG, 1966), 73.
56. Campbell Dodgson, "The Luther Bible of the Bremer Presse," *Times Literary Supplement* (London), August 11, 1927, quoted in Zeller and Volke, "Der Foliodruck," 77.
57. Simons, author's foreword.
58. Wiegand, "Als ich Anna Simons zum ersten Male besuchte . . ." in Festschrift for Anna Simons, 49.
59. Simons, author's foreword.
60. Harald Keller, "Willy Wiegand and the Bremer Presse," special impression from *For Rudolf Hirsch for His 70th Birthday in December 1975* (Frankfurt a. M.: S. Fischer Verlag, 1975), 52.
61. Johnston, *Writing and Illuminating and Lettering*, 302–303.
62. Peter Behrens, "In Erinnerung an Gemeinsame Arbeit," in Festschrift for Anna Simons, 44.

63. Michael S. Cullen, *Der Reichstag: Geschichte eines Monuments* (Berlin: Frölich und Kaufmann, 1983), 320.
64. Alice Gregory, "Women Once Heard, Now Silent," *New York Times,* December 4, 2016, 17.
65. Yvonne Schwemer-Scheddin, "Anna Simon," in *Hundert Jahre Typographische Gesellschaft München: eine Chronik* (1990), 21–31.
66. Herbert Steiner, A.M.S., "Festschrift for Anna Simons," 84.
67. Steiner, A.M.S., "Festschrift for Anna Simons," 82.
68. Anna Simons, "Stanley Morrison, Meisterdrucke aus Vier Jahrhunderten," *Die Bücherstube* 4, no. 4 (1925): 184–86.
69. Anna Simons, "Moderne englische Pressen: Ein Bericht über ihre Entstehung und ihre Tätigkeit in Neuester Zeit," *Imprimatur, Ein Jahrbuch für Bücherfreunde, zweiter Jahrgang* (1931): 135–67; Anna Simons, "Cobden Sanderson," *Die Bücherstube* 2, nos. 3/4 (1923): 79–81.
70. Simons, handwritten letter to Edward Johnston, 1934, Newberry Library.
71. Johnston, *Edward Johnston*, 98.
72. Josef Lehnacker, "Anna Simons zum Gedächtnis," *Form und Technik* 4, no. 8 (August 1953): 197–99.
73. Steiner, A.M.S., in "Festschrift for Anna Simons," 85.
74. Kurt Georg Schauer, *Deutsche Buchkunst 1890 bis 1960* (Hamburg, Germany: Maximilian-Gesellschaft, 1963), 88.
75. Annemarie Meiner, "Anna Simons, Meisterin der Schriftkunst," *Die Welt der Frau*, no. 8 (June 1948): 10–11.

*In the eager attempt to get to the content of a text,
we overlook only too easily the rich formal treasure that lies in letters.
We overlook the ornamental quality of letters.*

—Rudolf von Larisch, 1914

*Ruler and compass supplanted the broad-nibbed pen.
Letters were drawn and compassed instead of written.
In our day it took hard work to get back to the so obvious
understanding that letters are shaped by writing.*

—Rudolf von Larisch, 1925

Rudolf von Larisch (1856–1934)

In Rudolf von Larisch's introduction to the first volume of *Beispiele künstlerischer Schrift* (Examples of artistic writing), he wrote:

> We have today artistic lettering again! Invigorating as a breath of spring was the influence of the Modern Movement on lettering. After a long ossification of its forms, lettering has come into powerful motion, it lives, it flowers again. And to its benefit this movement will grow when artists alone are the driving force. Only the artist may create, where the new in the arts is to spring up.[1]

Larisch here evokes the great enthusiasm for and interest in letters at the turn of the nineteenth century in Vienna. The artists of the Secession[2] had begun to reject conventional styles in painting, architecture, and crafts, and also to question an area most rigidly controlled by convention, namely the appearance and use of letters. They started to play freely with the shapes of letters as well as the interactions of letters in text.

Rudolf von Larisch, pictured in *Anna Simons*, (Munich and Berlin: R. Oldenbourg Verlag, 1938), 19. Author's collection.

But beyond playful and unconventional letterforms, Larisch realized early on that there was a wider field in the realm of writing and lettering, one that needed to be staked out and developed as a separate discipline. His insights laid some of the foundation for the future field of modern typography. Starting from very different concerns, Larisch, like Edward Johnston in England, became a major advocate for the renewal of writing and lettering on the continent. Inspired by the invigorating ideas of the Secession, he began to observe, question, and analyze many aspects of this new field. He looked at writing and lettering not from any specific point of view, such as formal writing or calligraphy, but from the open-minded viewpoint of an artist.

By questioning the traditional appearance of Roman letters, Larisch made room for new interpretations. He studied individual letters—their shapes, their contours, their structure, as well as their interactions with other letters. He questioned why the formal quality of writing and lettering, and especially personal handwriting, had declined since the previous centuries. Comparing current handwriting to that of the fifteenth and sixteenth centuries reinforced his idea that the beauty of any text depends on the balance between "measure and proportion," that is, optically even letter spacing, combined with equal proportions between interior and in-between spaces of letters.[3] His firm belief in the importance of handwriting over the construction of letters was an essential contribution to the renewal of writing and lettering. He suggested the use of the most basic writing tool, the stylus, that is a return to the roots of the Latin alphabet, the Roman capital letter. He observed the influence of the background within and around letters as well as the influence of letters on the appearance of the background. Based on his knowledge of and interest in music, he studied rhythm as it might apply to writing and lettering. Experiments with fields of text—their shape, edges, gray value, texture, and position on a page—opened up new possibilities for design and typography.

An issue Larisch especially cared about, both in his writings and lettering as well as in his teaching of lettering, was the importance of judging based on optical impressions rather than measurements. He investigated the complex issue of legibility, its pros and cons, which sometimes unleashed much criticism against him. Experimentation with different writing tools led him to invent and initiate the production of new tools. He tested out a broad range of writing surfaces such as metal, glass, ceramic, leather, fabric, and wood, and observed their influences on the shapes of letters. The results of his investigations influence typography, type design, trademark design, and poster design to this day.

Larisch was born in 1856 in Verona, Italy, then part of Austria. Due to the early deaths of his parents—his father had been a high-ranking officer in the Austrian army—and since Larisch's own health did not allow a career in the military, he had to earn his own living. Thus, rather than getting a formal education in music or the arts, areas in which he was clearly gifted, he began to work as a clerk in the Ministry of the Interior in Vienna. Later he was promoted to the Imperial Cabinet Council and became an archivist at the Order of the Golden Fleece,[4] the oldest and most prestigious order of the House of Hapsburg. Through this work he came in contact with a wide range of historic documents. Given the age and significance of the order, such documents would have been written by highly talented scribes and were therefore of exceptional quality. This experience made him aware of the carelessness of contemporary writing—official documents, personal letters, public signs, inscriptions—compared to the beauty of manuscripts and heraldry from previous centuries.

Although he was employed full time, Larisch pursued other interests. In addition to his enthusiasm for writing and lettering, he took courses in the history of music, was close to music circles in Vienna, and audited courses at the Vienna School of Arts and Crafts. Like Edward Johnston, he was largely self-taught.

Larisch started publishing his ideas and discoveries early in his new career of writing and lettering. By sending his publications to influential artists, architects, and designers—most were interested in new approaches to the design of letters—Larisch quickly became known throughout the German-speaking part of Europe. Along with his work at the Imperial Cabinet Council, he began to teach at a variety of schools, most important in 1902 at the Vienna School of Arts and Crafts and in 1920 at the Academy of Fine Arts in Vienna. With the establishment of the Wiener Werkstätte by Joseph Hoffmann and Koloman Moser in 1903, Larisch was asked to be a consultant in all matters pertaining to lettering.[5]

Larisch's teaching, as well as his writing about teaching, was of far-reaching significance. By giving students great freedom to experiment and limiting his own input to questions of legibility or formal inconsistencies, he enabled them to produce astonishingly inventive and beautiful work. Even after graduating, students stayed in close contact with him. A small collection of student work, donated by Larisch's wife, is now in the Klingspor Museum in Offenbach a. M., Germany, which may be the only place that still holds original work connected to Larisch.[6]

In 1912 both Larisch and Johnston gave highly acclaimed presentations at the International Art Teachers' Conference in Dresden, Germany.[7] For the first time these two important innovators in the field of writing and lettering presented side by side. With the help of Anna Simons, who served as translator in private conversations, they got on famously.

The first of Larisch's published works (1896) was *Der Schönheitsfehler des Weibes* (The imperfection of women), which Larisch described as an anthropometric-aesthetic study. Following the Greek ideal, he contended that the proportions of the male body—legs and torso of equal length—are more beautiful than those of the female body, since in his observation women tend to have a longer torso and shorter legs. He then went on to argue that the fashion ideas for women's clothing throughout history had been governed by the need for optical illusions to hide those imperfect proportions. Although outlandish to a modern reader, this essay demonstrates Larisch's early interest in issues of measurement and proportion, which would continue to be important elements of his later theories on the art of lettering.

Larisch was forty-three when in 1899 he published *Über Zierschriften im Dienste der Kunst* (About ornamental lettering in the service of art). In this essay Larisch draws attention to the frequently crude lettering on the edifices of cultural institutions, on signage, tombstones, memorials, titles of books, and certificates, and identifies the many careful visual considerations that such lettering demands. *Über Zierschriften im Dienste der Kunst* started Larisch's career as a theoretician and teacher of lettering.

The text begins by criticizing much of the lettering done during the latter part of the nineteenth century, attributing it to either fine artists with no background in lettering or calligraphers lacking artistic sensitivity. Larisch identified two major mistakes: "the poorly drawn contour of the letter itself" and "the faulty positioning of letters in relationship to each other."[8] He wanted artists to be sensitive to the design and readability of letters, and to maintain consciousness of their written origin, but those were his only requirements. As to the placement of letters, he drew from his study of heraldry and came up with the term "ornamental distribution of masses."[9]

Rudolf von Larisch, *Der Schönheitsfehler des Weibes: Eine anthropometrisch-ästhetische Studie*, 2nd ed. (Munich: Verlag Jos. Albert, 1899). Author's collection.

Rudolf von Larisch, *Über Zierschriften im Dienste der Kunst* (Munich: Verlag Jos. Albert, 1899). Photo courtesy Bayerische Staatsbibliothek, Munich.

Rudolf von Larisch, Introduction, *Beispiele künstlerischer Schrift* (Vienna: Verlag Anton Schroll und Co., 1900). Photo courtesy Sammlung Klingspor Museum. Offenbach a. M.
The shaded area between each pair of letters has to be judged and compared to all other areas between letters within a word. All areas should appear equal to each other. The distinctly different shapes of some of these areas makes judgment more difficult.

Larisch, *Über Zierschriften im Dienste der Kunst*, 10. Photo courtesy Bayerische Staatsbibliothek, Munich.

Greek key (Meander design)

Shield of arms in a thirteenth-century manuscript from G. W. Eve, *Decorative Heraldry* (London: George Bell and Sons, 1897), 118. Photo courtesy Beinecke Library, New Haven, CT.

Larisch frequently coined his own terms since there were no names yet for the phenomena he was discovering. In more contemporary language, the term "ornamental distribution of masses" means the concern for a visually-considered relationship between form—in this case letters—and background. Thus, when positioning letters in words, he established a rule:

"Within a word, individual letters must be placed in such a way that they appear visually equidistant."[10] Letters in a word appear equidistant to each other only when the *areas* situated between such letters—and not the *distances* from the end of one letter to the other—are equal.[11] Larisch believed that earlier disregard for this simple rule was caused by teaching of lettering that emphasized measuring over seeing, as at left in the word "MILLIMI," where the feet of the letters are equidistant but the entire area between letters is totally unequal. Or to invoke Larisch's own mocking words, "With compass in hand, the wrong distances were precisely measured."[12]

Larisch called the recurrence of optically even spacing between letters "Rhythmus" (rhythm).[13] He determined that the best spacing occurs when not only the spaces *between* letters are equal but when they also match the spaces *within* letters, or the counter-forms of letters. This relationship of letter masses to background segments he compared to the Meander design,[14] with its even spacing within and between individual segments of the ornament.

Larisch's careful observation of the background, in developing his guidelines for optical letter spacing, must have increased his overall awareness of the ground as an important element in design. This included the enhanced brightness of the ground next to dark and tightly spaced letters, and, most important, how the placement of text or images activates and shapes the ground. He became more sensitive to the interplay between figure and ground, an essential concept in any composition. Referring to the craft of the smithy, he fittingly described this total interrelatedness:

> The shape of the heraldic figure was *forged*, stretched, and condensed until it filled its given space in the most perfect distribution of masses; many a well-known heraldic animal owes its sinuous shape only to this relationship of figure and ground and not any other made-up theory.[15]

Larisch thought that heraldry had fared much better than the field of lettering, where "so many undiscerning people created havoc with compass and ruler in the crude fist, instead of weighing and shaping with the compass of the eye."[16] Among numerous examples of this emphasis on visual sensitivity rather than reliance on measurement, he demonstrated that in a *horizontal* line the optical

and measured middle are identical, whereas in an *optical* bisection of a *vertical* line the upper half will *always* be smaller than the lower half, although both halves *appear* equal.

He pointed to the consequences of this optical illusion for the placement of middle horizontals in such letters as B and H.[17] In another example he described how "the eye, perceiving in an architectural manner, demands that higher-positioned form elements, such as the upper bowl in B or S, must have more robust and spatially important bases." Larisch called it "the principle of support and load."[18]

He was aware that the height of letters, in order to appear optically equal, needed to be varied. For example an O next to a Z—whose horizontal stroke clearly defines its height—must reach above and below the top and baseline to appear equal in height.[19] Larisch also advised that, in order to achieve an optically vertical edge in a block of text, letters such as A, O, T, and Y should move slightly outside the edge to compensate for the openings they create. He called this concept "das Abgrenzen von Schriftfeldern" or the demarcation of a field of text. He wrote, poetically, "The vertical of the ruler has to give way to the intuitive vertical, the vertical of the optical impression."[20]

With the publication of *Über Zierschriften im Dienste der Kunst*, seven years before Johnston's *Writing and Illuminating and Lettering*, Larisch laid the groundwork for writing, lettering, and the arrangement of letters in text, and for that matter "typography" as its own discipline within the Arts and Crafts movement. His creative thinking, his ability to see, combined with his great talent for writing clearly about visual issues—so apparent in his text—are the rare qualities that made it possible for Larisch to contribute in so many ways. He provided a theoretical base from which others could securely venture out.

In the first volume of *Beispiele künstlerischer Schrift*, which appeared in 1900, Larisch expressed his firm belief that a renewal of writing and lettering was only possible "if artists were the driving force."[21] Based on the wide interest in the publication *Über Zierschriften im Dienste der Kunst*, he invited prominent artists, designers, and architects from all over Europe to contribute examples of ornamental lettering. The publication included twenty-two entries from seven countries. Among the individual contributors were Walter Crane, Alphonse Mucha, Otto Eckmann, Emil Rudolf Weiss, Alfred Roller, Joseph Maria Olbrich, Walter Crane, Otto Hupp, and Koloman Moser. To allow for comparisons of legibility and evenness of spacing in different examples of lettering, Larisch set specific requirements for the artists. He limited contributions to twenty words, insisted that all letters of the alphabet had to be included, and—to focus attention on the area of the ground—required that letters be arranged in such a way that the same shape of the background area between individual letters could only occur once.

Here the middle horizontals in the black letters B, S, and H are correctly shifted upward to appear centered. The gray letters, turned upside down, make the upward shift of the middle horizontals clearly apparent. The traffic sign H for Hospital is frequently mounted upside down.

The ever-so-slight increase in the height of the O makes it appear similar to the height of the Z.

wrong correct wrong correct

Contributions to Rudolf von Larisch, ed., *Beispiele künstlerischer Schrift* (Vienna: Verlag Anton Schroll und Co., 1900) 1. All images on this page photo courtesy Sammlung Klingspor Museum, Offenbach a. M.

Alfred Roller (Vienna), *Beispiele künstlerischer Schrift*, 1: XXIX.

Walter Crane (London), *Beispiele künstlerischer Schrift*, 1: IV.

The shape of letters, on the other hand, he left open to the judgment of each artist. He wrote: "Concerning the other half of the problem of lettering, that is the character of a letter, its contour, its silhouette, there remains much to feel and little to say."[22]

The publication was such a success that it was repeated in 1902 and 1906. These volumes included works by Charles Rennie Mackintosh, Hendrik Petrus Berlage, Peter Behrens, F. H. Ehmcke, Wenzel Hablik, Rudolf Koch, William Nicholson, Carl Otto Czeschka, Emil Orlik, Joseph Maria Olbrich, Eugène Grasset, Felix Vallotton, and Otto Wagner, among others—many important artists and architects of the Arts and Crafts movement in Europe. The publication offers proof of the broad international interest artists had in a renewal of writing and lettering. Their experiments represented a completely fresh look at the Roman letter and the interaction of letters in text and had a freeing influence for the next several decades. At the time, some people misunderstood these examples as ideas for typefaces or models for lettering, but Larisch fervently insisted that these were experiments, not models.

RUDOLF VON LARISCH | 79

RACHE · BYZANZ · PERGAMENT · TOD ·
SÜHNE · WOTAN · CORIOLAN · ASTI ·
QUART · KALYPSO · MAZEPPA · MUTH · ·
TREUE · SIEGFRIED · RUBENS · XERXES
TEJA · AJAX · · OLBRICH ·

Joseph Maria Olbrich (Darmstadt, Germany), *Beispiele künstlerischer Schrift*, 1: XXIV.

WALTRAUT·LOURDES
IDYLL·BAUKUNST·HELD
LANDSCHAFT·DACAPO·
SAAZ·QUERKOPF·GOTT
TURGENJEFF·GAZELLE
MOZART·FASTNACHT
KALYPSO·YACHT·JUX

Alfred Roller (Vienna), *Beispiele künstlerischer Schrift*, 1: XXVIII.

The last two volumes of the series, titled *Beispiele künstlerischer Schrift aus vergangenen Jahrhunderten* (Examples of artistic writing from past centuries), focused on manuscripts from the fourteenth, fifteenth, and sixteenth centuries, which Larisch selected from the collections of the archives of the Order of the Golden Fleece and the Haus-, Hof- und Staatsarchiv in Vienna. They contained straightforward examples of practical correspondence, handwritten letters, and decrees by historic personalities in order to show the high writing culture of earlier times. It was his intention to challenge his own generation to reach a similar quality in their work. He did not suggest copying historic styles, but rather encouraged appreciation for the proportion of a block of text, its placement on the page, the quiet, even texture and gray values, and the gestural quality of the initials; in short, he encouraged an appreciation for the work of highly-skilled scribes.

Rudolf von Larisch, ed., *Beispiele künstlerischer Schrift aus vergangenen Jahrhunderten* (Vienna: Verlag Anton Schroll und Co., 1910) 4: XIII. Fifteenth-century manuscript from the archive of the Order of the Golden Fleece and the Österreichisches Staatsarchiv. Photo courtesy Sammlung Klingspor Museum, Offenbach a. M.

RUDOLF VON LARISCH | 81

Detail enlargement showing the similarity of inside spaces and in-between spaces of letters, resulting in a beautiful, even texture.

Rudolf von Larisch, *Über Leserlichkeit von ornamentalen Schriften,* 1st ed. (Vienna: Verlag Anton Schroll und Co., 1904). Author's collection.

Alfred Roller, "Slevogt-Ausstellung." K. K. Gartenbaugesellschaft, Vienna, 1897. Lithograph, 48 cm x 50 cm. Photo courtesy MAK, Museum für Angewandte Kunst, Vienna.

Student work in Larisch, *Unterricht in ornamentaler Schrift,* 11th rev. ed. (Vienna: Österreichische Staatsdruckerei, 1934), 83. Author's collection.

In this poem about clouds, the open spaces between words, together with the dark lettering, make the word spacing resemble white clouds.

In 1904 Larisch published a booklet, *Über Leserlichkeit von ornamentalen Schriften* (On the legibility of ornamental writing). The main part of this text is an elaborate defense against criticism directed at artistic experiments with letters. Larisch makes clear that "legibility" is a rather vague term, since it depends on individual readers, their familiarity with a text, and the typefaces and layouts they are accustomed to. Additionally, he points out that legibility is a characteristic that changes over time. He compares the critical public to "most vertebrates that go into attack mode when confronted with something unfamiliar."[23] He was probably referring to the storm of protest that broke out over the lettering on one of the first artistic posters in Vienna, by Alfred Roller. In a 1905 lecture at the Niederösterreichische Gewerbe Verein (Lower Austrian Society for Commerce and Trade), Larisch gave a lively description of the crowd of angry people staring at the unusual shape of the letter S on an exhibition poster for the German painter Slevogt.[24] With a special stab at the educated classes, who were his most vocal critics, Larisch stated that well-read people, accustomed to reading entire word pictures, had lost their ability to decipher even slightly unusual letters, in contrast to children or less educated readers. He lamented a general decline in visual awareness and sensitivity, "dull-sightedness," among the elite and the impact of this in many areas, especially in the realm of art.[25]

One of his most novel ideas was what he called "brutal legibility." He explained that "there are situations in writing where legibility is not the foremost issue, where the sole aim of the writing is to create a certain atmosphere, and access to the meaning is only revealed to the most persistent reader." He was even more direct in his statement that "such brutal legibility, which immediately releases the reader without any further stimulation, can hardly be the intention of the artist."[26] Here he boldly made room for the other aspect of letters—their formal, expressive potential—which is another of his vital contributions to the field of lettering. It is understandable that at the time such revolutionary ideas met with some opposition.

RUDOLF VON LARISCH | 83

Student work by Erika Giovanna Klien, "Kino" (Interpretation of the projection of images in a movie theater). Photo courtesy Sammlung Klingspor Museum, Offenbach a. M.

84 | RUDOLF VON LARISCH

Student work by Erika Giovanna Klien, "Frühling und Sommer" 1922, Skizzen von Erika Giovanna Klien. Photo courtesy Sammlung Klingspor Museum, Offenbach, a. M.

Facing page:
Rudolf von Larisch, page from a book design by the author, from *Unterricht in ornamentaler Schrift,* 9th ed. (Vienna: Österreische Staatdruckerei, 1929), 36. Photo courtesy Sammlung Klingspor Museum, Offenbach, a. M.

RUDOLF VON LARISCH | 85

STEHT
EIN BAVM
IM FELD,
SCHAVERND
VND
SCHEV.
WENN ICH
VORÜBERGEH,
WINKT ER MIR ZV
MIT TRAVRIGEN ARMEN
VND KLAMMERNDEN FINGERN.
BIST MIR
EIN FREVND,
FRIERENDER
BAVM.
KOMM ICH
AM FELD VORBEI,
SEH ICH
NACH
DIR.

1

Stands
a tree
in the field,
shivering
and
shy.
When I
pass him,
he waves to me
with sad arms
and numb fingers.
You are
a friend to me,
freezing
tree.
When I pass
the field,
I look
for
you.

Front cover of Larisch, *Unterricht in ornamentaler Schrift*, 10th rev. ed. (Vienna: Österreichische Staatsdruckerei, 1934). Photo courtesy Sammlung Klingspor Museum Offenbach, a. M.

Student work from Larisch, *Unterricht in ornamentaler Schrift*, 11th rev. ed. (Vienna: Österreichische Staatsdruckerei, 1934), 8. Author's collection.

Thanks to the success of his 1899 book *Über Zierschriften im Dienste der Kunst* (On ornamental writing in the service of art), Larisch was asked in 1902 to teach a course in ornamental lettering and heraldry at the School of Arts and Crafts in Vienna, one of the most forward-looking schools in Europe at the time and closely connected to the artists of the Secession. This appointment started his long and highly influential teaching career.

In 1905, about one year before Johnston's book *Writing and Illuminating and Lettering*, Larisch published his own textbook, *Unterricht in ornamentaler Schrift* (The teaching of ornamental writing and lettering). The book was so successful that new editions followed in quick succession. He reiterated many ideas from his first book on lettering, but now focused especially on issues concerning the teaching of this new field.

At the center of Larisch's teaching, like Johnston's, was an extensive practice of handwriting. His reasoning was that handwriting introduces students to experiences with movement and rhythm and develops in them a feeling for form. Beyond that, Larisch considered writing and lettering an ideal tool for developing in students—or anyone for that matter—a greater awareness and understanding of art in general. He compared such increased awareness of the visual arts with the result of similar basic exercises in music: "The continuous experience with rhythms inherent in the process of writing might be compared to the influence that musical exercises—such as scales and études—have on a sympathetic understanding of music."[27]

Larisch structured his teaching around two main themes: "the letter itself, its shape, its contour, its features, its structure" and "the relationship of letters to each other, their rhythmic sequencing, the ornamental distribution of masses of a field of text, the positioning of individual lines of text."[28] Such studies he believed to be parallel to any artistic activity.

Rather than copying historic examples, Larisch wanted students to write letters from memory. Most students used Roman capital letters, since they were familiar and their simple geometry made them easy to write. Larisch suggested imagining "a V as two poles leaning against each other at the bottom, an H as two vertical poles with a horizontal beam in the middle, a P as a vertical pole, the upper half connected to an arc," and so on.[29] Such interpretation made students aware of the abstract geometric form elements that shaped the Roman letters. To get a feel for these simple strokes, Larisch suggested writing them "with an outstretched arm, out of a loose shoulder joint, onto a blackboard or simply into the air."[30]

Without any models to follow, students would frequently come up with interesting, personal interpretations of letters. Larisch suggested that "it should be the goal of the teaching to protect these forms and confine gradual changes to other less harmonious letters."[31] Once students were able to write fluently with such a personal alphabet, Larisch suggested experiments with different tools

BRUNNEN, BIS ER BRICHT. DAS
GEBRANNTE KIND FÜRCHTET
DAS FEUER. MORGENSTUND' HAT
GOLD IM MUND. TRAU, SCHAU, WE
KEIN MEISTER FÄLLT VOM HIM-
MEL. ÜBUNG MACHT DEN MEIS-
TER. GOETHE. SCHILLER. HAUFF.

Exercise by an eleven- or twelve-year-old student from *Unterricht in ornamentaler Schrift*, edition unknown (Vienna: Österreichische Staatsdruckerei). Photo courtesy Staatliche Museen zu Berlin-Preussischer Kulturbesitz, Kunstbibliothek.

and materials. "Ornamental handwriting," as he called these exercises, was of special interest to him. He saw it as the beginning of all writing and considered it a useful tool in the search for new letterforms.

Larisch considered the most important goal in his teaching the development of the visual sensitivity required to create an optically even spacing of letters: "Beginners should be capable of closing a field of text in a rhythmically unified way; [in other words] they should be able—as they write—to space letters equally far away from each other" and thus achieve an even surface texture and gray value, or a "closed field," as he called it. He added: "Beginners have to learn to adorn a field with letters like pearls on a string, even if they later plan to disrupt such even texture with an effective opposition."[32]

That such a task was harder to solve than students initially thought becomes clear when reading the many hurdles and exceptions Larisch listed in his text. These include groups or pairs of letters that practically invite spacing mistakes, such as those with opposing verticals NIHK and IB, HD, HR, or opposing diagonals such as VAW, since they offer no resistance to a tighter spacing of letters. When combined with such pairs as TY, ZA, WT, or LA, which "rip their own gaps"—as Larisch put it—the difference becomes apparent. To solve the problem, the spacing of the first groups must be opened up.[33] In other pairs, especially those with indentations, like E and F, spacing involves another hurdle. He describes the gap from the left vertical of the F to the beginning horizontals of the E as an "open ocean," but the indentations within the E as "shallow coves," and thus not fully part of the gap.[34] To make things even more difficult, Larisch distinguishes between "dark letters," where individual strokes sit close together, as in M, R, and B, and "bright letters" such as O, G, C, and D. Dark letters, he explains, tend to "absorb the neighboring background gaps," so adjacent letters have to be placed a little farther away. "Bright letters," he continues, "beam light into the adjacent background gaps," so those gaps have to be tightened.[35]

Raise
YOUR GLASS

In this title for an article in *Vogue* Magazine, the uneven letter spacing breaks up the word GLASS and invites an unintended new meaning. Photo courtesy *Vogue* magazine.

NIHK IB HD HR VAW

Letters that offer no resistance to tighter spacing, and so invite spacing mistakes.

TY ZA WT LA

Letters that "rip their own gaps."

E F open ocean

MRB OGCD
Dark letters. Light letters.

Personal block book, student work by Fini Skarica, woodcut, 1924. From "Edward, Edward," a Scottish ballad, translated into German. Photo courtesy Sammlung Klingspor Museum, Offenbach, a. M.

The bright interior space of an O, on the other hand, Larisch considered to possess an attractive ornamental possibility: "Used with larger fields of text, the repetition of such an open letter creates a second rhythm not unlike a scattered ornament."[36]

To develop an awareness of all these effects that letters have on each other, Larisch asked students always to write entire fields of text rather than individual letters or alphabets. Such exercises also made students aware of the ground or margins that surrounds each field of text. These, he wrote, might consist either of "a simple white border or appear ornamentally articulated."[37]

Beginning with the 1921 edition of *Unterricht in ornamentaler Schrift*, Larisch included a history of the Roman alphabet. The history is very brief, however, and omits important phases in the development of the Roman letters. Also, the handwritten examples included—especially the Roman letters—are not very good. This is understandable since Larisch had just begun to include Johnston's approach in his own teaching and therefore did not yet have the skills for such formal writing with the broad-nibbed pen. But this section allowed him to include an overview of lettering experiments from previous decades.

Larisch's introduction to Johnston's ideas and teaching, grounded as they were in a deep understanding of the history of the Roman letter, must have created a difficult situation for him. He realized the validity of Johnston's approach, but it contradicted his earlier views about the need for a total redesign of the shape of the Roman letter. He now understood clearly that the appearances of the letters of the Roman alphabet should never be totally redesigned, as they had developed over thousands of years, shaped by common writing tools such as the stylus, and to an even greater extent by the flat-edged brush and broad-nibbed pen.

Personal block book, student work by Anna Truxa, woodcut, 1925. "Of the most holy miracle which Saint Francis of Assisi wrought when he converted the very fierce wolf of Agobio." From Ugolino Brunforte, *The Little Flowers of the Glorious Messer St. Francis and of his Friars,* English translation by W. H. Heywood, 1906. Photo courtesy Sammlung Klingspor Museum, Offenbach a. M.

It is touching to read Larisch's words that "after the great successes of the new typefaces we created in these early years, the thought gradually—after some struggle—gained conviction that the quality achievements of lettering artists would still have room for expression, even with a continuance of the traditional forms of Roman letters."[38] Larisch gratefully remembered the contributions of many artists during those early years. He called it the Sturm und Drang (storm and stress) period, which it was necessary to move beyond.

Larisch's firm belief that letters needed to be written rather than constructed as outline drawings was based on his understanding that it is the nib of a writing tool, combined with the gesture of the hand, that shapes the appearance of letters. The outline of a letter then emerges as an additional feature. Therefore an important aspect of Larisch's teaching was to introduce students to a wide variety of writing tools and materials. He wrote: "The distinct language of tools and materials ennoble writing and lettering and leads to a valued simplicity by emphasizing the essential. It leads to a style."[39]

He divided writing tools into three main groups:

1. The stylus-like tools, which produce round endings and create strokes of equal thickness in any direction.

POLE QUANTUM

2. The broad-nibbed pen tools, which produce angular endings as well as hair and shadow strokes.

MERIDIAN

3. The graving tools, which in most cases remove part of the background, leaving the letterform intact, which leads to a printable form.[40]

[O]WA[D]

For beginning exercises Larisch suggested the use of a stylus, a blunt pencil, or the Quellstift, a tool that he invented and named. It consisted of a small stylus of wood or cork inserted into a pencil holder. In later years students used the Redis pen, an implement Larisch developed with Rudolf Blanckertz, a German pen manufacturer. The strokes were similar to those of the Quellstift, but this new tool was easier to use and commercially available.

NEAPEL ACHE BETONEISEN
OFFENBARUNGEN·X·HESIOD
BAJAZZO KALENDER WOTAN
VATERLAND QUIRINUS ALGE
PENTAMETER SYMPHONIEN

Writing with different pen widths, or variations in the height and density of letters, opened up many possibilities for changes in the texture, or lightness and darkness, of a field of text. Initial exercises with pen and paper were followed by "writing with punches, wood and slate studs on tin plates—placed upon a soft base—engraving or cutting letters into plaster or writing on clay."[41]

Detail of student work from *Unterricht in ornamentaler Schrift*, 11th rev. ed., 21.

Rudolf Geyer (Vienna), *Beispiele künstlerischer Schrift*, 3: IX.

Student work: detail of a paper stencil. Photo courtesy Sammlung Klingspor Museum, Offenbach a. M.

Student writing with a stylus-like tool from *Unterricht in ornamentaler Schrift*, 11th rev. ed., 22.

In each consecutive edition of *Unterricht in ornamentaler Schrift* Larisch added new ideas and materials. In 1909 he added the broad-nibbed pen to his list of tools. In 1921 he adapted aspects of Johnston's method to his own teaching. His books now contained exercises in the most important styles of the Roman letter. These allowed students to realize how simple changes in the angle of the pen and gestures of the hand had shaped the different styles of the Roman alphabet. Larisch also included an option for more intensive calligraphic studies: "The technique of the broad-nibbed pen leads to the path of artistic skill, which, if followed with good taste and diligent practice, can lead to the best results."[42]

In addition to the broad-nibbed pen's capacity to recreate historic writing styles, Larisch considered it an excellent tool for ornamental handwriting. He gave students free range to experiment with different tools, pens, and pen angles. Such experiments included, among others, writing letters with the broad-nibbed pen that had previously been written with the stylus, resulting in a totally new alphabet, or—entirely breaking with tradition—writing the Roman majuscule, minuscule, Gothic, and uncial with a stylus. Another such experiment involved writing a slanted Gothic, a style that did not exist in the history of the Gothic, or writing what Larisch called the Blockschrift (block letters), where the broad-nibbed pen is turned for horizontal strokes to achieve even stroke widths, but with rectangular endings unlike the round endings of the stylus. Larisch considered this style ideal for posters and emphasized that even in large sizes these letters should be written rather than constructed as outline drawings.

PASS/LYRIK/QUALM WOLFG·V·GŒTHE 19370 XJZ 58624

Student work, pen nib rotated, from *Unterricht in ornamentaler Schrift*, 11th rev. ed., 62.

Larisch's list of possible tools in the category of the broad-nibbed pen is large. He included the reed pen, the quill, a broad-nibbed steel pen, a chisel-like small piece of wood cut horizontally at the tip, all flexible and elastic copies of the reed pen, wooden spatulas, the flat-edged brush, and pieces of linoleum reinforced with wood. The dimensions of this last tool were unlimited and allowed students to create letters up to fifty centimeters high.

Student work: letters cut in metal, from *Unterricht in ornamentaler Schrift*, 11th rev. ed., 81.

Student work, paper stencil, "Urban Janke," from *Unterricht in ornamentaler Schrift*, 11th rev. ed., 91.

For the third group, the graving tools, Larisch suggested cutting letters into a variety of materials: paper, soft plaster, clay, linoleum, wood of different hardnesses, stone, and metal, or removing the background, keeping the letters intact. Techniques included "carving, cutting, scraping, etching, thus preparing for studies in punch cutting."[43] In all exercises with graving tools, Larisch reminded students to be sensitive to the language of the material, which frequently demanded simplifying the shapes of letters, reducing them to their essential forms.

Larisch felt strongly that especially in art schools the curriculum should expose students to a great variety of lettering applications. His list of such applications is large and ranges from posters to tombstones, ex libris, the use of letters on textiles or ceramics, and the design of new typefaces.[44] Larisch considered it of great value for more advanced students to design a new typeface, since such a comprehensive project developed an increased sensitivity to composition, shape, and structure. The assignment required achieving "with all one's might" a unifying character for all letters and at the same time clearly differentiating each letter from the others.[45]

RUDOLF VON LARISCH | 93

who
has
money
tends
to
be
ruled
by
money

Student work in sawed metal. From Eberhard Hölscher, "Rudolf von Larisch und seine Schule," *Monographien künstlerischer Schrift* 5 (Berlin/Leipzig: Heintze und Blanckertz, 1938), 21. Photo courtesy Deutsches Buch- und Schriftmuseum der Deutschen Nationalbibliothek, Leipzig, Grafische Sammlung.

Student work with paper stencil, "Ex Libris Oswald Dittrich." Photo courtesy Sammlung Klingspor Museum, Offenbach a. M.

Hertha Larisch-Ramsauer, gold-stamped leather binding for *Schriftform und Schreibwerkzeug* by Otto Hurm. From the exhibition catalogue for the Internationale Ausstellung moderner künstlerischer Schrift. Österreichisches Museum für Kunst und Industrie (Vienna: Krystall-Verlag, 1926). Photo courtesy Sammlung Klingspor Museum, Offenbach, a. M.

On the occasion of Larisch's seventieth birthday in 1926, the Austrian Museum for Art and Industry in Vienna mounted an exhibition of lettering artists from Austria, Germany, England, the Netherlands, Switzerland, Czechoslovakia, and Hungary.[46] The extensive catalogue by Hans Ankwicz-Kleehoven includes an essay by Larisch with the title "Ornamentale Schrift als Erziehungsmittel" (Ornamental writing as educational tool), which, in a clear and condensed form, reiterates many of his ideas. The exhibition was an extraordinary testament to Larisch's influence on designers all over Europe. Contributions from Austria included, next to his own work, that of his wife, Hertha Larisch-Ramsauer, and works by his students. Among the contributors from Germany were, among many others, O.H.W. Hadank, Emil Rudolf Weiss, Heinrich Wieynk, Carl Otto Czeschka, Walter Tiemann, Hermann Delitsch, Iwan (Jan) Tschichold, F. H. Ehmcke, Anna Simons, Rudolf Koch, and Friedrich Wilhelm Kleukens. England was represented by, among others, Alfred J. Fairbank, Eric Gill, Graily Hewitt, and Edward Johnston. Switzerland submitted contributions from Zürich School of Arts and Crafts members Walter Käch, Ernst Keller, and Josef Wieser.

RUDOLF VON LARISCH | 95

Student work in tulle embroidery by Fini Skarica, from the exhibition catalog for the Internationale Ausstellung moderner künstlerischer Schrift 1926, 19. Photo courtesy Sammlung Klingspor Museum, Offenbach a. M.

Cover design for the exhibition catalog for the Internationale Ausstellung moderner künstlerischer Schrift 1926. From Larisch, *Unterricht in ornamentaler Schrift*, Appendix, 11th rev. ed.

Above and opposite page:
Zur Feier des einhundertjährigen Bestandes der K. K. Hof- und Staatsdruckerei, 1804–1904. Cover, title page, text page, and colophon, woodcuts by Carl Otto Czeschka; cover design, floriated initials, ornaments, borders, and endpapers by Koloman Moser; typeface, Plinius Antiqua, by Rudolf von Larisch. Photo courtesy Sammlung Klingspor Museum, Offenbach a. M.

Larisch's primary accomplishments were his teaching and his writing. He also designed a variety of ex libris, book designs, trademark designs, and two typefaces for the Vienna State Printing Office. Plinius (1904)—based on fifteenth-century Venetian type—was used in the Festschrift (commemorative publication) for the one hundredth anniversary of the K. K. Hof- und Staatsdruckerei (Vienna State Printing Office).[47] Wertschriften (1905) was created for use on stamps, and also chosen for the text of the 1919 edition of *Unterricht in ornamentaler Schrift.* Larisch's typefaces did not receive wide use.

Larisch restored writing and lettering as an essential field of study to the curriculum of art education. He revived some of the principles of fine typography that had been lost during the latter part of the nineteenth century. He drew attention to the importance and intricacies of optically even letter spacing, which to this day is the main characteristic that distinguishes a well-designed text typeface from one poorly designed. He reawakened a consciousness of the abstract formal qualities of letters—their decorative potential, which had been largely lost in favor of a purely utilitarian view of written information.

Larisch brought back an awareness of the form-giving qualities of tools and materials. Through his acute observations of the many fine details of writing and lettering, he revived principles that are equally important for typography and type design today. To mention just a few again: middle horizontals in capital letters need to move above the measured middle to appear centered; capital letters with a large surrounding background area such as T, V, and A need to move outside the vertical edge of a block of text to make the edge seem vertical; the capital O needs to reach beyond the top line and baseline to appear equal in height when next to such letters as E or T; capital letters with a greater number of strokes appear darker; and dark letters intensify the white of the background, his awareness of the importance of the background in any design and his concern for the right "distribution of masses" speak to issues prevalent in modern design. Through his experiments in ornamental handwriting, Larisch demonstrated the amazing flexibility of the Roman letter. In short, he restored writing and lettering to their proper place as a field of cultural importance within the applied arts.

Rudolf von Larisch, Plinius Antiqua, 1904. Following William Morris's example, the face is based on a Venetian Renaissance Antiqua.

Larisch coined many new terms, among them *das Perlen von Buchstaben* (the pearling of letters on a string) to describe optically even letter spacing, *Eintakt* (measure of one), equal spaces within and between letters; *Rhythmus* (rhythm), the visually repetitive beat resulting from such even spacing; *ornamentale Massenverteilung* (the ornamental distribution of mass), the carefully considered shape and distribution of positive and negative area; *Fleckenwirkung* (spotting effect), the interaction of individual areas formed by letters or images and their relationship to each other and the ground; *Licht* (light), the increased intensity of the white paper next to the black strokes of letters; and *brutale Lesbarkeit* (brutal legibility), to allow for situations that challenge or entice the reader rather than placing emphasis exclusively on easy access to a text. He gave memorable names to the many concepts he developed, names that became instrumental in broadening his influence and thus helped me to trace that influence.

Larisch's ideas and discoveries were ahead of their time. In a memorial address for him Rudolf Blanckertz wrote: "Whoever listened to a lecture by Larisch, read his books, or spent time in his class as a student would have experienced with him the never-ending becoming of writing and lettering."

Notes

Epigraph 1, "Schriftpflege als Mittel der Kunsterziehung," *Internationale Ausstellung für Buchgewerbe und Graphic,* Leipzig, 1914.

Epigraph 2, Rudolf von Larisch, "Ornamentale Schrift als Erziehungsmittel," *Wegleitung Die Schrift,* Kunstgewerbemuseum der Stadt Zürich, 1925.

Unless otherwise noted, all translations in this chapter are by the author.

1. Rudolf von Larisch, ed., *Beispiele künstlerischer Schrift,* vol. 1 (Vienna: Verlag Anton Schroll und Co., 1900), introduction.
2. The Vienna Secession was an art movement founded in 1897 by a group of Austrian artists that included Joseph Hoffmann, Koloman Moser, Otto Wagner, and Gustav Klimt. The group decided to break away from the Association of Austrian Artists to protest its support of traditional artistic styles. Influenced by the Arts and Crafts movement in England, the Secession artists believed in breaking down boundaries between "high art" and "low art."
3. F. H. Ehmcke, "Zwei Pioniere der deutschen Schriftbewegung," in *Geordnetes und Gültiges* (Munich: C. H. Becksche Verlagsbuchhandlung, 1955), 73.
4. The Order of the Golden Fleece is a distinguished Catholic Order of Chivalry, founded in 1430 by Philip the III, Duke of Burgundy. The order still exists as a Spanish and Austrian branch. Some of the treasures and the archive of the order are kept in Vienna.
5. Paul Shaw, "Review of the Exhibition, *Vienna 1900: Art, Architecture and Design,*" Museum of Modern Art, New York, *Calligraphy Idea Exchange* 4, no. 3 (1987): 47.
6. Biographical information on Larisch is based on the following: Ehmcke, "Zwei Pioniere der deutschen Schriftbewegung," 22–26; Otto Hurm, *Johnston, Larisch, Koch: Drei Erneuerer der Schreibkunst* (Mainz: Gutenberg-Gesellschaft, 1955); Eberhard Hölscher and Otto Hurm, "Rudolf von Larisch und seine Schule," in *Monographien künstlerischer Schrift* (Berlin und Leipzig: Verlag für Schriftkunde Heintze und Blanckertz, 1938), n. p.
7. *Vierter Internationaler Kongress für Kunstunterricht, Zeichnen, und Angewandte Kunst,* Vorbericht (Dresden: Kongressleitung, 1912), title page.
8. Rudolf von Larisch, *Über Zierschriften im Dienste der Kunst* (Munich: Verlag Joseph Albert, 1899), 5.
9. Larisch, *Über Zierschriften im Dienste der Kunst,* 6.
10. Larisch, *Über Zierschriften im Dienste der Kunst,* 7.
11. Larisch, *Über Zierschriften im Dienste der Kunst,* 8.
12. Larisch, *Über Zierschriften im Dienste der Kunst,* 18.
13. Larisch, *Über Zierschriften im Dienste der Kunst,* 7–8.
14. Larisch, *Über Zierschriften im Dienste der Kunst,* 27.
 The "Meander" ornament was named after the winding course of a river in Greece.
15. Larisch, *Über Zierschriften im Dienste der Kunst,* 35–36.
16. Larisch, *Über Zierschriften im Dienste der Kunst,* 36.
17. Larisch, *Über Zierschriften im Dienste der Kunst,* 21–22.
18. Larisch, *Über Zierschriften im Dienste der Kunst,* 22.
19. Larisch, *Über Zierschriften im Dienste der Kunst,* 25–27.
20. Larisch, *Über Zierschriften im Dienste der Kunst,* 27.
21. Larisch, *Beispiele Künstlerischer Schrift,* introduction.
22. Larisch, *Beispiele Künstlerischer Schrift,* introduction.
23. Rudolf von Larisch, *Über Leserlichkeit von ornamentalen Schriften,* 1st ed. (Vienna: Verlag Anton Schroll, 1904), 18.
24. Rudolf von Larisch, "Die ornamentale Schrift im Verkehrsleben" (lecture) (Vienna: Niederösterreichischer Gewerbeverein, 1905), 8.
25. Larisch, *Über Leserlichkeit von ornamentalen Schriften,* 10.

26. Larisch, *Über Leserlichkeit von ornamentalen Schriften*, 11.
27. Rudolf von Larisch, *Unterricht in ornamentaler Schrift*, 11th ed. (Vienna: Österreichische Staatsdruckerei, 1934), 4.
28. Larisch, *Unterricht in ornamentaler Schrift*, 3.
29. Larisch, *Unterricht in ornamentaler Schrift*, 6-7.
30. Larisch, *Unterricht in ornamentaler Schrift*, 8.
31. Larisch, *Unterricht in ornamentaler Schrift*, 17.
32. Larisch, *Unterricht in ornamentaler Schrift*, 10.
33. Larisch, *Unterricht in ornamentaler Schrift*, 26.
34. Larisch, *Über Zierschriften im Dienste der Kunst,* 28–29.
35. Larisch, *Unterricht in ornamentaler Schrift*, 29.
36. Larisch, *Unterricht in ornamentaler Schrift*, 28.
37. Larisch, *Unterricht in ornamentaler Schrift*, 16.
38. Larisch, *Unterricht in ornamentaler Schrift*, 42.
39. Larisch, *Unterricht in ornamentaler Schrift*, 44.
40. Larisch, *Unterricht in ornamentaler Schrift*, 45.
41. Larisch, *Unterricht in ornamentaler Schrift*, 46.
42. Larisch, *Unterricht in ornamentaler Schrift*, 48.
43. Larisch, *Unterricht in ornamentaler Schrift*, 81–83.
44. Larisch, *Unterricht in ornamentaler Schrift*, 94–96.
45. Larisch, *Unterricht in ornamentaler Schrift*, 99–101.
46. Ankwicz-Kleehoven, Hans ed., *Internationale Ausstellung Moderner Künstlerischer Schrift 1926* (Vienna: Krystall-Verlag, 1926).
47. *Die K. K. Hof- und Staatsdruckerei 1804–1904* (Vienna: K. K. Hof- und Staatsdruckerei, 1904), Colophon.

And Ehmcke is one of those who made, indeed, remade, the art of writing and lettering—the artistic use, arrangement, and design of letters—into a separate field, a field that is growing toward a distinct worthiness, a separate, clearly defined discipline in the realm of art.

—Emil Preetorius, 1928

F. H. Ehmcke (1878–1965)

In a 1927 article in *Klimsch's Jahrbuch*, F. H. Ehmcke called *Gebrauchsgraphik* (applied graphic design) a collective noun, standing for a wide variety of graphic works. He believed that it should encompass only work that belonged also to the realm of art—"art understood here as inspired creations in technical or craft-related fields"—and exclude all work that served immediate needs only—"all work not created by a feeling hand or seen as part of a larger concept by an intelligent mind."[1] This is an apt description of Ehmcke's own professional work and the values he imparted in his teaching.

Ehmcke is regarded as having started the first modern graphic design office in Germany. Though fascinated by William Morris's renewal of book design in England, he decided, since he needed a steady income, to put his own dreams of a private press on the back burner and focus instead on straightforward, everyday printing and design. Within a year of embarking on his new career—for which there was not even a name yet—Ehmcke had become widely known as a successful proponent of this new profession.

Ehmcke was born in 1878 in Hohensalza, then part of Germany, today part of Poland. At the age of fifteen he started a four-year apprenticeship as a lithographer at a luxury paper factory. In 1899 he enrolled in the Unterrichtsanstalt des Königlichen Kunstgewerbe Museums (School of the Royal Prussian Museum for Arts and Crafts) in Berlin. There he studied with, among others, Emil Doepler. Jeremy Aynsley writes in *Graphic Design in Germany 1890–1945*: "Doepler taught principles of pattern design and ornament mainly through drawing exercises. In these he developed the student's awareness of positive and negative form, as well as of the spatial organization of repeated motives."[2] Ehmcke's later frequent reliance on ornamental patterns for the design of book covers, stamps, initials, and even trademarks can be directly attributed to Doepler's influence.

In 1900 Ehmcke founded the Steglitzer Werkstatt together with Friedrich Wilhelm Kleukens and Georg Belwe, fellow students at the school in Berlin and all of them twenty-two years old. They acquired an old lithography press, set up a workshop—the only place they could afford was a garret in a tenement house in the outskirts of Berlin—and went about trying to attract clients. The tiny garret served not only as a shop for the Werkstatt but also as sleeping quarters for Ehmcke and Belwe.

With a lithography press, all lettering and images must be drawn by hand on stone. As demand for their work increased, they decided to invest in presses that would allow them to use existing typefaces. They bought first a hand press, and soon after a mechanical press for letterpress printing; a place was found for the latter in a remodeled chicken coop on the grounds of the tenement house. The fonts they chose were Eckmann Schrift and Behrens Schrift—both cast by the Rudhard'sche Schriftgiesserei—the first newly developed typefaces in this early renewal period of typeface design in Germany.[3]

F. H. Ehmcke, ca. 1900. Photographer unknown. From Ruari McLean, *How Typography Happens* (London: British Library and Oak Knoll Press, 2000), 48.

F. H. Ehmcke, trademark design for the Steglitzer Werkstatt, Berlin, 1900. From *160 Kennbilder: Eine Sammlung von Warenzeichen, Geschäfts-Verlags- und Büchersignets* (Munich: C. H. Beck'sche Verlagsbuchhandlung, 1925), 1. Photo courtesy Staatsbibliothek zu Berlin, Potsdamer Platz.

Example of Eckmann Schrift, designed by Otto Eckmann with a soft, pointed brush. From Georg Kurt Schauer, *Deutsche Buchkunst 1890–1960* (Hamburg: Maximilian Gesellschaft, 1963), 1:44.

Example of Behrens Schrift, designed by Peter Behrens and the first font in the twentieth century based again on writing with a broad-nibbed pen. Ibid., 1:44.

Clara Möller-Coburg, design of a poster stamp for Syndetikon, hand lithograph, ca. 1902. Photo courtesy Sammlung Klingspor Museum, Offenbach a. M.

F. H. Ehmcke, design of a poster stamp for Syndetikon, hand lithograph, 1902. Photo courtesy Staatliche Museen zu Berlin-Preussischer Kulturbesitz, Kunstbibliothek.

Vom Schlechten kann man nie zu wenig und das Gute nie zu oft lesen: schlechte Bücher sind intellektuelles Gift, sie ver=

Vom Schlechten kann man nie zu wenig und das Gute nie zu oft lesen: schlechte Bücher sind intellektuelles Gift, sie

In their first 1902 mission statement for the Steglitzer Werkstatt, the three founders outlined the kinds of work they wished to provide: unfussy, direct, but high-quality printed matter such as calling cards, letterheads, catalog covers, colored postcards, menus, ex libris, and posters. In describing their products as they did, they clearly intended to distance themselves from any association with Art Nouveau and Secession aesthetics:

> Due to the misunderstandings experienced by a large part of the business community concerning the artistic demands of the current times, we, who are artists ourselves, decided about a year ago to found the Steglitzer Werkstatt, where, next to all other branches of the applied arts, printing is given special attention, to the extent that one might consider it, as in its golden days, to be a printing art. These ordinary, unpretentious creations are meant to provide a welcome contrast to the nervous, flickering confusion of flourishes of all that proclaims itself as fashion and struts around under the collective name of Secession or Jugendstil, and thus provide a place of rest for the eyes. You occasionally may find yourself in need of a printing office and are requested, with this advertisement, to keep our office in mind.

With this manifesto Ehmcke, Kleukens, and Belwe established their place in the history of graphic design. At a time when Jugendstil and Secession styles were at their height in popularity, Ehmcke's was the first voice to call for simpler, more appropriate forms in the applied arts and for problem solving rather than decoration. Five years later, these ideas became the founding principles of the Deutscher Werkbund (German Werkbund), known for its concern for quality in all mass-produced goods.[4]

Soon after its founding in 1902 the Steglitzer Werkstatt expanded its program to include a school for the book trade, with a focus on book design and printing. A promotional announcement listed some of the topics students would encounter, among them an introduction to typesetting and typography, "exercises in black-and-white drawing," and "courses in lithography."[5] Eventually students would be asked to design ornamental patterns and incorporate these in a coherent way into a given text. Other options for the students included learning to draw plants from nature and participating in actual projects of the Werkstatt so that they would become familiar with the entire problem-solving process of design.

F. H. Ehmcke, manifesto of the Steglitzer Werkstatt, 1902. Set in Eckmann Schrift and printed in two colors on a hand letterpress. Photo courtesy Sammlung Klingspor Museum, Offenbach a. M.

Peter Behrens, ca. 1910. Photographer unknown. He was a painter, the first corporate designer, and the most influential German architect of the first half of the twentieth century. Photo courtesy R. McLean, *How Typography Happens* (London, The British Library and Oak Knoll Press, 2000), 48.

Bücher

Sample word set in Behrens Schrift, enlarged. Ibid., 44.

As the number of jobs increased the founders hired professionally-trained typesetters and printers, erected a new building for the Werkstatt in the garden of the tenement house, and in 1903 turned the Werkstatt into a GmbH (limited liability company). Within three years they had taken over the entire tenement building and, as more space was now available, increased the Werkstatt program by hiring additional workers in a variety of crafts. Among these was Clara Möller-Coburg (1869–1918), a talented artist trained in weaving and embroidery who contributed greatly to the design work of the Werkstatt. She later became Ehmcke's wife.

It was soon clear that the founders of the Steglitzer Werkstatt had overextended themselves; their financial situation became precarious. In 1903 Kleukens left, and he and later Belwe accepted teaching positions at the Leipziger Akademie für Graphische Künste und Buchgewerbe (Leipzig Academy for Graphic and Book Arts).[6] That same year Peter Behrens, director at the Kunstgewerbeschule in Düsseldorf (Düsseldorf School of Arts and Crafts), appeared unexpectedly at the Werkstatt to offer Ehmcke a faculty position. Ehmcke accepted. After his departure the Werkstatt continued on for some time, but its "historic mission" was completed during the years 1900 to 1903.[7]

At the time Behrens hired Ehmcke, he himself had only recently been appointed to the directorship at the Düsseldorf school by Hermann Muthesius, who had been charged with the reorganization of the Preussische Kunstgewerbeschulen (Prussian Arts and Crafts Schools). By hiring new faculty, which included members of the Wiener Werkstätte (Vienna Workshop) as well as Ehmcke and Anna Simons, "Behrens was able," "within four years, to turn a somewhat outdated institution into one of the best Arts and Crafts schools in Germany."[8] Trained originally as a painter, Behrens embodied the ideas of the Arts and Crafts movement, which rejected specialization and, as Georg Kurt Schauer writes, "considered the painter of yesterday the form giver and designer of today."[9] Behrens's recent work in type design had received considerable attention. His Behrens Schrift, produced in 1902 by the Rudhard'sche Giesserei and later by the Klingspor Foundry, was one of many attempts in early German type design to create typefaces that combined elements of Gothic and Latin letters. Behrens Schrift was also the first typeface based again on writing with a broad-edged pen.

During his tenure at the Düsseldorf school from 1903 to 1913, Ehmcke focused his teaching on ornamental writing, lettering, typography, and printing. The newly-established summer courses in writing and lettering for art teachers, running from 1905 to 1912, gave him a firsthand introduction to the teachings of Edward Johnston as well as a deeper involvement with the ideas of Rudolf von Larisch. From this time on, ornamental writing and lettering as well as type design became major areas of interest in Ehmcke's work and teaching.

Behrens had chosen Ehmcke to acquaint students with the Larisch approach, whereas Simons, whom he hired in 1905, was to introduce the approach of Johnston. With these two appointments Behrens was, as Ehmcke pointed out, "the first to open the way for the renewal of writing and lettering in Germany."[10]

In the impressive 1911 book published by Eugen Diederichs, titled *Ziele des Schriftunterrichts: Ein Beitrag zur modernen Schriftbewegung* (Goals for the teaching of writing and lettering: A contribution to the modern writing movement), Ehmcke documented his teaching in the summer program.[11] The publication is richly illustrated and includes, next to basic writing exercises, experiments in ornamental writing and lettering. Most examples are student work, but Ehmcke also included pieces of his own to demonstrate the possible uses of decorative lettering in practical applications.

Ehmcke had become a fervent admirer of Larisch, and this publication shows how carefully he studied Larisch's books and the extent to which his teaching now represented many of Larisch's ideas. As he was to state repeatedly, he considered Larisch's ideas superior to those of Johnston. In a 1926 article "Angewandte Schrift" (Applied writing and lettering) in volume 25 of the *Mitteilung der Pelikan Werke*, he wrote:

> Modern ornamental lettering received its strongest impulse from Rudolf von Larisch and his school. Moreover, even in direct contrast to the English school of Edward Johnston, Larisch defined the ornamental aspect of writing and lettering as the truly artistic element, and therefore named his most important book *Unterricht in ornamentaler Schrift* (The teaching of ornamental writing and lettering).[12]

Ehmcke points out that Larisch was the first to see beyond the purely utilitarian purpose of letters and call attention to the rich realm of their formal, ornamental possibilities. Following Larisch's example, Ehmcke's teaching now paid special attention to handwriting and the use of a wide variety of writing tools. In the same article he stated:

> The study of writing and lettering is not only an excellent educational tool to develop a sense of form—because of the inherent regularity of the structure of letters—but also as a guide toward an experience of rhythm as well as through the constraint of an optically even spacing of letters.

Rather than focusing on individual letters, Ehmcke asked students to pay attention to the even texture and tonal value of an entire field of text. The variety of textures in his students' work is surprisingly rich. This resulted from the specific writing tool chosen; variations in letter, line, and word spacing; and changes in the style of letters. To heighten the decorative potential, Ehmcke pushed such writing exercises to the very edge of legibility.

Sample of writing with a Quellstift, a stylus-like tool, by Ehmcke's student Hugo Jäkel. Ehmcke's caption reads: "Negative presentation of a text in capital letters." F. H. Ehmcke, *Ziele des Schriftunterrichts: Ein Beitrag zur modernen Schriftbewegung* (Jena, Germany: Eugen Diederichs Verlag, 1911), 3. Images on this and the next two spreads are courtesy Staatsbibliothek zu Berlin, Potsdamer Platz.

Sample of writing with a pointed brush by Ehmcke's student Peter Bertlings. Ehmcke's caption reads: "Correct linear arrangement of a text." Ibid., 12.

The same text as in image above but set with reduced line spacing. Ehmcke's caption reads: "Reduced line spacing leads to a closed field, a condition necessary for decorative stencils." Ibid., 12.

Sample of stencil lettering by Ehmcke's student Adolf Verdieck. Ehmcke's caption reads: "The stencil principle is intensified toward an emphasis on the spotting effect of the background." Ibid., 16.

Sample of a linocut by Ehmcke's student Christian Müller. Ehmcke's caption reads: "Extreme attempt to keep the printing surface intact. Larger white areas are avoided. The cut is limited to lines of the same widths, which act as background while the remaining black forms the letters." Ibid., 4.

F. H. EHMCKE | 111

Sample of Deutsche Schrift written with a reed pen by Ehmcke's student Franz Liedmann. Ehmcke's caption reads: "The Gothic principle is intensified toward the decorative." Ibid., 66.

Sample of decorative writing with a Quellstift, again by Franz Liedmann. Ehmcke's caption reads: "The appearance of a closed field is achieved through the total removal of line spacing. The ornamental quality is heightened by the increased word spacing and the addition of a prominent dot." Ibid., 74.

Sample of writing with a reed pen by Ehmcke's student Helmuth Triller. Ehmcke's caption reads: "Prominent emphasis of the horizontal expansion. The decorative quality of the field of text is achieved through great reduction in line spacing." Ibid., 28.

Of the Düsseldorf school's first writing and lettering course for art teachers from Prussian trade and arts and crafts schools in 1905, Ehmcke wrote:

> Behrens was in charge of the course. I did the actual teaching, with the help of my shop supervisor, who assisted with the typesetting. That was followed in the second half—for the thus already prepared students—by a course on writing with the broad-nibbed pen in the method of the English lettering artist Edward Johnston, taught by Johnston's student Anna Simons. . . . When Miss Simons began her exercises in the second half of the course I participated myself (and so did Behrens) and thus gladly took advantage of the opportunity to learn about this English method, which seemed to me in its foundation extremely healthy in its aim, on the other hand, too archaic. It is a question of tight adherence to handed-down forms, the best, however, from the best periods of calligraphic scripts. But Larisch's method gives the students more freedom and offers far greater possibilities for development.[13]

What Ehmcke forgot to mention here is that the "English method" Simons was teaching was based on Johnston's revelation that all early manuscript hands as well as all early type design in Europe had been shaped by writing with the broad-edged pen and had further developed via variations in pen angle.

Before Johnston there was in Germany little familiarity with Latin letters, but their importance as a prerequisite for modern type design was not lost on Ehmcke. In 1907 he completed the drawings for his first face, Ehmcke Antiqua, which came out in 1908, cut by Louis Hoell and produced by the Flinsch Foundry. Two more followed while he was still teaching in Düsseldorf—Ehmcke Italic (1910) and Ehmcke Fraktur (1912), both also cut by Hoell—and then, from Ehmcke's time in Munich, Ehmcke Fraktur Medium Bold, Ehmcke Schwabacher, and Ehmcke Rustika (1914), Ehmcke Schwabacher Medium Bold (1915), Ehmcke Mediaeval and Ehmcke Italic (1924), Ehmcke Mediaeval Bold (1925), Ehmcke Latein and Ehmcke Latein Medium Bold (1925), Ehmcke Elzevir and Ehmcke Elzevir Bold (1927), and finally Ehmcke Brotschrift (1927).[14]

Ehmcke frequently claimed that all of his faces were based on historical sources. Yet to a current reader, individual letters may look a bit puzzling; consider for example the drastically pulled-down curve in the capital P or the lowered left arm of the capital A in the Ehmcke Antiqua (opposite page). As I see it, these are examples of Ehmcke following Larisch's demand for optically even spacing of letters. One way to do so, Ehmcke had decided, was to further reduce large white spaces such as those on both sides of the capital T, the right side of L and P, and the spread of the arms of A. He did so by shortening the horizontals of T and L, lowering the curve of P, and reducing the spread of the arms of A. He began applying these ideas with his first design, Antiqua, about which Schauer writes that "after the heavy faces of the turn of the century, it is for the first time again a light face with delicate hairlines."[15]

Inside page of the Flinsch foundry type specimen for Ehmcke Antiqua, which was cut by Louis Hoell and cast in 1908 by the Schriftgiesserei Flinsch, Frankfurt a. M.
All images on this page and the next two spreads are photos courtesy Deutsches Buch- und Schriftmuseum der Deutschen Nationalbibliothek, Leipzig, Grafische Sammlung.

Cover and inside page of the type specimen for Ehmcke Elzevir, cast in 1927 by Ludwig Wagner Schriftgiesserei, Leipzig.

EHMCKE ELZEVIR
ENTWORFEN VON PROF. F. H. EHMCKE / MÜNCHEN
ORIGINALSCHNITT / GESETZLICH GESCHÜTZT
IN DEN GRADEN NONPAREILLE BIS SECHS CICERO

LUDWIG WAGNER AKT.-GES. / SCHRIFTGIESSEREI
UND MESSINGLINIEN-FABRIK / LEIPZIG C1

¶ DIE FARBEN für diese Probe lieferten die Farben-Fabriken von E. T. Gleitsmann gegr. 1847 / Dresden, Filialen in Wien und ¶ Rabenstein N.-Ö., Trelleborg, Mailand und Aussig a.d. Elbe /

Cover page of the Stempel Foundry type specimen for Ehmcke Schwabacher, cast in 1920 by D. Stempel AG, Frankfurt a. M.

Ehmcke Fraktur
mit Initialen und halbfetter Auszeichnungsschrift
geschnitten nach Entwürfen von Prof. F. H. Ehmcke

Schriftgießerei D. Stempel AG Frankfurt am Main

Cover page of the Stempel Foundry type specimen for Ehmcke Fraktur, cut by Louis Hoell and cast first in 1912 by Officin W. Drugulin, Leipzig, and later in 1917 by D. Stempel AG, Frankfurt a. M.

Soon after his appointment at the Düsseldorf School, and after an initial period when he tried to compete with Behrens in architecture and furniture design, Ehmcke realized that, given his strong background in the crafts, he should focus on his skills as lithographer and letterpress printer. This was an important realization for both his teaching and his professional work.

In 1904, though against the wishes of Behrens, who wanted to train "designers for industry rather than as 'dilettantes in the crafts,'" Ehmcke set up shops at the school for lithography, bookbinding, and letterpress printing.[16] It was on these presses that he began to design books for commercial publishers. This work ranged from the design of an entire book—including decisions about the book's size, shape, choice of typeface, typography, cover design, dust jacket, initials, and chapter headings—to the design of cover and title page only. Since these editions frequently had only small print runs, Ehmcke could afford to take the time and care usually only available to books printed by private presses. After 1907, when his own typefaces started becoming available to him, he used them on these projects. Two important books from this period, both designed for the Eugen Diederichs Verlag, were *Idyllen des Theokrit* (1910), set in Ehmcke Antiqua, and *Die Grundworte des indischen Monismus aus den Upanischads des Veda* (1914), set in Behrens Schrift and Behrens Antiqua, with ornamental treatment and cover design by F. H. Ernst Schneidler, then still Ehmcke's student. During his entire time in Düsseldorf Ehmcke designed more than twenty books for Diederichs alone, as well as many books for other major publishers. Among some of his occasional work is the design of a commemorative statement for the artists' association Düsseldorfer Sonderbund, which showcases a beautiful application of his Antiqua. He also designed many trade and publishing marks, including the famous Eugen Diederichs lion.

Behrens's resignation from the Düsseldorf school in 1908 to become artistic consultant for the AEG (General Electricity Company) in Berlin was the impetus for a number of other faculty members to leave as well. Over time the new director, Wilhelm Kreis, was unable to maintain the quality of the program. In 1912, therefore, Ehmcke began to apply for positions at other schools. When his search proved unsuccessful, he asked Hermann Muthesius for a one-year leave to travel in Italy, which was granted. During his travels a chance visit with Richard Riemerschmid, the German architect, designer, painter, and at that time director at the Staatliche Kunstgewerbeschule München (Munich School of Arts and Crafts), led to Riemerschmid's offering Ehmcke a faculty position. He accepted and began his new teaching appointment in 1913, after his return from Italy. With the exception of a one-year leave to teach at the Kunstgewerbeschule Zürich (Zürich School of Arts and Crafts), Ehmcke taught at the Munich School of Arts and Crafts from 1913 to 1938, when faculty intrigues compelled him to retire.

F. H. Ehmcke, publisher's mark for the Eugen Diederichs Verlag, Munich, 1913. From *160 Kennbilder: Eine Sammlung von Warenzeichen, Geschäfts-, Verlags- und Büchersignets,* (Munich: C. H. Beck'sche Verlagsbuchhandlung, 1925) 13. Photo courtesy Staatsbibliothek zu Berlin, Potsdamer Platz.

> SONDERBUND
> WESTDEUTSCHER KUNST
> FREUNDE UND KÜNSTLER
>
> GRÜNDUNGSAUSSCHREIBEN·MCMIX

F. H. Ehmcke, Ehmcke Antiqua used in a commemorative statement for the Düsseldorfer Sonderbund, an alliance of artists, collectors, and museum specialists founded in 1909. Photo courtesy Deutsches Buch- und Schriftmuseum der Deutschen Nationalbibliothek, Leipzig, Grafische Sammlung.

Riemerschmid was the ideal boss. He agreed to Ehmcke's wish for the installation of shops for letterpress printing, lithography, and bookbinding, and also, in the face of resistance from some faculty members, supported Ehmcke's request that Simons be invited to teach her intensive course on formal writing. She was first appointed in 1914, and as Ehmcke recalled, "this arrangement was repeated every year and proved extremely profitable for students of all departments."[17] In 1953, two years after Simons's death, Ehmcke for the first time fully acknowledged her important role in the renewal of writing and lettering.

> [Anna Simons] master of beautiful writing without equal, taught her course of formal writing not only in Munich and Düsseldorf but also in Zürich, Hamburg, Frankfurt a. M., Nürnberg, Weimar, and Halle. She continued to teach even during the Third Reich, and the high level of the German writing culture, which lasted up to World War II, was due to her influence, a writing culture that exists today only in Switzerland.[18]

122 | F. H. EHMCKE

For the publisher's mark of the Rupprecht Presse Ehmcke used the traditional emblem of printers and publishers, the imperial orb, in this case with the Bavarian diamond shapes on the orb and the R raised on the cross.

Cover and title page of Frédéric le Grand, *L'Antimachiavel* (Munich: Rupprecht Presse, 1922). Title set in Ehmcke Rustika, text in Ehmcke Kursiv. This was the sixteenth book published by the Rupprecht Presse. This image and all images on the following two spreads are photo courtesy Bayerische Staatsbibliothek, Munich.

When, in the spring of 1914, Ehmcke mentioned his plan to found a private press—a dream of his that went back to the time of the Steglitzer Werkstatt—Riemerschmid suggested that he set it up in connection with the school. He promised that the school would provide the necessary space and a well-trained staff to handle the technical demands of typesetting and printing. Even so, the project would need additional financial backing, and this was initially secured from the Holbein Verlag in Munich, who also donated a hand letterpress. Riemerschmid further suggested that Ehmcke ask several prominent local personalities to form an honorary committee, and that Crown Prince Rupprecht of Bavaria be approached to give the imprimatur of his name to the new venture; if he agreed, the press would be named the Rupprecht Presse. The committee was formed, the crown prince gave permission to use his name, and Ehmcke had been appointed sole director of the new press. But then, in August 1914, World War I broke out and everything came to a halt.

After four years of war, in November 1918, the German Empire collapsed and Emperor Wilhelm II went into exile in the Netherlands. What followed in Germany were continuous political upheavals and, with skyrocketing inflation, increased poverty.

In spite of all this, Ehmcke resumed work at the Rupprecht Presse as soon as a sufficient workforce of printers and typesetters had returned from the war.

L'ANTIMACHIAVEL

ou examen du Prince de Machiavel

par Frédéric le Grand

And finally, in 1920—after the publication of the Rupprecht Presse's first book, *Ein Fürstenspiegel* by Hubert Thomas—Ehmcke published his mission statement for the press:

> It is the aim of the Rupprecht Presse to publish texts that are masterpieces of the human mind, in a form that captures the essence of the works, and at the same time clearly presents them as products of our time.[19]

We know that Ehmcke was deeply influenced by William Morris's beautiful books, but he considered the volumes subsequently published by Doves Press (1900–1917) more current models for well-designed books. Arnulf Backe and Hedda Backe, in their 2005 book *Die Rupprecht Presse: Ein Porträt*, include an article by Ehmcke from 1911, in which he stated:

> In professional circles there is no doubt that the books produced by the English Doves Press—simply as objects of skilled craft—represent the most impressive book design of our time. Every book, from the first to the last page, presents exceptional quality of composition, artfully balanced typographic work, well-measured distribution of text on the page, the perfect relationship of letter masses to headlines and widths of the margins, and finally the optimal disposition of the entire text within the book.[20]

As Ehmcke had complete authority over the press, he was now able to use his typefaces to their full advantage, choosing for each book's topic or text the face that would be most appropriate. The type for all books was set by hand, and the books were printed with a hand press on handmade paper. According to the Backes, Ehmcke held to this standard of care for quality "from the first to the last book, in spite of the fact that interest in his books by experts as well as the general public was lacking and sales meager."[21] Schauer commented in his chapter "The Art of the Book in Germany" in *Book Typography 1815–1965 in Europe and the United States of America* that "no other press has rendered Germany's national typography with greater variety and was less influenced by the rest of Europe than the Rupprecht Presse."[22]

Between 1918 and 1934, the year of Rupprecht Presse's closing, Ehmcke created fifty-seven exceedingly beautiful books covering a wide range of topics in German literature. The choice of topics was the work of Rudolf von Delius and, from the twelfth book on, Karl Wolfskehl, both of whom served as literary advisors to the press. Because of postwar shortages, many of the first books had paper rather than the usual leather bindings. All of the ornamental patterns for the paper cover designs, however—whether printed from linoleum plates or lithographic stones—are beautiful and appropriate to the content. "The perfect unity of page size, typography, paper, printing, and cover design," Schauer comments, "follows in the footsteps of the English press tradition and does honor to it."[23]

Cover design and chapter opening of Heinrich von Kleist, *Germania an ihre Kinder* (1920–21), set in Ehmcke Schwabacher. This was the twelfth book published by the Rupprecht Presse.

2.

Deutsche, muth'ger Kinder Reigen,
 Die, mit Schmerz und Lust geküßt,
In den Schoß mir kletternd steigen,
 Die mein Mutterarm umschließt,
Meines Busens Schutz und Schirmer,
 Unbesiegtes Marsenblut,
Enkel der Kohortenstürmer,
 Römerüberwinderbrut!

Chor:

Zu den Waffen! zu den Waffen!
Was die Hände blindlings raffen!
 Mit dem Spieße, mit dem Stab
 Strömt ins Thal der Schlacht hinab!

Chapter openings for chapters 1 and 2 of Leopold von Ranke, *Savonarola und die florentinische Republik gegen Ende des fünfzehnten Jahrhunderts* (1919). The initial letters of all chapters in every book were handwritten by Anna Simons in red and blue ink. Title page and text set in Ehmcke Fraktur. This was the sixth book published by the Rupprecht Presse.

Zweites Kapitel

Wenn der Uebergang von einer Regierung zur andern selbst in der erblichen Monarchie die Verschiedenheit der Epochen begründet, wie viel wichtiger und schwieriger ist es in der Republik, einem mächtigen Oberhaupt einen Nachfolger zu geben, der ihn wirklich fortsetze. Wiewohl Florenz Republik war, so lag doch ein Moment für die Erblichkeit der Gewalt darin, daß jene Genossenschaft der vornehmsten Geschlechter bestand, welche die Autorität zu teilen sich berechtigt glaubte, aber sich daran gewöhnt hatte, ein Oberhaupt anzuerkennen, dessen Ansehen auf einem großen Besitz und der Gewohnheit einer indirekten Gewalt beruhte.

Nach Lorenzos Tode wurde nun Piero ohne Schwierigkeit durch die vornehmen Geschlechter, die Magistrate und die allgemeine Beistimmung als Oberhaupt der Republik anerkannt. Die benachbarten Fürsten begrüßten ihn in dieser Eigenschaft, gleich als könne es nicht anders sein. Allein wie schon bei dem Eintritt des älteren Piero und hernach gegen Lorenzo selbst unter den nahen und befreundeten Geschlechtern ein starkes Aufwallen der republikanischen Gesinnungen hervorgetreten und nur mit Anstrengung und Gefahr beseitigt worden war, so ließen sich auch unmittelbar nach Pieros Eintritt ähnliche Regungen bemerken. Zu den vertrautesten Freunden Lorenzos hatten Paol Antonio Soderini und Bernardo Rucellai gehört und an dem Regiment teilgehabt, aber schon unter Lorenzo waren sie dadurch verletzt worden, daß dieser sie weniger konsultierte als einige Vertraute von Verstand und Geist, die aber von niederer Herkunft waren. Unter Lorenzo war die Autorität durch die Intelligenz gleichsam geheiligt worden; was aber unter ihm geduldet werden konnte, schien unerträglich unter dem Nachfolger, der die bürgerlichen Tugenden seines Vaters nicht besaß, sich vielmehr in den Aeußerlichkeiten des Lebens eines jungen Fürsten gefiel. Soderini und Rucellai stellten ihm vor, daß er nur unter Begünstigung der Mitglieder des Stato, d.h. des aristokratischen Elementes sich werde behaup-

Page of generic designs from *Gildenzeichen, nach Entwürfen von F. H. Ehmcke und Mitarbeitern* (Offenbach a. M.: Schriftgiesserei Gebr. Klingspor, 1907), 45. Other designers I was able to identify on this page are Friedrich Wilhelm Kleukens and Ludwig ten Hompel. Photo courtesy Sammlung Klingspor Museum, Offenbach a. M.

F. H. Ehmcke, generic design for an equestrian store. Ibid., 9432. Photo courtesy Staatliche Museen zu Berlin-Preussischer Kulturbesitz, Kunstbibliothek.

Ehmcke was a highly creative designer. He could draw and he could see. But he also had something else, which Schauer described as an intent in all of his work to "strengthen and secure the link between artistic expression and the information to be transmitted."[24] When the information was that of an image, Ehmcke was not merely illustrative but rather transformed that image into a sign. He accomplished this by removing all nonessential visual properties and relying mainly on the shape of an object to communicate its most important qualities.

Ehmcke's interest in the sign-like image was evident as early as 1902, when the Klingspor foundry gave him the assignment to create emblems for a wide variety of trades. The foundry already had several such emblems but wanted not only to improve the designs but also to complete their collection of trade emblems. This was a huge job for Ehmcke, Belwe, and Kleukens, and required as well an additional group of helpers. What they came up with were simplified, trade-appropriate images, each limited to one color and placed tightly within a rectangle. A final product of this project was the publication *Gildenzeichen* (Guild signs), which includes close to ten thousand emblems and came out in 1907, during the time Ehmcke was teaching in Düsseldorf. Today this publication is a wonderful document of a time when a moving van was pulled by draft horses, when automobiles had only recently been invented, and when the steam engine of a train pulled its supply of coal behind it.

Many of Ehmcke's later publishing and trademarks are representational but designed abstractly as shapes, lines, and textures as well as showing great sensitivity to their interaction with the ground. A good example is the trademark for the Berlinische Feuerversicherung (Berlin Municipal Fire Insurance Company), where the tail of the phoenix is at once tail and flame, thus showing the phoenix truly rising from the ashes. Other examples include his publishing mark for the Delphin Verlag and the famous lion he created for Eugen Diederichs Verlag. Marks such as these demonstrate Ehmcke's ability to place signs into a given field in such a way that the image and the resulting background are completely interrelated. To quote Ehmcke from his publication *160 Kennbilder: Eine Sammlung von Warenzeichen, Geschäfts- Verlags- und Büchersignets*:

> Even though the first trademarks already show my determined resolve toward objectivity, simplicity, and appropriateness, still, a firm intent toward stylistic representation was necessary to change a perception spoiled by the naturalistic drawing education of the time. The obvious danger of thereby achieving the reverse—a stiff or mannered style—could, I realized, only be avoided by bringing to one's tasks a more open-minded understanding, and a more complex nature-based perceptiveness. In short, to apprehend nature not through its accidental, momentary appearance but through the constancy of its organic and rhythmic manifestations.

F. H. Ehmcke, trademark for Berlinische Feuerversicherung, 1925. From Ehmcke, *160 Kennbilder,* 37. All images from *160 Kennbilder* on this page and the next are photo courtesy Staatsbibliothek zu Berlin, Potsdamer Platz.

F. H. Ehmcke, publisher's mark for Delphin Verlag, Munich, 1913. Ibid., 55.

F. H. Ehmcke, publisher's mark for Eugen Diederichs Verlag, Munich, 1913. Ibid., 13.

A few of Ehmcke's marks rely only on letters, among them those he designed for the bookstore Schmitz and Olbertz (note the two ending letters in common, "tz"), the publishing houses Reclams Universal Bibliothek, Piper Drucke, and the organization Deutscher Werkbund. Schauer considered Ehmcke the most important creator of trademarks during the first half of the twentieth century.

F. H. Ehmcke, publisher's mark for the bookstore Schmitz and Olbertz, Düsseldorf, 1908. Ibid., 25.

F. H. Ehmcke, trademark for Reclams Universal Bibliothek, Leipzig, 1916. Ibid., 78.

F. H. Ehmcke, publisher's mark for R. Piper Drucke und Co. Verlag, Munich, 1923. Ibid., 145.

F. H. Ehmcke, trademark for the Deutscher Werkbund, Munich, 1911. Ibid., 35.

Ehmcke's sensitivity to texture and value gave him additional tools for surface treatments. Both examples depicted here—the stamp designs for the state of Bavaria and initials for a new edition of Grimms' fairy tales—rely on texture and value differences to create separation between letter or image and background.

F. H. Ehmcke, stamp design for the state of Bavaria. Photo courtesy Sammlung Klingspor Museum, Offenbach a. M.

F. H. Ehmcke, design of Fraktur initials E and A for a new edition of *Grimms Märchen*, ed. Friedrich von der Leyen (Jena: Eugen Diederichs Verlag, 1912). Photo courtesy Sammlung Klingspor Museum, Offenbach a. M.

Ehmcke designed a large number of books for commercial publishers. Although most of the cover designs combine typography with ornamental patterns, he took a different approach in his covers for a series of books on fairy tales. In these books, front and back cover are filled entirely by an intricate ornamental pattern. A closer look reveals that each pattern consists of tiny signs that reflect the culture from which the particular collection of fairy tales originated. The pattern for the cover of *Märchen aus dem Balkan* (Popular legends from the Balkans), shows diagonal bands of flowering red and black vines. These vines reach in a repetitive way into the open area between them, thus creating small islands of white. The islands are populated by tiny fairy-tale-like scenes, such as a group of peacocks, a running deer followed by hunting dogs, a woman riding a long-horned goat, a group of eagles, jumping lions, a king in his chariot, and a fierce warrior on his horse raising a saber—all images associated with this part of the world. The pattern, on the other hand, used for the book *Nordische Volksmärchen* (Nordic popular legends) is filled with pine trees, castles, unicorns, flying geese, witches on brooms, stars, moons, and water nymphs; the predominantly geometric shapes of the images evoke folk embroidery (opposite page). In Ehmcke's designs for these books the titles appear simply as small labels tacked onto the front covers.

F. H. Ehmcke, designs for front and back covers of *Märchen aus dem Balkan,* ed. August Leskien (Jena: Eugen Diederichs Verlag, 1915). Cover text set in Ehmcke Schwabacher. All images on this spread and the next page are photo courtesy Staatliche Museen zu Berlin-Preussischer Kulturbesitz, Kunstbibliothek.

Detail enlargements of front and back covers of *Märchen aus dem Balkan* (see opposite page).

Detail enlargements of F. H. Ehmcke's designs for front and back covers of *Nordische Volksmärchen* (Jena: Eugen Diederichs Verlag, 1922).

In much of his work Ehmcke used letters—in most cases his own—not only to communicate but also to function as image. One can find this in his posters, book covers, catalogs, magazines, and trademarks. For the cover of the 1909 *Insel-Almanach* he took advantage of repetitive circles inherent in the number 1909 set in Ehmcke Antiqua. By arranging the numbers vertically, he gave up easy legibility for a seemingly abstract rhythm of lines and circles. The Insel Verlag trademark on the back cover of the same book—the famous ship in a circle, designed by Peter Behrens—perfectly echoes the circles on the front.

Another example of Ehmcke's use of letters as image is the 1914 poster for the German Werkbund exhibition. The most prominent image here is one letter, the festively crowned W set in Ehmcke Latein. This was a fresh and highly unusual solution at a time when such posters would ordinarily show some heroic figure on a horse.

F. H. Ehmcke, cover design for *Insel Almanach,* 1909. Set in Ehmcke Antiqua. Photo courtesy Staatliche Museen zu Berlin-Preussischer Kulturbesitz, Kunstbibliothek.

F. H. Ehmcke, poster design for the German Werkbund exhibition in Cologne, 1914, color lithography. Photo courtesy Museum für Gestaltung Zürich, Plakatsammlung.

Additional examples of Ehmcke's use of letters as image are these two cover designs which apply grid structures both to function as ornament and to organize the text. The cover for a magazine on applied arts uses a tile-like square grid pattern to place each letter or a combination of two letters. Word abbreviations are indicated, where needed, with dots inside the tiles. The dotted grid lines of the cover (opposite page) beautifully assure the prominence of the title.

F. H. Ehmcke and Clara Möller-Coburg, cover design for a special edition of the periodical *Zeitschrift für Angewandte Kunst* no. 2, 9 (ca. 1903). The images on this spread and the next are photo courtesy Staatliche Museen zu Berlin-Preussischer Kulturbesitz, Kunstbibliothek.

Facing page:
F. H. Ehmcke, cover design for a publication of the *Städtische Gewerbeschule in Frankfurt a. M.*, 1908. Set in Ehmcke Antiqua.

An especially beautiful example of Ehmcke Antiqua was used in this poster for an exhibition of lace at the Gewerbe Museum in Graz, Austria. Here a block of text is centered on the poster and surrounded by a light-yellow dot pattern, evoking lace. A simple increase in size and density of dots on all sides of the text block and on the outer frame of the poster results in a darker, more intense yellow, functioning as a subtle reinforcement of the frame.

F. H. Ehmcke, poster for a lace exhibition at the Gewerbe Museum, Graz, Austria. Text set in Ehmcke Antiqua.

TELLUNG
OENIGL.
ES GRAZ
MUSEUM

To Ehmcke's use of letters one should add his contribution to the genre of large-scale lettering for memorial plaques on buildings and for tombstones, including the stone he designed for Anna Simons's grave in Prien am Chiemsee. Schauer writes:

> Next to Rudolf Koch, Ehmcke deserves the greatest credit for the examples he set with his writing and drawing of representative and large-scale lettering. Like Koch and Larisch, he saw formal writing as the obvious point of departure for any work with type design and typography.[25]

F. H. Ehmcke, entrance inscription on the administration buiding for an organization of German medical doctors (Haus der Deutschen Ärzte), Brienner Strasse 23, Munich. From *Monumentale Schriften von F. H. Ehmcke* (Munich: Georg D. W. Callwey, 1953), 23. All images on this spread are courtesy Bayerische Staatsbibliothek, Munich.

F. H. Ehmcke, memorial plaque on the birthplace of the painter Wilhelm Leibl, Cologne, 1912. Carved in marble and gilded. Ibid., 5.

F. H. Ehmcke, construction plaque on the boarding school Landerziehungsheim Schondorf, southern Germany, 1934. Ibid., 22.

Ehmcke's courses at the school in Düsseldorf, where he taught from 1903 to 1913, were titled Lettering and Printing: Two-Dimensional and Graphic Arts. By 1914, when he was appointed to the Munich School of Arts and Crafts, his course was simply titled Teaching Lettering and Graphic Design. Within ten years a field of study called graphic design had become accepted reality!

Ehmcke was considered not only a gifted designer but also an excellent teacher. In his essay "Rückblick und Ausblick: Skizze eines Lebenslaufes" (A look back and a look forward: sketch of a life) he defined his teaching philosophy as follows: "To give special consideration to the originality, individuality, and uniqueness of each student, greatest freedom in the choice and direction of their studies, strictest discipline, on the other hand, in all craft-related areas."[26] The craft-related topics he refers to would have included letterpress and lithographic printing as well as such image-making techniques as linoleum cuts, woodcuts, wood engraving, drawing or painting on lithographic stones, and printing from stones.

Before the invention of offset lithography it was vital to pay close attention to the possibilities and limitations of each printing technology. Straight lines were fairly easy to cut and lent themselves well to linoleum cuts, wood-engravings or woodcuts—the standard image-making techniques for letterpress printing. Great skill, on the other hand, was required for the shaping of curves. Also, the size of the background for raised images had to be kept sufficiently small so that the block would be able to support the paper at the printing stage. This problem did not arise for linear engravings, where most of the linoleum block remained intact. Having to consider such constraints, which imposed limitations on how images could be shaped and therefore how new forms could be created, demanded imagination and inventiveness from the students.

Sample of a linocut by Ehmcke's student Jakob Erbar. From F. H. Ehmcke, *Ziele des Schriftunterrichts: Ein Beitrag zur modernen Schriftbewegung* (Jena, Germany: Eugen Diederichs Verlag, 1911), 4. Both images on this spread are courtesy Staatsbibliothek zu Berlin, Potsdamer Platz.

The most important areas of study in Ehmcke's teaching always included ornamental writing, lettering, and typography as well as their various applications in graphic design and book design. During the times he was in charge of the graphic design program in Munich, and later in 1920–21 at the School of Arts and Crafts in Zürich, he also promoted Anna Simons's annual intensive course on formal writing.

Ehmcke believed that involvement with writing and lettering served as an ideal introduction to a deeper understanding of form and composition. As he states in the article "Schriftschulung als Erziehung zur Form" (Teaching of writing and lettering as a means toward understanding form):

> An occupation with the most basic forms of ornamental writing leads students directly to principles found in all artistic work: relationships of lines and shapes, their rhythmic arrangement, variation of round and straight, light and dark, the effect of contrast. Recognition, observation, and remembrance of such characteristic features—all these particularities, which should be considered in any artistic discipline—are introduced to students with the greatest ease through the basic principles of ornamental writing.[27]

Decorative lettering sample by F. H. Ehmcke's daughter, Susanne Ehmcke. Ehmcke's caption reads: "Letters as ornamental surface treatment." Ibid., 75.

144 | F. H. EHMCKE

F. H. Ehmcke Werkstatt Pressa Köln, three-color offset poster for the Pressa exhibit, Cologne, 1928. Photo courtesy Museum für Gestaltung Zürich, Plakatsammlung.

At the Steglitzer Werkstatt, as well as at the schools in Düsseldorf and Munich, Ehmcke frequently included students in his own projects. Thus, when in 1924 the German Werkbund chose Ehmcke to take on the entire promotion for a large international exhibition on printing in Cologne, titled Pressa, he hired a staff of current and former students as part of the F. H. Ehmcke Werkstatt Pressa Köln. The staff of students, who came from his programs in Düsseldorf, Munich, and Zürich, and from local arts and crafts schools, grew quickly from fourteen to seventy. The work included the design and sometimes also the printing of a variety of posters, poster stamps, newspaper ads, entrance tickets, guidebooks, signage, invitations, banners, uniforms, and the entire concept for the plaza surrounding the exhibition hall. The project took four years and is proof of Ehmcke's organizational talent.

Because the posters and all other printed work were identified only by the imprint F. H. Ehmcke Werkstatt Pressa Köln, it is hard to determine the identities of individual designers. However, a special edition of *Das Zelt: Zeitschrift des Ehmcke Kreises* lists forty-five students whose work was exhibited at the Pressa exhibition.[28] Among these were René Binder and Max Eichheim, both mentioned by Jeremy Aynsley in his book *Graphic Design in Germany* as the creators of the most unusual poster for Pressa (opposite page).[29] Functioning like a map, the poster refers to the location of the exhibition area relative to the Cologne cathedral and the Rhine River; interestingly, it breaks with the horizontal-vertical structure so typical of Ehmcke's other work.

Unidentified designer(s) and F. H. Ehmcke Werkstatt Pressa Köln, three-color lithographic poster stamps, 1928. Photo courtesy Deutsches Buch- und Schriftmuseum der Deutschen Nationalbibliothek Leipzig, Grafische Sammlung.

René Binder, Max Eichheim, and F. H. Ehmcke Werkstatt Pressa Köln, three-color offset poster, 1928. Photo courtesy Museum für Gestaltung Zürich, Plakatsammlung.

Page 3 of the annual report *Bericht über das Jahr 1921/22*, for the Gewerbeschule und Kunstgewerbemuseum der Stadt Zürich. Set in Ehmcke Schwabacher. Photo courtesy Zürcher Hochschule der Künste, Archiv.

Opposite page:
Title page and colophon of a new edition of *Meister Johans Hadloubs Minnelieder*, in Schweizer Minnesänger, ed. Karl Bartsch, (1886; Zürich: Gewerbeschule der Stadt Zürich, 1921). Set in Ehmcke Schwabacher by a class of day students in typesetting under the direction of J. Kohlmann and the art direction of F. H. Ehmcke. Wood cut of the title page by P. Gauchat. All images on the opposite page and the next spread are courtesy Deutsches Buch- und Schriftmuseum der Deutschen Nationalbibliothek, Leipzig, Grafische Sammlung.

In the fall of 1920 Alfred Altherr, director of the Kunstgewerbeschule Zürich (School of Arts and Crafts), offered Ehmcke a full-time appointment to establish a graphic design department as a separate entity within the school. After some deliberation Ehmcke accepted the offer, although for only one year. He requested that Simons also be hired to teach her famous course on formal writing.

It was an added bonus that Larisch happened to be in Zürich during the winter semester of 1921 and was able to give a well-received lecture on his ideas and his teaching. Thus a number of fortunate students were introduced to the work of Ehmcke, the theories underlying Larisch's teaching, and they were able to participate in an intensive course of formal writing with Simons. They also spent three half days across the fall and spring semesters in a class with Ehmcke on lettering and typography and their various applications. One example of the work of Ehmcke's class is the annual report of the school for the year 1921–22.[30] Set in Ehmcke Schwabacher, the black-letter typography is beautifully done; it includes two small initials that are probably by Ehmcke himself.

At the time of Ehmcke's arrival the Gewerbeschule in Zürich was organized into five departments covering a variety of professional fields in the crafts. One of these, the Kunstgewerbliche Abteilung (Department of Arts and Crafts), included, next to drawing and embroidery, the newly-established class of applied graphic design, as well as classes in lithography, bookbinding, typesetting, and letterpress printing. Since a major responsibility of the school was to educate apprentices at various levels of training, these workshops were well stocked with equipment and run by professionals from their respective fields.

This was an ideal situation for Ehmcke and may very well have led him to decide to devote a portion of his teaching to the establishment of a private school press, following the model of the Rupprecht Presse. The resulting Zürcher Drucke—a joint venture that combined classes of apprentices in bookbinding, typesetting, and letterpress printing as well as graphic design students, all under Ehmcke's artistic direction—became the first modern private press in Switzerland. Already by the middle of the 1921 fall semester the first book came off the press, *Meister Johans Hadloubs Minnelieder* (Master Johans Hadloubs love poetry), the work of a thirteenth-century Swiss lyric poet. It was set in Ehmcke Schwabacher; the typesetting was done by apprentices in the typesetting class under the direction of their faculty; the woodcut on the title page is by P. Gauchat; the book was printed in an edition of 150 copies. It was considered such a success for the newly-established graphic design department that Altherr sent a dedicated copy to Larisch and also proudly mentioned it in his article in the Festschrift for Anna Simons.[31]

MEISTER JOHANS HADLOUBS MINNELIEDER

ZÜRICH, 1921

Nach der Ausgabe von Karl Bartsch in den Schweizer Minnesängern 1886 neu herausgegeben von der Gewerbeschule der Stadt Zürich im Oktober 1921. Gedruckt als erstes Buch der Schule unter der künstlerischen Leitung von F. H. Ehmcke. Den Satz in Ehmcke-Schwabacher führten die Tagesschüler der Klasse für Schriftsatz unter J. Kohlmanns Aufsicht aus. Der Titelholzschnitt stammt von P. Gauchat. Der Druck erfolgte unter A. Schneider. Die Buntpapiere der Einbände wurden von R. Altermatt, E. Kretz und J. Morf in der von B. Sulser geleiteten Buchbinderei hergestellt. Die Auflage beträgt 150 Stück. Dieses Stück trägt die Nummer

36

Facing page:
Title page and colophon of a new edition of David Hess's folktale *Elly und Oswald, oder die Auswanderung von Stürvis* in Schweizer Alpenrosen (1820; Zürich: Kunstgewerbeschule der Stadt Zürich, 1922). Set in Ehmcke Fraktur, with typesetting by a class of students in typesetting under the direction of J. Kohlmann and art direction by F. H. Ehmcke. Title and illustrations by Otto Lüssi. Publisher's mark by Ernst Keller. This was the second book published by the school. Courtesy Deutsches Buch- und Schriftmuseum der Deutschen Nationalbibliothek, Leipzig, Grafische Sammlung.

The Zürcher Drucke's second publication, *Elly und Oswald, oder die Auswanderung von Stürvis* (Elly and Oswald, or the emigration from Stürvis), came out in fall 1922, again under Ehmcke's artistic direction. The text was set in Ehmcke Fraktur, and the calligraphic printer's mark was by Ernst Keller.

The Zürcher Drucke and other private presses in Germany and England were so particularly important at this time not only because they produced beautiful books but because these same books helped to raise the overall standard of the printing industry in Europe and the United States. One must remember that among the consequences of the Industrial Revolution was an explosion of cheaply produced reading matter. As the highly respected Swiss art and design historian Willy Rotzler wrote in his article "Book Printing in Switzerland":

> Aesthetic taste did not keep pace with technical advances in the printing industry and the mass production of printed matter. On the contrary, the more production was sped up, the lower the standard of type, setting, make-up, paper, presswork and binding.[32]

In the official catalog of the 1927 Buchkunst Ausstellung Leipzig (Leipzig Book Arts Exhibition) Rudolf Bernoulli honored the important contributions to the field of book design in Switzerland by the Kunstgewerbeschule Zürich (Zürich School of Arts and Crafts):

> Honor is due to the Kunstgewerbeschule Zürich, which through its clear-sighted and determined hard work—by bringing in capable teachers from Switzerland as well as, in the first years, other countries—created the first home for all aspects of the cultivation of the book arts in Switzerland.[33]

In 1938, after escalating disagreements with colleagues at the Munich school forced his retirement, Ehmcke established a private program in graphic design near his home in the Bavarian countryside. The outbreak of World War II in September of 1939 brought the program to a premature end. But by this time—he was now sixty-one years of age—he could look back on many notable contributions to the new field of graphic design, ranging from typefaces and book designs to posters, trademarks, stamps, inscriptions, architectural projects, and furniture design. Moreover, under his direction the Rupprecht Presse had produced fifty-seven beautiful books. In all of his work Ehmcke upheld the Werkbund principles of quality and appropriateness in material, production, and design.

Ehmcke's work has been honored in numerous exhibitions, among them one at the Kunstgewerbe Museum in Zürich in 1920, and a major exhibit in 1958 at the Klingspor Museum in Offenbach in honor of his eightieth birthday.

Elly und Oswald

oder
die Auswanderung von Stürvis
Eine Bündtnerische Volkssage

von David Heß

Nach der Erstveröffentlichung in den Schweizer Alpenrosen 1820 neu herausgegeben von der Gewerbeschule der Stadt Zürich im Oktober 1922. Gedruckt als zweites Buch der Schule unter der künstlerischen Leitung von F. H. Ehmcke. Die Überwachung des Textes besorgte Ernst Eschmann in Zürich. Der Titel und die Illustrationen wurden entworfen von Otto Lüssi, Lehrer an der graphischen Fachklasse, und teilweise von ihm selber in Holz geschnitten. Das Druckerzeichen wurde von Fachlehrer Ernst Keller entworfen. Den Satz in Ehmcke-Fraktur führten die Tagesschüler der Klasse für Schriftsatz unter Leitung von J. Kohlmann aus. Der Druck erfolgte unter J. Schneider. Die Einbände wurden von Schülern in der von G. Sulser geleiteten Buchbinderei hergestellt. Die Auflage beträgt 150 Stück.

GS

Dieses Stück trägt die Nummer
133

F. H. Ehmcke at ca. seventy years of age. Photographer unknown. Photo courtesy Sammlung Klingspor Museum, Offenbach a. M.

In addition to his design work and teaching, Ehmcke found time to write articles for magazines and daily newspapers. His many articles, which were published in two volumes titled *Persönliches und Sachliches* (Things personal and factual, 1928) and *Geordnetes und Gültiges* (Things in order and valid, 1955), gave me much valuable information not only about Ehmcke himself and his views on the new fields of graphic design and design education but also about his great respect for William Morris, his defense of classical typography against Jan Tschichold's new typography, and his attempts to understand the fine arts as they evolved during his lifetime.

Beside the books I have included in this chapter, Ehmcke also published among others: *Schrift, Ihre Gestaltung und Entwicklung in Neuerer Zeit* (Typefaces, their design and development in recent times, 1925)[34] and *Deutsches Schreibbüchlein* (German Writing Manual for the teaching of blackletter manuscript hands, 1934).[35]

After the end of World War II in 1945, from 1946 to 1948 Ehmcke briefly resumed teaching at what was now called Hochschule der Bildenden Künste in Munich. Ehmcke died in 1965 at the age of eighty-seven at his house in Widdersberg.

Profoundly influenced by Larisch's theories and ideas on the readability, arrangement, and design of letters, theories that Larisch widely published in his slightly obscure writing style, it was another of Ehmcke's many contributions that, by applying these theories and ideas in his own work, he gave life to them, made them understandable "even to the most dull-sighted person."[36] Ehmcke's work proved the important role the ornamental aspect of letters and text can play in the repertoire of graphic designers. Ehmcke can be considered one of the first typographers in the modern sense.

Notes

Chapter epigraph: Emil Preetorius, "F. H. Ehmcke," *Das Zelt: Zeitschrift des Ehmcke-Kreises* 3, no. 10 (Munich: Verlag Ehmcke Klasse, Staatliche Kunstgewerbeschule Munich, 1928), 6. Unless otherwise noted, all translations in this chapter are by the author

1. F. H. Ehmcke, "Deutsche Gebrauchsgraphik," in *Klimsch's Jahrbuch* (Frankfurt a. M.: Verlag Klimsch und Co., 1927), 9.
2. J. Aynsley, *Graphic Design in Germany 1890–1945* (London: Thames and Hudson, 2000), 70.
3. F. H. Ehmcke, "Die Steglitzer Werkstatt: Eine Erinnerung," in *Persönliches und Sachliches* (Berlin: Verlag Hermann Reckendorf GmbH, 1928), 58–61.
4. The Deutscher Werkbund was founded in 1907 by a group of respected artists, architects, skilled craft speople, industrialists, merchants, and writers for the purpose of improving the quality, on all levels, of mass-produced goods, so that German products would be more competitive in the global marketplace.
5. Christian Heinrich Kleukens, "Die Steglitzer Werkstatt," *Gutenberg Jahrbuch 1952*, ed. A. Ruppel (Mainz: Gutenberg Gesellschaft, 1952), 160–64.
6. Georg Kurt Schauer, *Deutsche Buchkunst 1890–1960*, 2 vols. (Hamburg: Maximilian Gesellschaft, 1963), 1:57.
7. Schauer, *Deutsche Buchkunst 1890–1960*, 1:57.
8. F. H. Ehmcke, *Geordnetes und Gültiges: Gesammelte Aufsätze und Arbeiten aus den letzten fünfundzwanzig Jahren* (Munich: C. H. Beck'sche Verlagsbuchhandlung, 1955), 138.
9. Schauer, *Deutsche Buchkunst 1890–1960*, 1:31.
10. Ibid., 1:63.
11. F. H. Ehmcke, *Ziele des Schriftunterrichts: Ein Beitrag zur modernen Schriftbewegung* (Jena, Germany: Eugen Diederichs Verlag, 1911).
12. F. H. Ehmcke, "Angewandte Schrift," in *Mitteilung der Pelikan Werke 25* (Hannover and Vienna: Verlag von Günter Wagner, 1926), 24.
13. Quoted in H. Cossmann, E. Malzburg, and J. Urbach, eds., *F. H. Ehmcke und seine Neusser Schüler* (Neuss, Germany: Clemens-Sels-Museum, 1984), 52.
14. Arnulf Backe and Hedda Backe, "Die Rupprecht Presse: Ein Porträt," *Berliner Bibliophilen Abend* 3 (2005): 52–55.
15. Schauer, *Deutsche Buchkunst 1890–1960,* 1:71.
16. Cosmann, Malzburg, and Urbach, *F. H. Ehmcke und seine Neusser Schüler,* 53.
17. F. H. Ehmcke, "Wirken und Leben mit Richard Riemerschmid," *Geordnetes und Gültiges*, 145.
18. Ehmcke, "Wirken und Leben mit Richard Riemerschmid," 148.
19. F. H. Ehmcke, "Pronunciamento 1920," in *Persönliches und Sachliches,* Gesammelte Aufsätze und Arbeiten aus fünfundzwanzig Jahren (Berlin: Verlag Hermann Reckendorf GmbH, 1928), 5. Also quoted in Backe and Backe, *Die Rupprecht Presse*, 41.
20. Quoted in Backe and Backe, *Die Rupprecht Presse*, 55–56.
21. Backe and Backe, *Die Rupprecht Presse,* 40.
22. Georg Kurt Schauer, "The Art of the Book in Germany 1890–1960," in *Book Typography 1815–1965 in Europe and the United States of America,* ed. Kenneth Day (Chicago: University of Chicago Press, 1966), 119.
23. Schauer, *Deutsche Buchkunst 1890–1960*, 1:75.
24. Schauer, *Deutsche Buchkunst 1890–1960*, 1:78.
25. Schauer, *Deutsche Buchkunst 1890–1960*, 1:71–73.

26. F. H. Ehmcke, "Rückblick und Ausblick: Skizze eines Lebenslaufes," in *Persönliches und Sachliches: Gesammelte Aufsätze und Arbeiten aus fünfundzwanzig Jahren* (Berlin: Verlag Hermann Reckendorf GmbH, 1928), 108.
27. F. H. Ehmcke, "Schriftschulung als Erziehung zur Form," in *Kunstschrift und Schriftkunst*, ed. Hugo Busch and H. Cossmann (Mönchengladbach: B. Kühlen Kunst- und Verlagsanstalt, 1927), xiii.
28. F. H. Ehmcke, "Pressa Köln," *Das Zelt: Zeitschrift des Ehmcke Kreises* 4, no. 5 (1928).
29. Jeremy Aynsley, *Graphic Design in Germany, 1890–1945.* (Berkeley and Los Angeles: University of California Press, 2000), 118.
30. Gewerbeschule und Kunstgewerbemuseum der Stadt Zürich: *Bericht über das Jahr 1921/22* (Zürich: Werkstätten für Schriftsatz und Buchdruck, Graphische Abteilung), 19.
31. *Anna Simons*, Schriften der Corona 8 (München-Berlin-Zürich: R. Oldenbourg Verlag, 1938), 56. Hereafter Festschrift.
32. Willy Rotzler, "Book Printing in Switzerland," in *Book Typography 1815–1965 in Europe and the United States of America*, 306–307.
33. Rudolf Bernoulli, "Schweiz," in *Internationale Buchkunst Ausstellung Leipzig 1927* (Leipzig: Insel Verlag, 1927), 260–61.
34. F. H. Ehmcke, *Schrift, Ihre Gestaltung und Entwicklung in Neuerer Zeit* (Hannover: Günter Wagner Verlag, 1925).
35. F. H. Ehmcke, *Deutsches Schreibbüchlein* (Iserlohn: Brause und Co. Verlag, 1934).
36. F. H. Ehmcke, *Rudolf von Larisch, zum 1. April 1926* (Leipzig: Werkstätten der Staatlichen Akademie für Graphische Künste und Buchgewerbe, 1926), n.p.

Then the essential question poses itself: What influence do single individuals have in the web of artistic events, complex and exposed to constant change? How far, on the contrary, is not everything planned toward change, piece by piece, and long ago, and must necessarily flow where it flows to? Thus single individuals, be they ever so great, would only be something like important little wheels in the machine, or especially brilliant stones in the iridescent mosaic of the whole.

—Willy Rotzler, 1976

Waves of Influence: Zürich Connections

The existence of links between the Kunstgewerbeschule (School of Arts and Crafts) in Zürich and Anna Simons, Rudolf von Larisch, and F. H. Ehmcke only became clear to me over time. My first and most important discovery was an essay in the 1938 Festschrift for Anna Simons by Alfred Altherr, director of the Zürich school from 1912 to 1938:

> A true graphic design department as a separate entity was established with the appointment of F. H. Ehmcke, who had come from Munich. I owe it to Ehmcke that I became acquainted with Miss Anna Simons and Professor Larisch, going back to the year 1920–21. Zürich was then a meeting place of many intellectuals from other countries; among them, for her artistic contributions, I count Miss Anna Simons.[1]

In the list of faculty at the school for the years 1920 and 1921 there is only a reference to Ehmcke, not to Simons or Larisch, since no records were kept for part-time faculty. But there was a listing in the school's annual report for the academic year 1921–22 about a lecture Larisch gave during that winter semester with the title "Ornamentale Schrift als Kunsterziehung" (Ornamental writing and lettering as art education). How important that lecture was in connection with the contributions of Simons and Ehmcke became clear to me through a passage in a 1936 article by Simons titled "Begegnungen mit Rudolf von Larisch" (Encounters with Rudolf von Larisch):

> An unforgettable experience for me was a lecture that Larisch gave in 1921 at the School of Arts and Crafts in Zürich, a school to which Professor Ehmcke had been given a leave from Munich and where I then, through his intercession, taught a course in formal writing. In a stirring, sparkling lecture, aided by drawings on the blackboard, Larisch explained to the students and an invited circle of guests the goals and methods of his teaching. The students, by no means easy to inspire, were carried away and explained later that they could have listened for hours. The clear and broadly understandable presentation was formally so accomplished that even the more intellectual, though, on the subject matter less competent, were thoroughly delighted.[2]

But I discovered other, more subtle links as well. In his introduction to a 1997 book by André Gürtler, *Schrift und Kalligraphie im Experiment* (Experiments with letterforms and calligraphy)[3], Adrian Frutiger mentions some important ideas he learned from Alfred Willimann: that the pen can express the spirit of the centuries, that its stroke on a sheet of paper brings the light to shine, and that interior space and distance—precisely complementing each other—can wonderfully arrange a line: clear links to Simons and Larisch! The idea that "the pen can evoke the spirit of the centuries" goes back to Simons, and in turn to Johnston. The principle about white space within and between letters leads back to Larisch, who coined the term "light" for the contrast of a black pen stroke to the white paper, and "rhythm" for optically even letter spacing.

Alfred Altherr (1875–1945). Architect, furniture designer, and director of the Kunstgewerbeschule and the Kunstgewerbemuseum, Zürich. Photo courtesy Zürcher Hochschule der Künste ZHdK, Archiv.

Walter Käch (1901–1970), working on rubbings of Roman inscriptions in the courtyard of the Museo Civico in Padua, Italy. Photo courtesy Zürcher Hochschule der Künste ZHdK, Archiv.

Ernst Keller (1891–1968). Photo courtesy Zürcher Hochschule der Künste ZHdK, Archiv.

It was this introduction to Gürtler's book that led me to contact Frutiger, and later to visit him. Frutiger told me how much he owed his teachers Alfred Willimann and Walter Käch, and that without them he could never have accomplished all that he did in type design. He also gave me several pages of an unfinished manuscript.[4] He had planned to honor the contributions of Käch and Willimann with a book on what he had learned from them. The book was never completed, but the manuscript gave me important information for this present effort. Frutiger did not know much about Larisch and had assumed that many of the ideas he had learned from Willimann were Willimann's.

Altherr in the Festschrift for Anna Simons also wrote:

> As head of a course on formal writing, she [Simons] had in her class a substantial number of talented graphic designers who would later play an important role as creators of the Schweizer Schriftplakat (Swiss lettering poster). The influences of her course on the teaching of graphic design were of lasting importance, in spite of the fact that the application of formal writing in Switzerland was not as common as in Germany. Her presence as a talented teacher, lettering artist, and personality of strong character will not be forgotten.[5]

The designers of the Swiss lettering posters include, most prominently for this discussion, Walter Käch, Ernst Keller, Otto Morach, and Heinrich Kümpel.

After a lithography apprenticeship, Käch began his graphic design education at the School of Arts and Crafts in Zürich. Rather than completing his studies there, however, in 1921 he followed Ehmcke to Munich to work for a year as his assistant. There he would have become increasingly familiar with the ideas and skills of Larisch as well as with those of Simons, who taught her intensive course on formal writing once a year in Ehmcke's department.

Keller began an apprenticeship in 1906 as a draftsman and lithographer in Aarau, Switzerland. From 1911 to 1914 he worked in the Werkstatt für deutsche Wortkunst (Workshop for German word art) in Leipzig.[6] Leipzig was then a center for book arts, lettering, and typography, and there Keller would have come into contact with the ideas and work of Walter Tiemann, Emil Rudolf Weiss, Larisch, and Simons, among many others. In 1918 he was hired to teach at Altherr's school in Zürich, and, after Ehmcke's return to Munich in 1921, he succeeded Ehmcke as the head of the graphic design department.[7] He may well have heard Larisch's talk in the winter of 1920-21 and taken advantage of the opportunities to study with Ehmcke and Simons.

The Swiss Lettering Poster

The Swiss lettering poster to which Käch and Keller made noteworthy contributions is considered a uniquely Swiss style. The most significant characteristic of these posters is that the text message *is* the image. Hierarchies of importance in the usually brief but concentrated text are expressed through variations in size and weight of individual words and text segments. Thus a poster might show prominently only one letter, a single word, or a small group of words, with the rest of the text given smaller size, thinner line weight, or lighter color. Many of these posters average twenty-eight by thirty-nine inches, so individual words or text areas are a powerful presence and draw attention to the beauty of the shapes of letters and the rich ornamental quality of a field of text. Since these posters were printed as lithographs or cut in linoleum, they would have been drawn in the original size on the stone or linoleum block, retaining the immediacy of the drawing. The beauty and liveliness of the letterforms derives from the fact that most letters were handwritten with a variety of tools—from a broad-nibbed pen to a blunt stylus, flat piece of charcoal, or pointed or flat-edged brush—and then outlined and painted on a lithographic stone or carved in linoleum. Rather than being limited to a range of existing typefaces, designers thus had a wide choice of lettering styles, from blackletter, Roman, and informal handwriting to free variations of traditional letterforms. Some of the posters included a simplified, sign-like image. The composition of most of these posters consisted of a traditional centered arrangement, not unlike a title page in a book. The general impression is not refined or slick—it is even somewhat coarse—but powerful and alive.

What are the connections between the lettering posters and the influence of Simons, Ehmcke, and Larisch? Most examples of this poster style were made between the years 1922 and 1933 and represent a clear break from earlier styles. Comparing a poster by the young Alfred Willimann from 1914 with one by Walter Käch from 1925 makes this apparent. In the earlier poster by Willimann (top right), the verbal message is presented in a stiff, decorative way without any attempt to visually evoke the theme of the exhibit. The poster by Walter Käch (right), on the other hand, announcing an exhibition of writing and lettering, clearly emphasizes and evokes the theme of the exhibit by the beautiful, handwritten blackletter style of the title "Die Schrift." The very fact that such a major exhibit on writing and lettering took place, only four years after Simons, Ehmcke, and Larisch taught at the school in Zürich, is another proof of their influence.

Alfred Willimann, "Populäre Statistische Darstellungen." Kunstgewerbemuseum Zürich, 1914, lithograph. Photo courtesy Museum für Gestaltung Zürich, Plakatsammlung.

Walter Käch, "Die Schrift" Kunstgewerbemuseum Zürich, 1925. Two-color lithograph. Photo courtesy Museum für Gestaltung Zürich, Plakatsammlung.

158 | WAVES OF INFLUENCE: ZÜRICH CONNECTIONS

This totally new approach of using text as image was not limited to posters but included other applications as well. Examples are a wall treatment by Ernst Keller, and a book design by Walter Käch. What such designs have in common is that all letters are based on gestural hand writing, a prominent concern of Simons and Larisch. The tight line spacing, sometimes combined with increased word spacing, and the resulting decorative textures of fields of text suggest the kinds of experiments Larisch used in his teaching. The wall treatment by Keller (below), a poster by Heinrich Kümpel (opposite page), as well as the book design by Käch (following spread) are beautiful examples of this.

Ornamental wall treatment (bible text in silver on dark blue ground) by Ernst Keller in the room for Art in Protestant Churches at the National Exhibit of Switzerland in Zürich, 1939. The two small figures on the bottom right beautifully scale the design. From *Ernst Keller, Graphiker 1891–1968, Gesamtwerk* (Zürich: Orell Füssli AG, 1976), 129. Photo courtesy Zürcher Hochschule der Künste ZHdK, Archiv. Keller's design was clearly inspired by the work of a student of Larisch. (below)

Student work in Rudolf von Larisch, *Unterricht in ornamentaler Schrift*, 11th ed. (Vienna: Österreichische Staatsdruckerei, 1934), 83. Author's collection.

WAVES OF INFLUENCE: ZÜRICH CONNECTIONS | 159

Heinrich Kümpel, poster for the exhibit "Friedhof und Grabmal," Kunstgewerbemuseum Zürich, 1933. Two-color lithograph. Photo courtesy Museum für Gestaltung Zürich, Plakatsammlung. The simple diagonal cut into the black ground changes the background into a tombstone, reflecting the title of the exhibit.

160 | WAVES OF INFLUENCE: ZÜRICH CONNECTIONS

Gothic minuscules and Roman capitals from a block book of "Meister Eckehart," *Sermon on St. John XII* (pub. date 1926). Design and woodcut by Walter Käch. Clockwise from right: frontispiece, title page, colophon, two-page spread. Photo courtesy Museum für Gestaltung Zürich, Grafiksammlung.

WAVES OF INFLUENCE: ZÜRICH CONNECTIONS | 161

Diz ist meister Eckehart
dem got nie nuzt verbarc

DIESES VON 33 HOLZ-
TAFELN GEDRUCKTE
BUCH, ENTWORFEN &
GESCHNITTEN VON
WALTER KÄCH, ERSCHIEN
IN ZÜRICH IM DEZEM-
BER 1926 ALS PRIVAT-
DRUCK. DIE EINMALIGE
AUFLAGE ZÄHLT 50
STÜCK. DIESES BUCH
HAT DIE NUMMER 2

Walter Käch.

162 | WAVES OF INFLUENCE: ZÜRICH CONNECTIONS

Some posters, especially those by Keller (this spread), and a poster by Willimann from 1932 (following spread), show that abstract forms, the character of letters, as well as the treatment of blocks of text can evoke an essential quality of the message to be conveyed. Willimann's poster "Licht in Heim, Büro, Werkstatt," is a beautiful homage to Larisch's idea that the white paper surrounded by black becomes light. A poster by Armin Hofmann from 1955 (following spread) was done much later but still belongs to this group.

Ernst Keller, sketch for store advertising poster "Jelmoli gut und billig," pencil and tempera, 1924. Photo courtesy Museum für Gestaltung Zürich, Grafiksammlung.

Ernst Keller, poster for the exhibit "Finnische Knüpfteppiche," in the Kunstgewerbemuseum Zürich, 1926; one-color linoleum cut. The tight arrangement and overlapping letters evoke textiles. Photo courtesy Museum für Gestaltung Zürich, Plakatsammlung.

164 | WAVES OF INFLUENCE: ZÜRICH CONNECTIONS

Alfred Willimann, poster for the exhibit "Licht in Heim, Büro, Werkstatt" in the Kunstgewerbemuseum, Zürich, 1932; one-color lithograph. Photo courtesy Museum für Gestaltung Zürich, Plakatsammlung.

WAVES OF INFLUENCE: ZÜRICH CONNECTIONS | 165

Armin Hofmann, poster for the exhibit "Tempel und Teehaus in Japan," in the Gewerbemuseum, Basel, 1955. One-color linoleum cut. Photo courtesy collection of Armin and Dorothea Hofmann.

Formal Writing and Type Design at the Kunstgewerbeschule in Zürich

Altherr's implication that broad-nibbed pen writing influenced only poster design in Switzerland, whereas in Germany it found a wider use, is questionable.[8] Simons's intensive course in broad-nibbed pen writing, as well as the teaching of Ehmcke and Larisch, clearly had a lasting influence on the emerging fields of modern typography and type design at the school in Zürich. The two most important teachers who continued the study of broad-nibbed pen writing were Willimann and Käch. Willimann had developed and refined his skills through added studies with Simons as well as his own intensive practice and research. Käch, next to his studies with Simons and Ehmcke, had focused additionally on the drawing of letters through his study of the proportions of Roman stone inscriptions. Both Willimann and Käch passed these skills on to their students, among them Hans Eduard Meier and Adrian Frutiger, who in turn became not only highly skilled scribes but among the most influential type designers of the second half of the twentieth century. Thus in the fourth generation after Johnston and Larisch the revival of writing and lettering in Switzerland came to full fruition.

Alfred Willimann, 1900–1957

Willimann's connection to Simons was the most difficult for me to trace. But in a small archive of documents related to Willimann at the Hochschule für Gestaltung und Kunst (now the Zürcher Hochschule der Künste, Zürich University of the Arts) I found typewritten, stapled pages by a former student, Max B. Kämpf, in which Kämpf speaks of Willimann and his course on formal writing between 1946 and 1951: "Where he (Willimann) received his knowledge and experience in formal writing remained unknown to us. Occasionally he talked about a course by the German lettering artist Anna Simons in which he had participated. When one studies early examples of the calligraphy of Willimann, parallels to the work of Simons become apparent."[9] This little note is the only written document I found that links Willimann to Simons.

However, another clue came from a telephone interview I had with Frutiger in 2004, in which he mentioned that Erich Alb, a contemporary of Willimann, once told him that Willimann owed much of his knowledge and skill to Simons. It was Frutiger who first told me of Willimann's stay in Munich, and I also found the fact mentioned in a 1957 obituary for Willimann by Hans Fischli, then director at the Zürich school. Fischli though does not mention the reason for Willimann's stay.[10] However, Frutiger told me that "Willimann had been so much impressed by Simons—and he was impressed by very few people—that he visited her in Munich."[11]

Alfred Willimann writing in a student's exercise book, ca. 1946. Photo courtesy Zürcher Hochschule der Künste ZHdK, Archiv.

All of this supports the assumption that Willimann may well have studied with Simons during her stay in Zürich and additionally took her intensive course at the School of Arts and Crafts in Munich, where Simons taught once or twice a year in Ehmcke's department. Thus Willimann and Käch clearly belonged to a tradition that can be traced back to Johnston and Larisch.

Both Willimann and Käch taught art students in their foundation year as well as apprentices. The foundation year was mandatory for graphic design students, and it was also available at the end of their apprenticeship to students enrolled in one of the many vocational training programs for which Switzerland was then and still is known. These training programs required a four-year apprenticeship at a chosen firm, combined with a one-day-a week enrollment in a variety of courses in, among others, printing, typesetting, and lithography.[12]

It was through their apprenticeship as compositors that Frutiger and Hans Eduard Meier, later designers of the important typefaces Univers, Frutiger, and Syntax, became students of Käch and Willimann. It was fortunate that the director of the school in Zürich at the time, Johannes Itten, in 1949 extended the apprenticeship program to include a one-year master class in writing and lettering. The teachers for this new class were Willimann and Käch. Students graduated with a degree of Schrift Gestalter (letterform designer). This master class allowed both Frutiger and Meier to continue their studies with Käch and Willimann.

Of the teachers at the Zürich school who focused in particular on writing and lettering, Willimann was considered the most skillful calligrapher. Born in 1900, he studied for one year at the Zürich School of Arts and Crafts and did a brief apprenticeship as a graphic designer. He also studied for two years in Berlin, taking courses in sculpture and drawing. In 1924 he returned to graphic design, working first for the printing firm Orell Füsli and then, in 1929, accepting Altherr's offer to teach a drawing course for lithography apprentices. From 1931 to 1957, the year he died, he taught formal writing for design students and apprentices. After 1934 he also offered a course in drawing and formal writing in the photography department, which was headed by Hans Finsler. This drew Willimann to photography, where he began to experiment with photomontage. In 1938 he added a new and influential course to the curriculum of the photography department, which linked photography to graphic design, typography, and printing. Willimann was the intended successor of Finsler. Willimann's own work encompassed a wide range of disciplines, from sculpture to poster design, book design, exhibitions, and logotypes. Willimann's teaching, based on Frutiger's recollections in an unpublished manuscript, shows links to Johnston, Simons, and Larisch.[13]

Alfred Willimann writing on the blackboard, ca. 1940. Photo courtesy Zürcher Hochschule der Künste ZHdK, Archiv.

𝐄𝐭 𝐡𝐚𝐞𝐜 𝐬𝐜𝐫𝐢𝐛𝐢𝐦𝐮𝐬
𝐯𝐨𝐛𝐢𝐬 𝐮𝐭 𝐠𝐚𝐮𝐝𝐞𝐚𝐭𝐢𝐬,

Edward Johnston, foundational hand, 1918, from *Edward Johnston: Formal Penmanship and Other Papers*, ed. Heather Child (London: Lund Humphries, 1971), 157.

Like Johnston and Simons, Willimann started his courses by writing on the blackboard with a flat piece of chalk. His reference to the importance of equal spaces within and between letters, the concept of rhythm, clearly stemmed from Larisch.[14] Frutiger recalled:

> [Willimann] stood in front of the class and wrote on the blackboard, without comment, a few lines of text, the longer edge of a piece of chalk imitating the broad-nibbed pen. He would do this with intense concentration. After that, he added information about the style and time of the script. These were brief and to the point: "Roman, half-cursive, majuscule, 250 A.D." He expanded on the specific pen angle, the resulting strokes . . . and described the importance of equal spaces within and between letters—that is, the rhythm of the script.[15]

Like Johnston, Willimann was observant and intensely analytical. When he became interested in a new subject he studied it, taking it apart until he came to its essence. His teaching continued a tradition, but he also reevaluated and changed it. He was clearly knowledgeable about the contributions of Johnston, Simons, and Larisch and used the best from each for his teaching. Larisch's principle of *Eintakt* (measure of one)—equal spaces within and between letters—clearly distinguishes his thinking from that of Johnston and Simons, who placed prominence on the quality of the black strokes while disregarding the important role of white spaces in the creation of good word pictures. This passage from Frutiger traces another connection to Larisch:

> Before us lies a white sheet of paper, untouched—inactive. Carefully, Willimann set the pen down and wrote the first vertical—a black stroke, of course—but with it a segment of white paper is covered up. The sheet is not white anymore. In contrast to the black (a shadow), the white becomes light.[16] Then he set the pen down again and wrote a second stroke—of the same height at a carefully proportioned distance. And now appears, enclosed between the two strokes, the exactly delineated white. The space glows. A line of text, words, is a succession of interior and in-between spaces. In this radiance lies the beauty of the script.[17]

Frutiger continued: "Then he wrote two or three words [consisting of a variety of strokes]—round ones, diagonals, verticals, and horizontals. Willimann seemed to play a game; it was like music."[18] Rather than letters or words, this was writing abstract form elements, basic rhythmic gestures. Willimann's teaching process recalls that of Simons's, but additionally includes new ideas and observations:

> Then he would sit down for ten minutes with each student to explain the precise mechanism of the pen: the flow of the ink, which through variation in pressure changes the stroke in its form as well as its color. Then the essential setting down and lifting up of the pen, at the correct distance. As to the height, the control of the top line (guidelines were not allowed) resulted in the overall flow of the script.[19]

Frutiger's account adds a few further descriptions. One of them in particular focuses on Willimann's intense care for quality and on his attention to individual students:

> Willimann taught us to formulate letters first in the imagination, to foresee them, and only then to put them down on paper. He taught us [in the process of practicing formal writing] to direct the eye to the surrounding area rather than focus solely on the emerging letter. All this demanded and developed the concentration without which good formal writing remains unattainable. Central for Willimann were *Mass* [measure] and *Ordnung* [order]. This he explained to me from the very beginning: measure and order not only in writing and lettering but in any form of creative activity. Willimann taught us, through his own example, to imbue every activity, creative or craft related, with a great amount of care. He demanded complete engagement of all energies and an alert concentration, if only for the writing of one line [of letters] in a given space.[20]

Johnston's goal was to bring back writing styles of previous centuries and make them available to current readers as well as to practitioners of formal writing. But, most important, his rediscovery of the tool used by ancient scribes brought the Roman letter back to its roots of broad-nibbed pen writing. Willimann used the practice of formal writing to give students a sense of the history of the Roman alphabet. His goal was to entice them to see such forms in a much more analytical way. Like Larisch, he tried to develop in students a perception for rhythm and abstract form, and for the interplay of positive and negative areas. With that he brought formal writing into the modern era.

Frutiger wrote:

> The purpose and reason for formal writing was not the endless practicing of one style, but rather to work through a few important stages in the history of writing. This was, for Willimann, a very good way to entice and educate students into specific formal perception. Writing was to open students' eyes, mind, and sensitivity to the architecture and structure of these figures, to their specific measure, and with that to further, in general, an education in measure and shape.[21]

The exercise books of Willimann's students show similarities with those of Simons's in some of the manuscript hands studied, the writing on vellum, the careful and consistent page layout, experiments with different letter sizes, weights, and line spacing, and the care of the writing. Rather than having to bind loose pages, as Simons's students did, Willimann's students were able to purchase ready-made exercise books, and the ample choice of steel pens—no more cutting of reed pens—allowed for smaller writing. The exercise books are beautiful and informative. The sometimes heavy-handed writing of a beginning student clearly lacking in control contrasts with Willimann's eloquent annotations explaining the problem and demonstrating the solution.

In Willimann's annotations (opposite page), the drawings of the arched versus flat foot, as well as the slightly concave versus round stroke ending (left of the feet), clearly illustrate the difference between elegant versus heavy-handed stroke endings caused by too much pressure or too much ink in the pen. The drawing under the bottom of the C shows the correct ending of a broad-nibbed pen stroke in the writing of a C. The drawing above the E and N explains how both horizontal or diagonal pen strokes should be placed on or against vertical ones. Willimann's pencil markings explain that individual pen strokes within a letter must stand on each other. His wonderful annotation "Licht unsteht [sic]" (the light is erratic) refers to the uneven spaces between letters—and this student's writing is very uneven. What Willimann relies on here is Larisch's principle that a black pen stroke on white paper makes the paper appear as light. In other words, the amount of reflection from the white paper, that is, the area between letters, has to be equal for any good letter spacing.

Heidy Harler, pages from an exercise book in Willimann's class. Photo courtesy Zürcher Hochschule der Künste ZHdK, Archiv.

WAVES OF INFLUENCE: ZÜRICH CONNECTIONS | 171

IIIICCCCLLEEFFGNAMB — Willimann's writing

ABCDEFGHIJKLMNOPI
QRSTUVWXYZ·1234567
ÄÜ 890·12

UNTERSCHRIFT IM ALLGE
INEN VERSTEHEN WIR FIX
IERTE EINE BEDEUTUNG- — Student's writing

UNTER SCHRIFT IM ALLGE — Willimann's writing

Next to his detailed corrections, Willimann provided students with model sheets of a few of the most important manuscript hands in his own exquisite handwriting.

Alfred Willimann, two examples of his writing with the broad-nibbed pen. Photo courtesy Museum für Gestaltung Zürich, Grafiksammlung.

Irish half uncial, eighth century.

ABCDEFGHIKLMNOPQRSTUVWXYZ
QUIETAGALLIACAESAREUTCONSTI
TUERATINITALIAMADCONVENTUS
AGENDOSPROFICISCITURIBICOGNO
SCITDECLODIICAEDEDESENATUSCE
CONSULTOCERTIORFACTUSUTOMNES
IUNIORESITALIAECONIURARENTDI
LECTUMTOTAPROVINCIAHABEREINSTI
TUITEAERESINGALLIAMTRANSALPINAM
CELERITERPERFERUNTURADDUNTIPSI
ETAFFINGUNTRUMORIBUSCIIQUOD
RESPOSCEREVIDEBATURRETINERIURBA

Rustica, third–fourth century.

Rubbing from a stone inscription at the Museo Civico, Bologna, 10–40 CE, from Walter Käch, *Rhythmus und Proportion in der Schrift* (Olten und Freiburg im Breisgau: Otto Walter-Verlag, 1956), 46. Author's collection.

Adrian Frutiger, *Lehren und Lernen*, detail of an unpublished manuscript describing his studies with Willimann and Käch. Author's collection.

Ferdinand Theinhardt, Akzidenz Grotesk bold, 35 pt, 1880.

Walter Käch, 1901–1970

Whereas Willimann's class focused exclusively on formal writing, Käch's master class concentrated on lettering, the drawing and painting of letters, although his other courses also included the practice of formal writing. His master class was offered one half-day a week. It was optional to take a class with either Käch or Willimann. Hans Eduard Meier studied prominently with Willimann, whereas Frutiger worked with both Willimann and Käch. Frutiger recalled:

> Walter Käch was a practicing graphic designer and would teach his course on lettering—the drawing of letters—every Saturday morning. He was a passionate lettering artist. His prominent interest was the study of the Roman inscriptional letters. He would visit every place in Italy where accessible stone inscriptions could be found to produce hundreds of rubbings. In his studio he would then analyze their form, proportion, the stroke widths, the dimensions of the letter.[22]

Käch published the results of his studies in his 1956 book *Rhythmus und Proportion in der Schrift* (Rhythm and proportion in lettering).[23] These studies also filtered into his teaching. In his master class he gave students the assignment to develop a sans-serif typeface based on rubbings of Roman inscriptional letters. Frutiger described this process:

> In the course of studies, the first step was to measure the rubbings of the Roman capital letters. Then followed the assignment to design a sans-serif alphabet. Normally it was the sketch which was closest to the rubbings that provided the basis for the sans-serif alphabet. Sketches were discussed and corrected. Such sketches consisted initially of careful outline drawings on heavy tracing paper. The drawings were later filled in with paint. Corrections were made by scraping with a sharp knife.[24]

Frutiger recalled Käch's comments on an outline drawing of the letter O:

> The vertical orientation of the oval, the interior space, is the main contrast to the wide O. The narrowing of the stroke width, from the widest part at the optical middle of this letter, to the narrower parts at the top and bottom—when seen in a flat plane—must happen gradually. The illustration also shows that with round forms, equivalent, harmonious curves must be drawn. Or, in the case of the condensed O, the round segments above and below must be drawn in such a way that they provide sufficient contrast to the straight middle part.[25]

In the mid-twentieth century Frutiger believed that there was "no model or method" for drawing sans-serif letters. The best such typeface available in Switzerland was Akzidenz Grotesk, which Käch considered closest to classical letterforms. He abhorred constructed letters, such as the early attempts of Paul Renner's typeface Futura. For Käch the drawing of letters did not mean constructing them with a T-square and compass. All curves were to be drawn by hand. As Emil Ruder stated in his essay "Walter Käch in Dankbarkeit"

(Walter Käch in gratitude): "A circle drawn with a compass was for Käch not an O but a technical drawing."[26]

Käch knew that the Roman inscriptional letters were based on brush-written forms (William R. Lethaby mentions this in his introduction to Johnston's *Writing and Illuminating and Lettering*).[27] Käch also knew, as Simons had stressed in her teaching, that these letters represented the root from which all later writing styles developed. Reconnecting sans-serif letters to this root in the variation of stroke weights and general proportions was, as Frutiger stated, Käch's legacy.

Käch's master class in type design was a major influence on the design of sans-serif typefaces in Switzerland. It was in Käch's class that Frutiger developed his idea for the type family Univers (right). As he was recalling his studies, Frutiger remembered witnessing a difference of opinion between Willimann and Käch on the issue of letter spacing. Willimann asserted that "a line of lowercase letters was an alternating play of equal white spaces, the interior spaces being identical to the in-between spaces;" Willimann, and Frutiger after him, believed that this "measure of one" influenced the readability of text.[28] In contrast, Käch's theory of letter spacing, as he explained in a blackboard diagram (see below), was based on the linear proportions of interior and in-between spaces. Here my translation of his explanation:

> The widest diameter is that of the interior space of the letter O.
> The diameters of the interior spaces of N, U, M are smaller.
> The larger part of the diameter of N, U, M is the space between two straight letters.
> The smaller one is the space between a round and a straight letter.

Frutiger clarified that for large dimensions Käch's theory of letter spacing was correct: in-between spaces must be tighter than interior spaces. The word "uno" on the blackboard exemplifies these proportions. For text sizes, however, the interior spaces should be close to the in-between spaces.

Walter Käch, blackboard writing. Photo courtesy Museum für Gestaltung Zürich, Grafiksammlung.

abcdefg hijklmno pqrstuv

Adrian Frutiger, Univers LT Pro bold, 35 pt, 1957.

Walter Käch, blackboard diagram explaining proper letter spacing. Photo courtesy Museum für Gestaltung Zürich, Grafiksammlung.

Walter Käch, *Schriften, Lettering, Écritures* (Olten, Switzerland: Otto Walter-Verlag, 1949), cover. Photo courtesy Museum für Gestaltung Zürich, Grafiksammlung.

Walter Käch, *Rhythmus und Proportion in der Schrift* (Olten und Freiburg im Breisgau: Otto Walter Verlag, 1956), cover. Author's collection.

In his class of formal writing Käch's teaching showed many links to Johnston and Simons. One of his students, Werner Wälchli, recalled:

> In the few early exercises, which consisted of elements of the first script [Roman capital letters], it was important to pay attention to the correct pen angle. The vertical strokes had to show the right contrast to the horizontal ones. The pen was filled with a small stick in such a way that the pen nib remained clean on the underside and thus assured a sharp and precise stroke ending. During Käch's rounds of the class to demonstrate by his own writing or to make corrections, he carefully wrote his highly-accomplished forms, concentrating intensely, his hand subtly vibrating. The students learned by comparison.[29]

Both Willimann and Käch taught lettering and formal writing in Zürich, but Käch remained closer to the concerns and ideas of Johnston, Larisch, and Simons. In his introduction to Käch's book *Schriften, Lettering, Ecritures* (1949) Berchtold von Grünigen wrote: "In his consistent and tenacious work for the school, as well as in his own work, Käch continued and developed what he inherited from his teachers."[30] During the 1940s, according to Jost Hochuli, this adherence to the ideas of Johnston, Simons, and Larisch brought him into opposition with representatives of the constructive approach, "which in Zürich had won a lasting influence not only on painting and sculpture but especially on graphic design. This resulted occasionally in heated confrontations."[31]

In 1966 Käch was vindicated when Emil Ruder, another student of Käch, wrote in his "Walter Käch in Dankbarkeit:"

> Through Käch we learned to understand the dependence of writing and lettering on tradition, as well as the laws and proportions of Greek and Roman inscriptional letters. We also understood script as rhythmic form created by the fluid motion of writing, that is, the interconnection of alternating movements and alternating forms.

Ruder goes on to underscore Käch's contribution:

> He [Käch] has a large share in the new assessment of formal writing and lettering noticeable everywhere. We must give Walter Käch tremendous credit as part of a development which concerns us here especially, that is, the renewed interest in the values of an artistic approach to writing and lettering and its influence on the printing of books. We know also, especially from Käch, that typefaces—next to the demands of punch cutting—are subordinate, to a certain degree, to the laws of the written letter. In the aim of our time, to revive the spontaneity of the directly-written word as well as interest in the rhythmical in all areas, we see the most beautiful vindication and acknowledgment of the cause Käch fought for over several decades.[32]

Some Thoughts on the Roots of Helvetica

In 1957 Neue Haas Grotesk—later renamed Helvetica—was designed by Max Miedinger and cast by the Haas'sche Schriftgiesserei in Münchenstein, Switzerland. According to a biography of him in Malsay and Müller's *Helvetica Forever* (2008), Miedinger, after his 1926–30 apprenticeship as a typesetter, attended evening classes at the school in Zürich until 1936.[33] He was particularly interested in type design and published his first typeface, Pro Arte, in 1954. According to Frutiger, Helvetica, designed three years later, shows Käch's influence.

But there are more obvious connections to Käch. Käch's book *Schriften, Lettering, Ecritures,* which was published in 1949, shows detailed studies of sans-serif typeface design based on the proportions of Roman inscriptional letters. These stone inscriptions, before they were carved, were written with a broad-edged writing tool held at an angle of approximately 20 degrees, which resulted in thinner horizontal and thicker vertical strokes as well as thinner stroke weights on the tops and bottoms of curved strokes. Käch applied this rhythmic change of stroke weights to the design of sans-serif typefaces. When comparing Käch's design of a lowercase sans-serif alphabet (see image on right) with Miedinger's Helvetica, created eight years later, many similarities immediately become apparent: the variation in stroke weights, the horizontal endings of curved strokes, and especially the drawing of the lowercase A. The capital letters of Helvetica also look very similar to the capital letters on the cover of *Schriften, Lettering, Ecritures*. In fact, Peter Bain, in a 2016 article in *Eye Magazine,* spoke of Käch's *Schriften, Lettering, Ecritures* as having "rendered a vista of the future of typeface design." He went on to declare: "More than sixty-five years ago this instructional portfolio made an outstanding contribution to Swiss letterform design in the twentieth century."[34]

Helvetica also shows numerous similarities with Ferdinand Theinhardt's Akzidenz Grotesk (aka Berthold Grotesk), one of the nineteenth-century Berthold fonts that Käch prized highly and Miedinger would have known. However, Helvetica is somewhat more elegant, especially at large sizes, due to the slightly shorter ascenders caused by the larger x height, the slightly more oval O, the more beautiful joining of curves to verticals as in M, U, and D and the distinctly narrower inside spaces in the M than in the U.

Comparing lowercase letters one can also see surprising similarities between Helvetica and half uncial, among them the large x height, resulting in short ascenders, the small side bearings, the consistent horizontal stroke endings of curved strokes as in E and S, and the nearly symmetrical curves in the inside spaces of letters such as M, and U. Frutiger, in fact, mentioned in his manuscript that Käch described the horizontal endings of curved strokes as "uncial-like" and suggested their use to his students, including Frutiger, who adapted such endings in his design of Univers.[35] Käch and Miedinger may well have used the half uncial as an additional model for their designs. Or maybe this similarity between Helvetica and Irish half uncial is simply my own joyful discovery.

Max Miedinger, Helvetica Bold, 32 pt., 1957.

abcdefghi jklmnopqr stuvwxyz

Drawing of a lowercase Grotesk (sans-serif) alphabet, from Käch, *Schriften, Lettering, Ecritures.* Photo courtesy Museum für Gestaltung Zürich, Grafiksammlung.

Walter Käch, detail of cover (opposite page).

Helvetica Bold, capitals, 26.6 pt.

LETTERING

Akzidenz Grotesk Bold, 36 pt.

domum es

Helvetica Bold, 35 pt.

domum es

Irish half uncial.

domum es

Hans Eduard Meier, ca. 2010. Photo courtesy Museum für Gestaltung Zürich, Grafiksammlung.

Hans Eduard Meier, 1922–2014

During the 2004 Leipzig TypoTage I interviewed Meier. When I showed him Frutiger's recollections of Willimann's teaching Meier entirely agreed with them. Trained as a typesetter, Meier had studied with Willimann from 1945 to 1946. He also worked briefly with Käch but considered Käch's approach to formal writing and especially lettering too constructed and precise. During their foundation year Willimann taught the Zürich school students four half days a week, so Meier received sixteen hours a week of training in formal writing, in addition, of course, to extensive practice at home. Thus he, like Frutiger, became a highly skilled scribe. Meier recalled: "For Willimann, the understanding of letters as abstract form was strong. The separate parts of a letter had to join again into a whole." Meier gratefully remembered the generous time Willimann spent with interested students and how he demonstrated specific issues by his own writing.

After his foundation year Meier continued for another two years in the Zürich graphic design program under Keller. He then worked for several years in Paris and Zürich as a practicing designer before Willimann called him back to Zürich to teach the foundation year class in formal writing. After Willimann's death in 1957, Meier became his successor at the Kunstgewerbeschule where he remained until 1986. In 1959 he published his small, very beautiful book *The Development of Writing*, originally an end-of-year project in Willimann's class. In it Meier elegantly rewrote and annotated the important styles in the history of the Roman alphabet. This impressive booklet has been reprinted again and again and is today in print in a new revised edition under the title *ABC Formen der Lateinischen Schriftentwicklung* (ABC forms of Latin script development).

In the course with Willimann, Meier focused on writing humanist script, and thought at some point that it should be possible to turn this script into a sans-serif typeface. By 1955 he had completed his drawings for what was to become Syntax Antiqua. The typeface was cast in 1968 as hot metal type by D. Stempel AG. As the first sans-serif face based entirely on humanist script—Meier's own writing with a broad-nibbed pen—Syntax had tremendous influence on later typeface design.

Hans Eduard Meier, Syntax LT Roman, 32 pt., 1968.

ABCDEFGHIJKLMNOP
abcdefghijklmnopqrst
1234567890

Square capitals fourth century.

Rustic capitals fifth century.

Humanist script minuscule fifteenth century.

Humanist script, majuscule, fifteenth century.

Hans Eduard Meier, *The Development of Writing*, 10th ed. (Cham, Switzerland: Syndor, 1994), cover. (This spelling of Meier's name reflects an error on his birth certificate, which he only finally corrected later in life).[36] Photo courtesy Graphis Press, Zürich.

(Left) *The Development of Writing*, parts of pp. 11 and 35. Close to original size. Photos courtesy of Rudolf Barmettler, Zürich.

Adrian Frutiger, c. 1995. Detail of a photo. Photo courtesy Museum für Gestaltung Zürich, Grafiksammlung.

Adrian Frutiger, 1928–2015

In 1949, after his apprenticeship at a printing firm in Bern, Switzerland, and additional courses at the Kunstgewerbeschule of the same town, Frutiger worked briefly as compositor at the printing firm Gebr. Fretz in Zürich. In 1950 he decided to take additional courses at the Kunstgewerbeschule in Zürich and joined the one-year letterform design class with Willimann and Käch that Meier too had completed. He started with four afternoons a week with Willimann, focusing on broad-nibbed pen writing. Later he added Käch's class on type design, and he mentioned to me how glad he was to have done so. It was for this course that Frutiger began to design what would become his typeface Univers. When Käch suggested the use of horizontal endings for curved strokes Frutiger realized that this would allow him to design an entire family for his typeface, from light to black, condensed to ultracondensed, extended to ultraextended. He was able to realize this idea in 1952 when he became a type designer at the Paris foundry of Deberny and Peignot. He completed Univers in 1957 in the form of an extended family, just as he had envisioned as a student.

Frutiger continued to work on and off in a variety of positions at Deberny and Peignot and in 1960 started his own studio. He consulted for many foundries and institutions, among them Linotype, D. Stempel AG, and Bauersche Giesserei, as well as for typewriter faces at IBM. He also designed a house typeface for the Centre Pompidou in Paris. Indeed, during his career he created about sixty typefaces.[37] He designed typefaces for signage, including Alphabet Roissy for the Paris airport Charles de Gaulle, Alpha BP for BP Chemicals, and a typeface for machine reading, OCRB (optical character recognition), which works equally well for human reading. He taught at the École Estienne and the École Nationale Supérieure des Beaux Arts in Paris. He was deeply knowledgeable about the history of Roman letters and is considered the most prolific and influential type designer of the second half of the twentieth century.

Adrian Frutiger's Univers LT Pro 55 Roman, 33 pt. Original publication by Deberny and Peignot, Paris, 1957.

ABCDEFGHIJKLMNO
abcdefghijklmnopqrst
1234567890

For the completion of his one-year master class in type design and formal writing in Zürich Frutiger, as Meier before him, had been assigned to write a history of Western script. After writing the different manuscript hands on paper he transferred them as mirror images onto beechwood plates and completed the assignment as woodcuts of the nine scripts he had chosen. The project took him more than a year, but the result is impressive.

Adrian Frutiger, cover design and detail of a page from a facsimile of *Schriften des Abendlandes in Holztafeln geschnitten* (Cham, Switzerland: Syndor, 1996). The page excerpt (left) shows Frutiger's version of ninth-century Carolingian minuscule. Photo courtesy Erich Alb.

ABCDEFGHIJKLMNOP
abcdefghijklmnopqrs
1234567890

Frutiger LT Pro 45 Roman, 33 pt., 1976. This typeface was conceived as a print version of the signage font Alphabet Roissy for Paris's Charles de Gaulle airport.

Conclusion

It was a fortunate accident that the four most important representatives of the renewal of writing and lettering in Europe—Edward Johnston and Rudolf von Larisch, as well as their students Anna Simons and F. H. Ehmcke—introduced a small group of students at the School of Arts and Crafts in Zürich to the ideas, concerns, and skills at the heart of this renewal. Prominent among these students were Alfred Willimann and Walter Käch. They, like several other students of their generation, later became influential teachers in their own right.

An essential aspect of the history that this book documents is the importance of teaching. Johnston, Simons, Larisch, Ehmcke, Willimann and Käch, were all dedicated teachers, as were after them, Adrian Frutiger, Hans Eduard Meier, and others. Good teaching passes skills and ideas on to later generations, giving those skills and ideas the chance to develop and be adapted and so achieve new fruition.

Johnston's major contribution was twofold: one, his rediscovery of the writing tools used by early scribes, tools, that for more than two millenia had shaped our Roman letters; and two, his realization that the shape of our letters grew out of writing rather than out of drawing or constructing them. Simons's wide transmission of this skill of broad-edged pen writing—a craft that can only be learned by doing, watching, imitating a teacher, and training the hand until the gestures are in muscle memory—became an important basis that made modern type design possible.

One of Larisch's most significant contributions was his understanding of the importance of what he called "light." That is his observation that between black pen strokes the white paper appears brighter than the surrounding area. This observation enforced his definition of correct letter-spacing: equal *areas* (not linear distances) of white within and between letters; when Willimann adapted this idea to broad-nibbed pen writing, he recaptured the beauty it once had in the Middle Ages and Renaissance. Frutiger summed this up splendidly in his foreword to Gürtler's *Experiments with Letterforms and Calligraphy*:

> This book is for me another link in the chain that moves from master to student and again from master to student. Alfred Willimann taught me to understand how the pen can express the spirit of the centuries. He showed me how the stroke of the pen on a sheet of paper brings the light to shine, how interior space and distance, precisely complementing each other, can wonderfully arrange a line. This love of capturing the light I was able to pass on to André Gürtler.[38]

With his long experience as a practicing designer, it was Ehmcke's contribution that he used what he learned from all, Larisch, Simons and also Johnston, and thus proved the significance of their ideas and skills for the emerging field of applied graphic design.

What providence that the teaching of Johnston, Simons, Larisch, and Ehmcke took place in Switzerland, which, during World War II, was one of the few safe countries in Europe for any artistic development to survive and grow. Formal writing and lettering could therefore continue as a tradition, a tradition that made the school in Zürich into a center for modern typeface design. Typefaces such as Hans Eduard Meier's Syntax, Frutiger's Univers and Frutiger, and Max Miedinger's Helvetica not only became some of the most widely used typefaces in the world, but also influenced subsequent typeface design.

The type family Stone Sans, by Sumner Stone (from 1984–1989 director of typography at Adobe Systems) was influenced by Syntax as was Lucida Sans by Kris Holmes and Charles Bigelow, the designers of the Lucida type family. (Lucida Sans was from 2001 until 2014 the system font for Apple OS X). What all of these type designers shared was a rigorous training in broad-edged pen writing. Stone, Holmes, and Bigelow studied in the United States with Lloyd Reynolds; Miedinger, Meier, and Frutiger in Switzerland with Willimann, and Käch. The education of all can be traced back to Johnston's "study of pen shapes of letters in early MSS at the British Museum" in the early 20th century;[39] and—through this process—his rediscovery of the "supreme letter-making tool," the broad-edged pen. It should come as no surprise that this writing tool was not only the forming influence in European writing but also foundational for the most beautiful Arabic and Hebrew manuscripts. This "most potent and magically-seeming tool"[40] as Johnston called it, continually allows us to find the way back to the roots of our letterforms.

Notes

Epigraph: Willy Rotzler, "Ernst Keller und die Schweizer Graphik," in *Ernst Keller Graphiker 1891–1968, Gesamtwerk*, Wegleitung 304 des Kunstgewerbemuseums der Stadt Zürich (Zürich: Orell Füssli, 1976), 11.

Unless otherwise noted, all translations in this chapter are by the author.

1. Alfred Altherr, "Anna Simons" Festschrift for Anna Simons, 56.
2. Anna Simons, "Begegnungen mit Rudolf von Larisch," *Rudolf von Larisch Gedächtnis Ausstellung* (Berlin: Preußische Druckerei und Verlagsanstalt, 1936), 4.
3. Adrian Frutiger, foreword to André Gürtler, *Schrift und Kalligraphie im Experiment* (Basel, Switzerland: Verlag Niggli AG, 1997), 9.
4. Frutiger, "Lehren und Lernen," unpublished manuscript describing his studies with Willimann and Käch. Author's collection.
5. Altherr, "Anna Simons" Festschrift for Anna Simons, 56.
6. In spite of some research at the city archives of Leipzig, which included checking telephone books of the years Keller spent there, the reference librarian, Olaf Hillert, could not find any establishment of that name. I assume that the city of Leipzig itself was considered "Werkstatt für deutsche Wortkunst."
7. Gewerbeschule und Kunstgewerbemuseum der Stadt Zürich, *Bericht über das Jahr 1921/22*, 8.
8. Altherr, "Anna Simons" Festschrift for Anna Simons, 56.
9. Max Kämpf, "Alfred Willimann, Erinnerungen an ihn und seinen Schriftunterricht aus den Jahren 1946–51", manuscript, Museum für Gestaltung Zürich, Grafiksammlung, ZHdK.
10. Hans Fischli, "Obituary for Alfred Willimann," *WERK-Chronik* 4 (1957), 68.
11. Frutiger, telephone interview with the author, 2004.
12. Guido Krummenacher, curator at the Zürcher Hochschule der Künste ZHdK, Archiv, e-mail to the author, 2004.
13. Frutiger, "Lehren und Lernen."
14. Rudolf von Larisch, *Über Zierschriften im Dienste der Kunst* (Munich: Verlag Joseph Albert, 1899), 27.
15. Frutiger, "Lehren und Lernen," part 1 on Alfred Willimann.
16. This description of the contrast between black pen strokes on white paper originated with Larisch: "Because usually we write black on white, we speak of the resulting background segments as light." Rudolf von Larisch, *Unterricht in Ornamentaler Schrift*, 2nd ed. (Vienna: K. K. Hof- und Staatsdruckerei, 1909), 42.
17. Frutiger, "Lehren und Lernen," part 1 on Alfred Willimann.
18. Frutiger, "Lehren und Lernen," part 1 on Alfred Willimann.
19. Frutiger, "Lehren und Lernen," part 1 on Alfred Willimann.
20. Frutiger, "Lehren und Lernen," part 1 on Alfred Willimann.
21. Frutiger, "Lehren und Lernen," part 1 on Alfred Willimann.
22. Frutiger, "Lehren und Lernen," part 2 on Walter Käch.
23. Walter Käch, *Rhythmus und Proportion in der Schrift* (Olten und Freiburg im Breisgau: Otto Walter-Verlag, 1956), 46.
24. Frutiger, "Lehren und Lernen," part 2 on Walter Käch.
25. Frutiger, "Lehren und Lernen," part 2 on Walter Käch.
26. Emil Ruder, "Walter Käch in Dankbarkeit," *Typographische Monatsblätter* 4 (April 1966), 290.
27. William R. , "Editor's Preface," in Edward Johnston, *Writing and Illuminating and Lettering* (London: A and C Black, 1994), vii–viii.
28. Frutiger, "Lehren und Lernen," part 2 on Walter Käch: Die Meinungsverschiedenheit.
29. Werner Wälchli, "Der Schriftunterricht," catalogue for the exhibition "Walter Käch: *Schriftgrafiker und Lehrer*" (Zürich: Kunstgewerbemuseum, 1973), 22.

30. Berchthold von Grünigen, introduction to Walter Käch, *Schriften, Lettering, Écritures* (Olten, Switzerland: Verlag Otto Walter AG, 1949), v–vii.
31. Jost Hochuli, "Zeit und Werk," *Walter Käch: Schriftgrafiker und Lehrer*, 19.
32. Emil Ruder, "Walter Käch in Dankbarkeit."
33. Victor Malsy and Lars Müller, *Helvetica Forever: Geschichte einer Schrift* (Baden, Switzerland: Lars Müller, 2008), 24. See also Friedrich Friedl, Nicolaus Ott, and Bernard Stein, *Typography: An Encyclopedic Survey of Type Design and Techniques throughout History* (New York: Workman, 1998), 382–83.
34. Peter Bain, "A Manual of Hand-Made Modernism," *Eye Magazine* 92 (2016), 38–43.
35. Frutiger, "Lehren und Lernen," part 2 on Walter Käch.
36. Erich Alb, e-mail to the author, July 26, 2014.
37. Heidrun Osterer and Philipp Stamm, eds., *Adrian Frutiger—Typefaces: The Complete Works* (Basel, Switzerland: Birkhäuser, 2014), 450.
38. Alfred Willimann, foreword to André Gürtler, *Experiments with Letterforms and Calligraphy* (Sulgen, Switzerland: Verlag Niggli AG, 1997), 9.
39. Johnston's entry into the British Who's Who of 1937.
40. Priscilla Johnston, *Edward Johnston* (London: Faber and Faber, 1959), 75.

Permissions

The following illustrations and photographs are reprinted by permission. All rights are reserved by the copyright holders listed below. Permission to reproduce any of these illustrations and photographs must be obtained directly from the copyright holder. Every effort has been made to trace all copyright owners. Graphics Press apologizes for any omissions and will remedy such cases in any future editions.

COVER © Unicorn Publishing Group

INTRODUCTION Photograph of one side of the Forum Stone in *Universalgeschichte der Schrift*, Harald Haarmann © 1990 (Frankfurt am Main: Campus Verlag GmbH, 1990) 295 • Detail of a tenth-century psalter, probably written at Winchester, England, Harley MS 290 (folio 203v) © British Library Board • Blackboard writing by Walter Käch, projected onto the photograph of a Roman stone inscription © Thea Altherr • Photograph of modern broad-edged and modern pointed pen © Mark Zurolo • Detail of a page from a nineteenth-century American ledger written in pointed pen current © Barbara Kanner • Detail of an exercise book of Anna Simons's student Thea Budnick © Gundula Grützner •

CHAPTER 1, ANNA SIMONS Photograph of Edward Johnston at Lincoln's Inn © Andrew Johnston • Seventh century uncial writing, probably Continental, Gospel of St. John, Loan MS 74 (folio 53v); Seventh-century English half-uncial writing of Latin Gospels, from the Durham Book, written at Lindisfarne, NE England, under Irish influence, Cotton MS Nero D IV (folio 8); Carolingian writing, English, tenth-century psalter, probably written at Winchester, England, Harley MS 2904 (folio 203v) © the British Library Board • Detail of Edward Johnston's blackboard writings at the Royal College of Art ca. 1926 © Professor Ewan Clayton • Simons's student Thea Budnick, modernized half uncial based on Johnston, detail of an exercise book © Gundula Grützner • Seventh-century Irish half uncial, Latin Gospels, Gospel of St. Matthew, in *Book of Kells*, TCD MS 58 (folio 61v) © the Board of Trinity College, Dublin • Simons's student Thea Budnick, page of versals in an exercise book © Gundula Grützner • Hermann Muthesius, 1905 letter to William Lethaby; Count Harry Kessler, 1905 letter to Edward Johnston, Manuscript Collection of the Newberry Library © The Newberry Library Chicago • Simons's student Thea Budnick, modernized half uncial in an exercise book © Gundula Grützner • Simons's student Rudo Spemann, page from Rudo Spemann's handwritten book *Die erst Epistel Pauli zu den Chorinthern* © Sammlung Klingspor Museum, Offenbach a. M. • Simons's student Thea Budnick, Carolingian script in an exercise book © Gundula Grützner • The Doves Bible, opening chapter, the first book of Moses, called Genesis. Initial and first line of text by Edward Johnston © William Andrews Clark Memorial Library, University of California, Los Angeles • BPM (Bremer Presse Munich) monogram design by Anna Simons, in *Die Bremer Presse*, Josef Lehnacker, ed. © 1964, Typographische Gesellschaft, München • Anna Simons, *Geschichte der Schrift* © 1926 Museum für Gestaltung Zürich, Grafiksammlung • Monumental letters being mounted on the pediment of the Reichstag in *Der Reichstag: Die Geschichte eines Monumentes*, Michael S. Cullen © 1983, Verlag Fröhlich und Kaufmann, Berlin • Inscription for the tombstone of Anna Simons in *Monumentale Schriften von F. H. Ehmcke*, Georg D.W. Callwey Verlag, 1953, 21 © Sabine Bloch •

CHAPTER 2, RUDOLF VON LARISCH All images are in the public domain •

CHAPTER 3, F. H. EHMCKE All work in this chapter identified as: "designed by F. H. Ehmcke or Clara Möller-Coburg" © Sabine Bloch •

CHAPTER 4, WAVES OF INFLUENCE: ZÜRICH CONNECTIONS Photo of Alfred Altherr © Thea Altherr • Photo of Walter Käch © Thea Altherr • Photo of Ernst Keller © Dr. Silvia Schmid-Keller and Sonia Pretignat-Keller • Poster by Alfred Willimann, "Ausstellung Populärer Statistischer Darstellungen" © Theres Lötscher-Willimann • Poster by Walter Käch "Die Schrift" © Thea Altherr • Ornamental wall treatment (bible text in silver on dark blue ground) by Ernst Keller © Dr. Silvia Schmid-Keller und Sonia Pretignat-Keller • Poster for the exhibit "Friedhof und Grabmal" by Heinrich Kümpel © Thomas Kümpel und Barbara Knöpfel-Kümpel • Poster by Ernst Keller, "Jelmoli gut und billig" © Dr. Silvia Schmid-Keller und Sonia Pretignat-Keller • Poster for the exhibit "Finnische Knüpfteppiche" by Ernst Keller © Dr. Silvia Schmid-Keller und Sonia Pretignat-Keller • Poster for the exhibit "Licht in Heim, Büro, Werkstatt" by Alfred Willimann © Theres Lötscher-Willimann • Poster for the exhibit "Tempel und Teehaus in Japan" by Armin Hofmann © Armin and Dorothea Hofmann • Photo of Alfred Willimann writing in a student exercise book © Theres Lötscher-Willimann • Photo of Alfred Willimann writing on the blackboard © Theres Lötscher-Willimann • Pages from a student's exercise book in Willimann's class © Theres Lötscher-Willimann • Two sample pages of broad-nibbed pen writing by Alfred Willimann © Theres Lötscher-Willimann • Rubbing of a stone inscription at the Museo Civico of Bologna in *Rhythmus und Proportion in der Schrift,* Walter Käch (Olten und Freiburg im Breisgau, Germany: Otto Walter Verlag 1956), 46 © Museum für Gestaltung Zürich, Grafiksammlung • Adrian Frutiger, *Lehren und Lernen,* detail of an unpublished manuscript describing his studies with Willimann and Käch © Museum für Gestaltung Zürich, Grafiksammlung • Walter Käch, blackboard writing © Thea Altherr • Walter Käch, blackboard writing, explaining the proper spacing of letters © Thea Altherr • Walter Käch, *Schriften, Lettering, Écritures* (Olten Switzerland: Otto Walter Verlag, 1949), cover © Museum für Gestaltung Zürich, Grafiksammlung • Drawing of a lower case Grotesk alphabet in *Schriften, Lettering, Écritures,* Walter Käch (Olten Switzerland: Otto Walter Verlag, 1949) © Museum für Gestaltung Zürich, Grafiksammlung • Photo of Hans Eduard Meier © Museum für Gestaltung Zürich, Sammlungen • *The Development of Writing,* Hans Eduard Meier, cover (Cham Switzerland: Syndor Press, 1994) © Graphis Press Verlag, Zürich • Hans Eduard Meier, *The Development of Writing*, details of pages 11 and 35 © Rudolf Barmettler • Adrian Frutiger in his study in Bremgarten, detail © Museum für Gestaltung Zürich, Grafiksammlung, ZHdK • Detail of a page in *Schriften des Abendlandes in Holztafeln geschnitten,* Adrian Frutiger © Museum für Gestaltung Zürich, Grafiksammlung •

Inge Druckrey's personal library of the fine press movement in Germany now resides with The Cary Graphic Arts Collection at Rochester Institute of Technology in New York. Included is Anna Simons's portfolio titled *Titel und Initialen für die Bremer Presse,* as well as an excercise book of one of Anna Simons's last students. This collection is archived in the catalogue as the Inge Druckrey Collection.

Index

ABC Formen der Lateinischen Schriftentwicklung 178
ABC forms of Latin script development 178
About ornamental lettering in the service of art 74
Academy of Fine Arts, Vienna 74
AEG 120
Akzidenz Grotesk 174, 177
Akzidenz Grotesk bold 177
Alb, Erich 166, 181, 185
Alphabet Roissy 180, 181
Altherr, Alfred 64, 146, 155, 156, 166, 167, 184, 186
Angewandte Schrift 107, 152
angled stroke endings 46
Ankwicz-Kleehoven, Hans 94, 100
Anna Simons: Eine deutsche Schriftkünstlerin 64
Anna Simons: A German lettering artist 64
anthropometric-aesthetic study 75
Antiqua 15, 42, 114, 120
Art Nouveau 104
arts and crafts 21, 27, 28, 69, 114, 144
Arts and Crafts movement 77, 99
Arts and Crafts schools 106, 114
Aynsley, Jeremy 103, 144, 152, 153

Bachmair, Heinrich F. S. 42, 70
Backe, Arnulf 123, 152
Backe, Hedda 123, 152
background within and around letters 73
Bain, Peter 177, 185
Barmettler, Rudolf 179, 187
Bauer Type Foundry 42
Bauhaus 30, 67
Bavaria stamp design 131
Bayerische Staatsbibliothek, Munich 67, 75, 76, 122, 140
Begegnungen mit Rudolf von Larisch 155, 184
Behrens, Peter 27, 28, 31, 42, 64, 65, 70, 78, 103, 104, 106, 107, 114, 120, 134
Behrens Schrift 103, 104, 106, 120
Beinecke Rare Book and Manuscript Library 76
Beispiele künstlerischer Schrift 73, 76, 77, 78, 79, 90, 99
Beispiele künstlerischer Schrift aus vergangenen Jahrhunderten 80
Belwe, Georg 103, 104, 106, 128
Bericht über das Jahr 1921/22 146, 153, 184
Berlage, Hendrik Petrus 78
Berlinische Feuerversicherung 128, 129
Bernhard, Lucian 42, 70
Bernoulli, Rudolf 148, 153

Berthold Grotesk 177
Bertlings, Peter 109
Biblia, Das ist: Die Gantze Heilige Schrifft-Deudsch 46, 48, 49
Bigelow, Charles 183
Binder, René 144, 145
blackboard 23, 24, 34, 39, 86, 175,
blackletter 31, 32, 38, 46, 48, 50, 59, 150
Blanckertz, Minna 38
Blanckertz, Rudolf 23, 67, 90, 98
block book 88, 89, 160
Blockschrift 91
Board of Trinity College 25
Bodoni, Giambattista 15
Bolk, Florian 65
Book of Kells 24, 25, 186, 187
Book Typography 1815–1965 in Europe and the United States of America 123
Bremer Presse 40, 41, 42, 43, 45, 46, 47, 48, 49, 50, 51, 52, 53, 54, 55, 56, 58, 59, 64, 67, 68, 70
Bremer Presse Bible type 48, 49
Bremer Presse books 42, 43, 46
Bremer Presse, The 59
bright letters 87
British Library Board 22
British Museum 21, 22
broad-edged brush 13
broad-edged pen 14, 15
broad-edged reed pen 17, 21
broad-nibbed pen 23, 39, 43, 50, 72, 88, 89, 90, 91, 104, 114, 157, 166, 168, 169, 170, 172, 178, 180, 182, 186
brutale Lesbarkeit 98
brutal legibility 82, 98
Buchkunst Ausstellung Leipzig 148, 153
Budnick, Thea 15, 24, 27, 32, 34, 38, 39
built-up versals 27
Byzantine writing 60

cancellaresca corsiva 14
capital letters 34, 48, 50, 86, 97, 108, 174, 176, 177
Carolingian 12, 15, 27
Carolingian minuscule 181
Carolingian script 22, 24, 39, 59
Carolingian writing 22, 61
Central School of Arts and Crafts, London 21
Chansons d'Amour 43, 53
Chaucer, Geoffrey 16
City of God 46, 47, 56, 57
Clayton, Ewan 23, 24
Cobden-Sanderson, Thomas J. 15, 16, 23, 30, 50, 66, 69
Cockerell, Sir Sydney 22
compact line spacing 38
condensed 38, 76, 94, 174, 180

construction of letters 73
construction plaque 141
constructive approach 176
copy book 24
counter-forms of letters 76
Crane, Walter 77
Crown Prince Rupprecht of Bavaria 122
crude lettering on the edifices of cultural institutions 75
Cullen, Michael S. 64, 71
cursive 16, 38, 59, 62, 168
Czeschka, Carl Otto 78, 94, 96

D. Stempel AG, Frankfurt a. M. 118, 119, 178
Dante 43, 45, 51
dark letters 87
darkness and texture of a page 38
das Abgrenzen von Schriftfeldern 77
DAS DEUTSCHE HAUS 64
Das Haus der Frau 59
De Civitate Dei Libri XXII 46, 47, 56, 57
Das Zelt: Zeitschrift des Ehmcke Kreises 144
Deberny and Peignot 180
Decorative Heraldry 76
Delitsch, Hermann 94
Delphin Verlag 128, 129
demarcation of a field of text 77
DEM DEUTSCHEN VOLKE 64
Der Reichstag: Geschichte eines Monuments 64, 71
Der Schönheitsfehler des Weibes 75
descenders 33, 39
Deutsche Buchkunst 1890 bis 1960 68, 104, 152
Deutsche Schrift 111
Deutscher Werkbund 104, 130, 152
Deutsches Buch- und Schriftmuseum der Deutschen Nationalbibliothek, Leipzig 93, 115
Deutsches Buch- und Schriftmuseum der Deutschen Nationalbibliothek, Leipzig, Grafische Sammlung 115, 116, 117, 144, 146
Deutsches Schreibbüchlein 150, 153
Development of Writing, The 46, 178, 179, 187
Didot, Firmin 15
Die Grundworte des indischen Monismus aus den Upanischads des Veda 120
Die Rupprecht Presse: Ein Porträt 123, 152
Die Schrift 99, 157, 186
distribution of masses 75, 76, 86, 97
Dittrich, Oswald 93
Divine Comedy 43, 45, 51
Doepler, Emil 103
Doves Bindery 23, 42

Doves Press 16, 23, 30, 41, 42, 50, 51, 64, 66
dull-sightedness 82
Durham Book 22, 24
Düsseldorf School of Arts and Crafts 27, 31, 106
Düsseldorf School for Crafts and Industry 42, 106, 120
Düsseldorfer Sonderbund 120, 121

Eckmann, Otto 42, 77, 103, 104, 105
Eckmann Schrift 103, 104, 105
Edward, Edward 88
Edward Johnston 21, 23
Ehmcke Antiqua 114, 115, 120, 121, 134, 136, 138
Ehmcke Brotschrift 114
Ehmcke Elzevir 114, 116
Ehmcke, F. H. 17, 27, 28, 30, 31, 38, 41, 42, 64, 67, 68, 136, 186
Ehmcke Fraktur 114, 119, 126, 148
Ehmcke Fraktur Medium Bold 114
Ehmcke Italic 114
Ehmcke Kursiv 122
Ehmcke Latein 114, 134
Ehmcke Mediaeval 114
Ehmcke Rustika 114, 122
Ehmcke Schwabacher 114, 118, 124, 132, 146
Ehmcke, Susanne 143
Eichheim, Max 144, 145
Ein Fürstenspiegel 123
Eintakt 98, 168
Elly and Oswald, or the emigration from Stürvis 148, 149
Elly und Oswald, oder die Auswanderung von Stürvis 148, 149
Emperor Wilhelm II 122
English fine press movement 59, 66
Enlightenment 16
equal proportions between interior and in-between spaces of letters 73
Erbar, Jakob 28, 142
Ernst Keller, Graphiker 1891–1968, Gesamtwerk 158
Eugen Diederichs Verlag, Munich 120, 128, 129
even texture 80, 81, 87
even texture and tonal value 107
ever-living and fluent prototypes 15
ex libris 58, 92, 96, 104
Examples of artistic writing 73, 76, 77, 78, 79, 90, 99
Examples of artistic writing from past centuries 80
Experiments with Letterforms and Calligraphy 155, 182
Eye Magazine 177, 185

Fairbank, Alfred J. 94
faulty positioning of letters in relationship to each other 75
Feldpost Bureau A.M.S. 66
Festschrift for Anna Simons 21, 32, 35, 41, 42, 51, 64, 66, 67, 68, 69, 70, 71, 96, 146, 153, 155, 156
F. H. Ehmcke and Clara Möller-Coburg 136
F. H. Ehmcke or Clara Möller-Coburg 186
F. H. Ehmcke Werkstatt Pressa Köln 144, 145
figure and ground 76
fine press 16, 59, 66
Finnische Knüpfteppiche 163, 186
Finsler, Hans 167
Fischli, Hans 166, 184
flat-edged brush 89, 91, 157
Fleckenwirkung 98
Flinsch Foundry 114
folio 12, 22, 24, 25, 43, 187
formal, expressive potential (of letters) 82
formal writing 17, 21, 28, 31, 32, 38, 67, 166, 167, 183
Forum Stone 12
Foundational Hand 24
foundry 115, 128, 180
Four Centuries of Fine Printing 66
Fraktur 38, 59, 61, 114, 119, 126, 131, 148
Fraktur script 61
French cursive 62
Friedhof und Grabmal 159, 186
Frutiger, Adrian 166, 167, 177, 181, 183, 184
Futura 38, 174

Gauchat, P. 146
Gebrauchsgraphik 103, 152
Geordnetes und Gültiges 99, 150, 152
German blackletter 48
German embassy, London 21, 27
German Reichstag 64, 65, 71
German script 41, 63
German Werkbund exhibition 134, 135
German Writing Manual for the teaching of blackletter manuscript hands 150
Germania an ihre Kinder 124
Geschichte der Schrift 60, 61, 62, 63, 186
Gewerbe Museum Graz, Austria 138, 139
Gewerbe Museum Basel, Switzerland 165
Geyer, Rudolf 90
Gildenzeichen, nach Entwürfen von F. H. Ehmcke und Mitarbeitern 128
Gill, Eric 23, 27, 28, 94
Glosses 22
Golden Type 16
Gothic writing 38, 61

Graphic Design in Germany 1890–1945 103, 144, 152
Graphis Press, Zürich 179
Grasset, Eugene 78
graver 17
gray value 58, 73, 87
Greek capital writing 60
Greek type of the Bremer Presse 50, 54, 55
Grimms Märchen 131
Grolier Club 40, 70
Grotesk 177
Grützner, Gundula 15, 24, 27, 32
guild signs 128
Gürtler, André 155, 156, 182, 184, 185
Gutenberg Bible 38

Haas'sche Schriftgiesserei 177
Hablik, Wenzel 78
Hadank, O. H. W. 94
hairlines 114
half uncial 15, 24, 27, 38, 50
half-uncial writing 22, 60
Hammersmith 16, 41, 69
hand press 51, 103, 123
handwriting 14, 17, 21, 41, 67
Harler, Heidy 170
Hauptmann, Gerhardt 30
Haus der Deutschen Ärzte 140
Haus-, Hof- und Staatsarchiv in Vienna 80
Helvetica 177, 183, 185
Helvetica bold 177
Helvetica Forever 177, 185
heraldry 74, 75, 76, 86
Hewitt, Graily 23, 94
history of writing 21, 39, 59, 169
Hitler, Adolf 15
Hochschule der Bildenden Künste, Munich 150
Hochuli, Jost 176, 185
Hoell, Louis 42, 51, 114, 115, 119
Hoffmann, Joseph 74, 99
Hofmann, Armin 162, 165, 186
Hofmann, Dorothea 165
Holbein Verlag 122
Holliday, Peter 27, 69
Holmes, Kris 183
Hölscher, Eberhard 58, 70, 93, 99
horizontal endings of curved strokes 177
House of Hapsburg 74
How Typography Happens 103, 106
Humanism 16
Humanist script 62, 179
Hupp, Otto 77
Hurm, Otto 94
hybrid face 48

Idyllen des Theokrit 120

Iliad and *Odyssey* 48
Imperfection of women, The 75
Imperial Cabinet Council 74
incunabula 42
initial 42, 43, 44, 46, 47, 48, 49, 51, 52, 53, 56, 57, 58, 59, 126, 127, 129, 130, 131
ink gain 50
Insel Almanach 134
interconnection of alternating movements and alternating forms 176
International Art Teachers' Conference, Dresden 75
Internationale Ausstellung moderner künstlerischer Schrift 94, 95
Irish half uncial 172, 177
Irish half-uncial writing 60
Itten, Johannes 167

Jäkel, Hugo 108
Jelmoli gut und billig 162, 186
Jenson, Nicklaus 50
Johnston, Andrew 21
Johnston, Edward 16, 17, 20, 21, 22, 23, 24, 27, 28, 30, 31, 32, 33, 38, 40, 41, 42, 50, 58, 64, 66, 67, 69, 70, 71, 73
Johnston, Priscilla 21, 23, 24, 40, 67
judging based on optical impressions 74

Käch, Walter 13, 94, 156, 157, 158, 160, 166, 167, 174, 175, 176, 177, 178, 180, 182, 183, 184, 185, 186
Kämpf, Max B. 166, 184
Kanner, Barbara 15
Keetmann-Simons, Käthe 67
Keller, Ernst 70, 94, 148, 156, 157, 158, 162, 163, 178, 184, 186
Kelmscott Press 16, 23, 64
Kessler, Count Harry 27, 28, 30, 69, 186
K. K. Hof- und Staatsdruckerei 96, 100, 184
Kleukens, Christian Heinrich 152
Kleukens, Friedrich Wilhelm 94, 103, 104, 106, 128
Klien, Erika Giovanna 83, 84
Klimsch's Jahrbuch 103, 152
Klingspor Foundry 106, 128
Klingspor Museum 38, 66, 70, 75, 76, 78, 80, 83, 84, 85, 86, 88, 89, 90, 93, 94, 95, 96, 104, 105, 128, 131, 148, 150
Koch, Rudolf 40, 41, 68, 78, 94, 99, 140
Kohlmann, J. 146, 148
Kreis, Wilhelm 120
Kümpel, Heinrich 156, 158, 159, 186
Kunstgewerbeblatt 31, 69
Kunstgewerbemuseum, Basel 165
Kunstgewerbeschule, Zürich 166, 178, 180

L'Antimachiavel 122
Larisch-Ramsauer, Hertha 94

Latin Gospels 22, 25, 186, 187
Latin letters 13
legibility 74, 75, 77, 82, 98
le Grand, Frédéric 122
Lehnacker, Josef 42, 43, 46, 59, 68, 70, 71
Lehren und Lernen 174, 184, 185, 186
Leibl, Wilhelm 141
Leipzig 40, 58, 59, 69, 70, 93, 99, 106, 115, 116, 119, 121, 130, 144, 146, 148, 153, 156, 178, 184
Leipzig Academy for Graphic and Book Arts 106
Leipziger Akademie für Graphische Künste und Buchgewerbe 106
Leskien, August 132
Lethaby, William 21, 22, 23, 27, 28
letterpress printing 15, 103, 120, 121, 142, 146
Letters as ornamental surface treatment 143
letter spacing 42, 46, 73, 76, 87, 96, 98, 155, 170, 175
Licht 98, 162, 164, 170, 186
Licht in Heim, Büro, Werkstatt 164, 186
Lieder der deutschen Mystik 52
Liedmann, Franz 111, 112
light 87, 98, 155, 162, 168, 170, 180, 182, 184
lightness and darkness, of a field of text 90
Lindisfarne 22
line spacing 38, 39, 109, 112, 113, 158, 169
linoleum 28, 91, 92, 110, 123, 142, 157, 163, 165
lithography press 103
London Mercury 48, 70
Ludwig Wagner Schriftgiesserei, Leipzig 116
Lüssi, Otto 148
Luther Bible 42, 46, 48, 49, 50, 70
Luther, Martin 46, 48, 49

Mackintosh, Charles Rennie 78
majuscule 91, 168, 179
manifesto of the Steglitzer Werkstatt 105
manuscript 13, 16, 17, 32, 33
Manuscript and Inscription Letters for Schools and Classes and for the Use of Craftsmen 66, 69
manuscript hand 13, 16, 17, 21, 22, 24, 27, 32, 34, 38, 39, 42, 46, 50, 60
Märchen aus dem Balkan 132, 133
Master Johans Hadloubs love poetry 146, 147
Materot, Lucas 14
McLean, Ruari 70, 103, 106
McLeish, Charles 42
Meander design 76

measure and proportion 73
measure of one 98, 168, 175
Meier, Hans Eduard 46, 166, 167, 174, 178, 179, 180, 181, 182, 183, 187
Meister Eckehart 160
Meister Johans Hadloubs Minnelieder 146, 147
memorial plaque 140, 141
Middle Ages 21
Miedinger, Max 177, 183
Ministry of the Interior, Vienna 74
minuscule 34, 38, 61, 91, 179, 181
Mitteilung der Pelikan Werke 107, 152
modernized half uncial 24, 32, 38
Modern Movement 73
modern typeface design 17
modern typography 17
Möller-Coburg, Clara 104, 106, 136, 186
Monographien künstlerischer Schrift 69, 93, 99
Monumentale Schriften von F. H. Ehmcke 67, 140
Morach, Otto 156
Morison, Stanley 28, 64, 66, 69
Morris, William 16, 17, 21, 22, 23, 150
Moser, Koloman 74, 77, 96, 99
MS 12, 22, 24, 25, 69, 186, 187
MSS 33, 183
Mucha, Alphonse 77
Müller, Christian 110, 177, 185
München-Gladbach 21
Munich School of Arts and Crafts 38, 41, 120, 142, 167
Museo Civico, Bologna 174
Museo Civico in Padua 156
Museum for Arts and Crafts, Weimar, Germany 27
Museum für Angewandte Kunst 82
Museum für Gestaltung Zürich, Grafiksammlung 13, 160, 161, 162, 170, 172, 173, 175, 176, 177, 178, 180
Museum für Gestaltung Zürich, Plakatsammlung 135, 144, 145, 157, 159, 163, 164
Muthesius, Hermann 21, 27, 28, 31, 69, 106

neoclassical typefaces 15, 16, 17
Neue Haas Grotesk 177
Newberry Library 28, 69, 71, 186
Newdigate, B. H. 48, 70
New York Times 64, 71
Nicholson, William 78
Niemeyer, Wilhelm 64
Nordic popular legends *132, 133*
Nordische Volksmärchen 132, 133

Offenbach a. M.: Schriftgiesserei

Gebr. Klingspor 128
Officin W. Drugulin, Leipzig 119
Of the most holy miracle which Saint Francis of Assisi wrought when he converted the very fierce wolf of Agobio 89
Olbrich, Joseph Maria 77, 78, 79
On the legibility of ornamental writing 82, 99, 100
160 Kennbilder: Eine Sammlung von Warenzeichen, Geschäfts- Verlags- und Büchersignets 103, 120, 128, 129
one-year master class in writing and lettering 167
optical illusion 77
optically-even letter spacing 73, 87, 96, 98, 155
Order of the Golden Fleece, The 74, 80, 99
Orell Füsli 167
Orlik, Emil 78
ornamental distribution of masses 75, 76, 86, 98
ornamentale Massenverteilung 98
Ornamentale Schrift als Erziehungsmittel 94, 99
Ornamentale Schrift als Kunsterziehung 155
ornamental handwriting 91, 97
ornamental lettering 75, 77, 86
Österreichisches Museum für Kunst und Industrie 94
outline drawings 50, 51, 90, 91, 174

Palatino, Giambattista 14
paper stencil 92, 93
Paul Mellon Collection 16
pearling of letters on a string 87, 98
Perlen von Buchstaben 98
personal alphabet 86
personal handwriting 73
Persönliches und Sachliches 150, 152, 153
plaster cutting 28, 90, 92
Plinius Antiqua 96, 97
pointed pen 14, 15
pointed pen current 15
Popular legends from the Balkans 132, 133
Populäre Statistische Darstellungen 157
positive and negative form 103
poster design 74, 135, 144, 145, 156, 157, 159, 162, 163, 164, 166, 167
precursive 36, 38
Preetorius, Emil 102
Pressa Köln 144, 145, 153
Preussische Kunstgewerbeschulen 106
Prince, Edward 16
principle of support and load 77
private press 41

Pro Arte 177
proportions of Roman inscriptional letters 177
Prussian Arts and Crafts Schools 106
Prussian Ministry of Commerce 21, 27, 69
punch cutter 16, 17, 42
punch cutting 15, 51

Quellstift 28, 90, 108, 112
quill 17, 28, 43

Reclams Universal Bibliothek, Leipzig 130
Redis pen 90
Redslob, Edwin 64
reed pen 17, 21, 34, 91, 111, 113
relationship of letters to each other 86
renewal of writing and lettering 73, 77, 78, 182
Renner, Paul 38, 40, 70, 174
Reynolds, Lloyd 183
rhythm 73, 76, 86, 88, 98, 155, 168, 169
Rhythm and proportion in lettering 174, 176, 184, 186
Rhythmus 76, 98, 174, 176, 184, 186
Rhythmus und Proportion in der Schrift 174, 176, 184, 186
Riemerschmid, Richard 120, 121, 122, 152
rip their own gaps 87
Robert Guiskard Herzog der Normänner 43
Roller, Alfred 77, 78, 79, 82
Roman alphabet 43, 88, 89, 91, 169, 178
Roman capital 60, 73, 86, 174, 176
Roman Forum 12
Roman half uncial 24
Roman inscriptional letters 174, 175, 176, 177
Roman stone inscriptions 12, 13
Rooke, Noel 16, 21, 23, 69
Rothenstein, William 41, 64, 70
Rotzler, Willy 16, 148, 154
Royal College of Art, London 21, 23, 24, 27, 41
R. Piper Drucke und Co. Verlag 130
Rückblick und Ausblick: Skizze eines Lebenslaufes 142, 153
Ruder, Emil 175, 176, 184, 185
Rudhard'sche Giesserei 106
Rudhard'sche Schriftgiesserei 103
Rudolf von Larisch und seine Schule 93, 99
Rupprecht Presse 122, 123, 124, 125, 126, 127, 146, 148, 152
Rusch, Adolf 42
Rustica 173

Saint Augustine 46, 47, 56, 57
sans-serif 174, 175, 177, 178

Savonarola und die florentinische Republik gegen Ende des fünfzehnten Jahrhunderts 126, 127
sawed metal 93
Schauer, Georg Kurt 68, 71, 104, 106, 114, 123, 128, 130, 140, 152
Schmidt, Hans 38, 70
Schmitz and Olbertz 130
Schneidler, Ernst 28, 38, 120
Schrift Gestalter 167
Schrift, Ihre Gestaltung und Entwicklung in Neuerer Zeit 150, 153
Schrift Museum Rudolf Blanckertz 67
Schriften des Abendlandes in Holztafeln geschnitten 181, 187
Schriften der Corona 64, 69, 153, 184
Schriften, Lettering, Écritures 176, 177, 185, 186
Schriftform und Schreibwerkzeug 94
Schriftpflege als Mittel der Kunsterziehung 99
Schriftschulung als Erziehung zur Form 143, 153
Schubart, Anna Marie 66
Schule 93, 99
Schwabacher 46, 48, 50, 59, 61, 114, 118, 124, 132, 146
Schweizer Schriftplakat 156
Schwemmer-Scheddin, Yvonne 66
scribe 178
script 22, 24, 33, 39, 41, 59, 61, 62, 63, 168, 176, 178, 179, 181
Secession 73, 86, 99, 104
serif 13, 38, 43, 46, 48, 50, 67
Sermon on St. John XII 160, 161
shapes of letters 73, 74, 92, 157, 183
side bearings 177
Simons, Anna 15, 17, 21, 27, 28, 30, 32, 33, 34, 35, 38, 40, 42, 43, 45, 46, 47, 49, 50, 51, 52, 53, 54, 55, 56, 58, 60, 64, 65, 66, 67, 69, 70, 73, 75, 94, 106, 114, 121, 126, 140, 142, 146, 153, 155, 166, 182, 184, 186
Skarica, Fini 88, 95
slanted penforms 24
Slimbach, Robert 13
Slevogt 62
Society of Calligraphers, England 30
Songs of Sappho 48, 50, 54, 55
spacing of letters 17, 87, 107, 114, 186
Spemann, Rudo 28, 38, 70
spotting effect 98
Staatliche Kunstgewerbeschule München 120
Staatliche Museen zu Berlin-Preussischer Kulturbesitz, Kunstbibliothek 87, 104,

128, 132, 134, 136
Staatsbibliothek zu Berlin, Potsdamer Platz 103, 108, 120, 129, 142
Städtische Gewerbeschule in Frankfurt a. M. 1908 136, 137
Steglitzer Werkstatt 103, 104, 105, 106, 122, 144, 152
Steiner, Herbert 64, 66, 68, 71
Stempel Foundry type 119
stencil cutting 28
Stone Sans 183
Stone, Sumner 183
stroke endings 21, 46, 170, 177
stroke sequences 21
Sturm und Drang 89
stylus 13, 73, 89, 90, 91, 108, 157
Suess, Ursula 32, 33, 34, 36, 38, 41
summer courses, Düsseldorf 27, 28, 30, 31
summer courses in writing and lettering 27, 31, 106
supreme letter-making tool 183
Syntax 167, 178, 183
system font 183

Tempel und Teehaus in Japan 165, 186
ten Hompel, Ludwig 128
textura 15, 36, 38, 50
texture 38, 42, 43, 46, 48, 58, 73, 80, 81, 87, 90, 107, 131
The Art of the Book in Germany in *Book Typography 1815–1965 in Europe and the United States of America* 123
the faulty positioning of letters in relationship to each other 75
The New Typography 69
the principle of support and load 77
Things in order and valid 150
Things personal and factual 150
Theinhardt, Ferdinand 174, 177
Thomas, Hubert 123
Tiemann, Walter 40, 70, 94, 156
Tiersch, Frieda 42
Titel und Initialen für die Bremer Presse 40, 43, 46, 51, 52, 53, 70
Titel und Initialen für S. Aurelii Augustini de Civitate dei Libri XXII 46
Titles and initials for the Bremer Presse 43
tombstone, Anna Simons 67, 140, 159, 186
trademark design 74, 103, 120, 128, 129, 130
Triller, Helmuth 113
Truxa, Anna 89
Tschichold, Jan 14, 15, 67, 94, 150
Twombly, Carol 13
type design 74, 97, 156, 166, 175, 177, 180, 181, 182
type family 175, 183

type foundries 27
typeface design 13, 15, 17, 103, 177, 178, 183
Typefaces, their design and development in recent times 150
typesetting 15, 104, 114, 122, 146, 148, 167
Typographische Gesellschaft München 59, 70, 71
typography 15, 17, 40, 42, 66, 67, 73, 74, 77, 96, 104, 106, 120, 123, 132, 140, 142, 146, 150, 156, 166, 167, 183
TypoTage 178

Über Leserlichkeit von ornamentalen Schriften 82, 99, 100
Über Zierschriften im Dienste der Kunst 75, 76, 77, 86, 99, 100, 184
uncial 22, 33, 38, 64
uncial writing 22, 60
unconventional letterforms 73
Univers 167, 175, 177, 180, 183
Universitätsbibliothek Heidelberg 15
Unterricht in ornamentaler Schrift 82, 84, 86, 87, 88, 90, 91, 92, 95, 96, 100, 107 158
Unterrichtsanstalt des Königlichen Kunstgewerbe Museums 103
Urban Janke 92

Vallotton, Felix 78
van de Velde, Henry 30, 31, 64, 69
van Krimpen, Jan 40
variation in stroke weights 177
vellum exercise books 39
Venetian typeface 16
Verdieck, Adolf 110
versals 15, 27
vertical edge in a block of text 77
Vienna School of Arts and Crafts 74, 86
Vogue magazine 87
von Beneckendorff und von Hindenburg, Paul 66
von Delius, Rudolf 123
von der Leyen, Friedrich 131
von Hesse, Gudrun 40, 70
von Hofmannsthal, Hugo 30
von Kleist, Heinrich 43, 124
von Larisch, Rudolf 17, 27, 32, 64, 68, 72, 73, 75, 76, 78, 80, 82, 84, 93, 96, 97, 99, 100, 106, 107, 153, 155, 158, 182, 184
von Ranke, Leopold 126
von Speyer, Johann 42

Wagner, Otto 78, 99
Walker, Emery 16, 23, 50, 51, 69
Walter Käch in Dankbarkeit 175, 176, 184, 185
Weber, Karoline Marie 21
Weimar School of Arts and Crafts 30, 31

Weiss, Emil Rudolf 28, 40, 42, 77, 94, 156
Werkstatt für deutsche Wortkunst 156, 184
Wertschriften 96
white space within and between letters 155
Wiegand, Dr. Willy 41, 42, 46, 48, 50, 51, 64, 70
Wiener Werkstätte 74
Wieser, Josef 94
Wieynk, Heinrich 94
William Andrews Clark Memorial Library 42
Willimann, Alfred 155, 156, 157, 162, 164, 166, 167, 168, 169, 170, 171, 172, 174, 175, 176, 178, 180, 182, 183, 184, 185, 186
Winchester Psalter 22, 24
Wolde, Dr. Ludwig 41, 42
Wolfskehl, Karl 123
Women Once Heard, Now Silent 64, 71
wood block 43
wood engraving 43, 142
word picture 46
World's Fair in St. Louis 64
World War I 28, 66, 122
World War II 32, 41, 121, 150, 183
Writing and Illuminating and Lettering 16, 17, 18, 21, 27, 33, 40, 58, 66, 69, 77, 86, 175, 184
writing and lettering 21, 23, 27, 28, 31, 32, 38, 40, 67, 68, 73, 74, 75, 77, 78, 86, 90, 96, 97, 98, 106, 107, 114, 121, 143, 155, 157, 166, 167, 169, 176, 182, 183
writing manual 14
writing movement 67, 68, 107
writing surfaces 74
writing tools 74, 89, 90, 182

x-height 34, 46, 177

Yale Center for British Art 16

Zapf, Hermann 40, 70
Zeitschrift für Angewandte Kunst 136
Ziele des Schriftunterrichts: Ein Beitrag zur modernen Schriftbewegung 107, 108, 142, 152
Zur Feier des einhundertjährigen Bestandes der K. K. Hof- und Staatsdruckerei, 1804-1904 96, 97
Zürcher Drucke 146, 148
Zürcher Hochschule der Künste ZHdK, Archiv 146, 155, 156, 158, 166, 168, 184
Zurich School of Arts and Crafts 17, 59, 60, 94, 120, 142, 146, 148, 155, 156, 167, 182

Colophon

PRINTED BY GHP ON ENDURANCE SILK TEXT

BINDING BY BASSIL BOOK BINDING

COMPOSED IN MINION PRO A TYPEFACE BY ROBERT SLIMBACH

TITLES COMPOSED IN SYNTAX MEDIUM BOLD A TYPEFACE BY HANS EDUARD MEIER

DESIGNED BY INGE DRUCKREY

COVER DESIGN BY EDWARD R. TUFTE

PUBLISHED BY GRAPHICS PRESS LLC